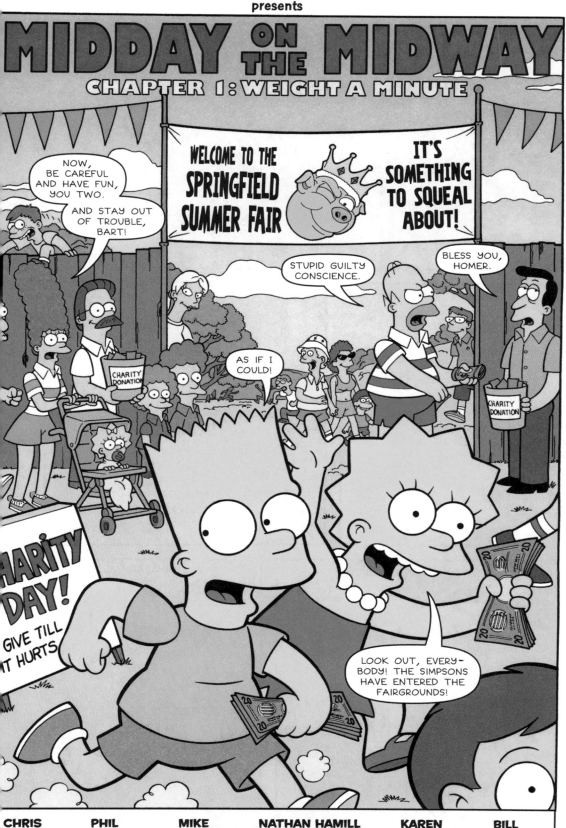

MATT GROENING
presents

MIDDAY ON THE MIDWAY
CHAPTER 1: WEIGHT A MINUTE

CHRIS
YAMBAR
SCRIPT

PHIL
ORTIZ
PENCILS

MIKE
DECARLO
INKS

NATHAN HAMILL
& ART VILLANUEVA
COLORS

KAREN
BATES
LETTERS

BILL
MORRISON
EDITOR

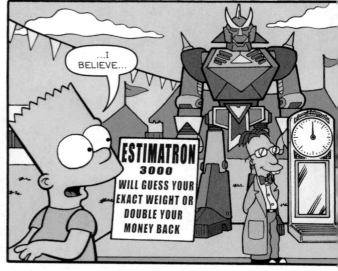

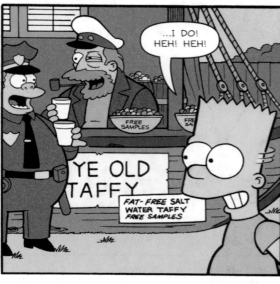

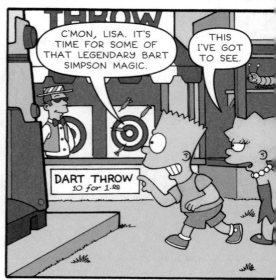

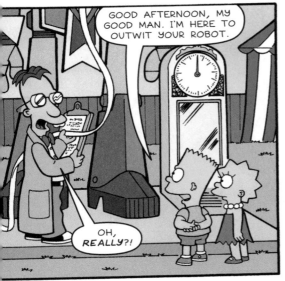

GOOD AFTERNOON, MY GOOD MAN. I'M HERE TO OUTWIT YOUR ROBOT.

OH, *REALLY*?!

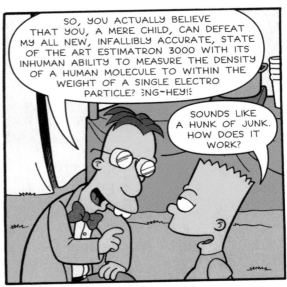

SO, YOU ACTUALLY BELIEVE THAT YOU, A MERE CHILD, CAN DEFEAT MY ALL NEW, INFALLIBLY ACCURATE, STATE OF THE ART ESTIMATRON 3000 WITH ITS INHUMAN ABILITY TO MEASURE THE DENSITY OF A HUMAN MOLECULE TO WITHIN THE WEIGHT OF A SINGLE ELECTRO PARTICLE? ∃NG-HEY!∃

SOUNDS LIKE A HUNK OF JUNK. HOW DOES IT WORK?

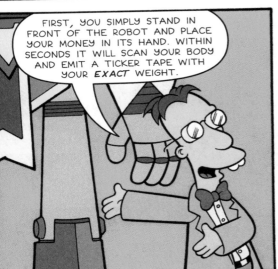

FIRST, YOU SIMPLY STAND IN FRONT OF THE ROBOT AND PLACE YOUR MONEY IN ITS HAND. WITHIN SECONDS IT WILL SCAN YOUR BODY AND EMIT A TICKER TAPE WITH YOUR *EXACT* WEIGHT.

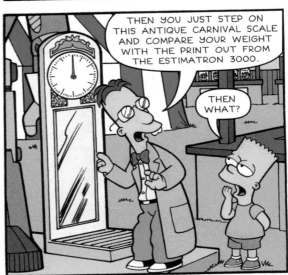

THEN YOU JUST STEP ON THIS ANTIQUE CARNIVAL SCALE AND COMPARE YOUR WEIGHT WITH THE PRINT OUT FROM THE ESTIMATRON 3000.

THEN WHAT?

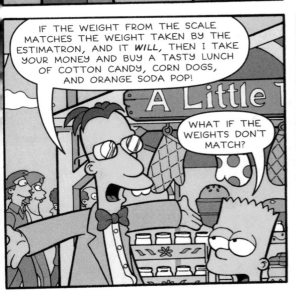

IF THE WEIGHT FROM THE SCALE MATCHES THE WEIGHT TAKEN BY THE ESTIMATRON, AND IT *WILL*, THEN I TAKE YOUR MONEY AND BUY A TASTY LUNCH OF COTTON CANDY, CORN DOGS, AND ORANGE SODA POP!

WHAT IF THE WEIGHTS DON'T MATCH?

A Little T

THEN I *DOUBLE* YOUR MONEY AND EAT THE BORING LUNCH OF SOY PROTEIN PATTIES AND CARROT STICKS THAT MY WIFE PACKED FOR ME.

Jewelry · Ring

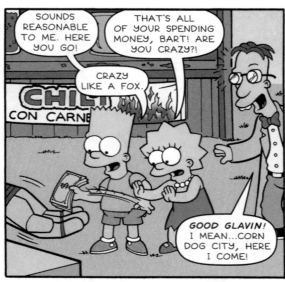

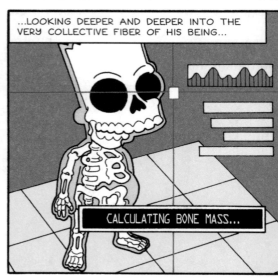

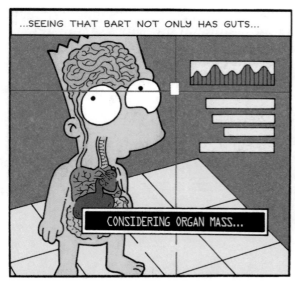

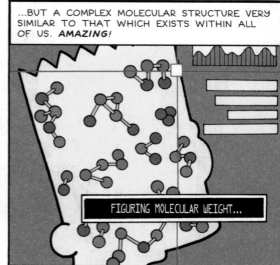

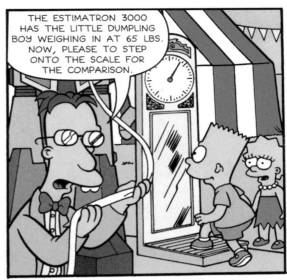

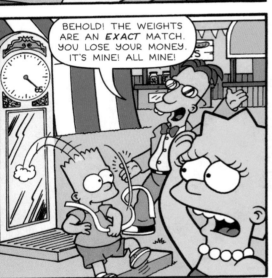

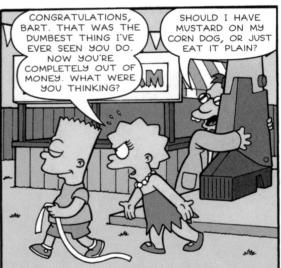

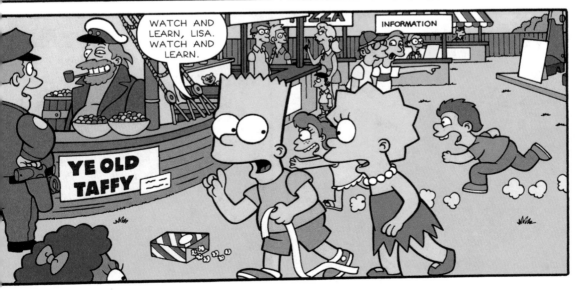

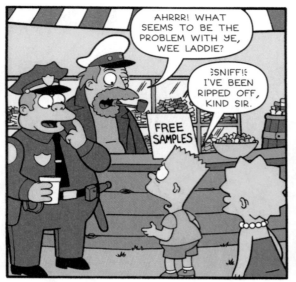

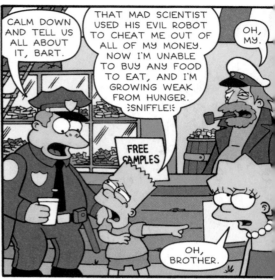

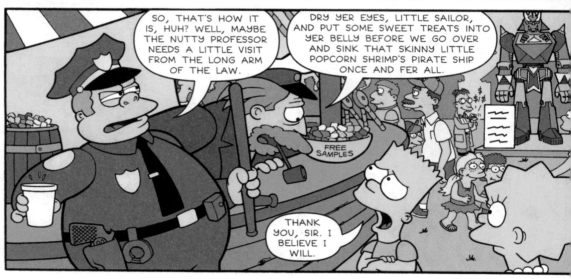

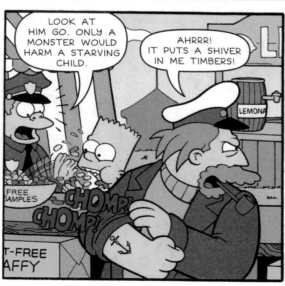

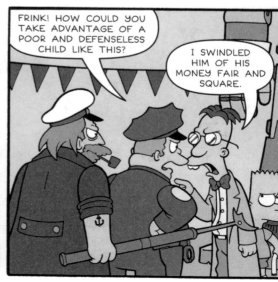

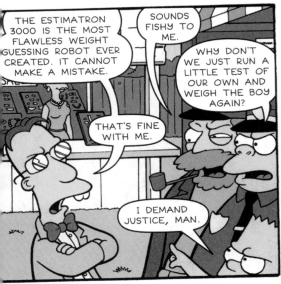

THE ESTIMATRON 3000 IS THE MOST FLAWLESS WEIGHT GUESSING ROBOT EVER CREATED. IT CANNOT MAKE A MISTAKE.

SOUNDS FISHY TO ME.

WHY DON'T WE JUST RUN A LITTLE TEST OF OUR OWN AND WEIGH THE BOY AGAIN?

THAT'S FINE WITH ME.

I DEMAND JUSTICE, MAN.

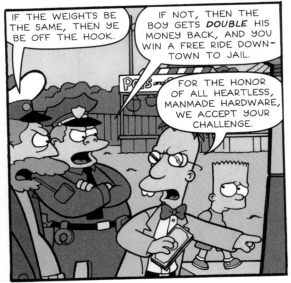

IF THE WEIGHTS BE THE SAME, THEN YE BE OFF THE HOOK.

IF NOT, THEN THE BOY GETS *DOUBLE* HIS MONEY BACK, AND YOU WIN A FREE RIDE DOWN-TOWN TO JAIL.

FOR THE HONOR OF ALL HEARTLESS, MANMADE HARDWARE, WE ACCEPT YOUR CHALLENGE.

TECHNOLOGY HAS SPOKEN ONCE AGAIN. PREPARE TO APOLOGIZE.

DING!

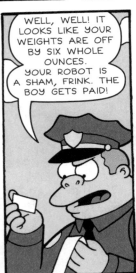

WELL, WELL! IT LOOKS LIKE YOUR WEIGHTS ARE OFF BY SIX WHOLE OUNCES. YOUR ROBOT IS A SHAM, FRINK. THE BOY GETS PAID!

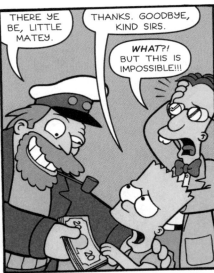

THERE YE BE, LITTLE MATEY.

THANKS. GOODBYE, KIND SIRS.

WHAT?! BUT THIS IS IMPOSSIBLE!!!

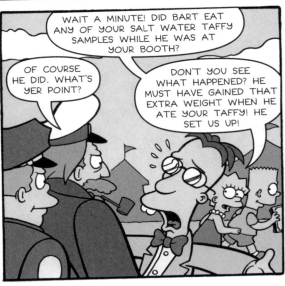

WAIT A MINUTE! DID BART EAT ANY OF YOUR SALT WATER TAFFY SAMPLES WHILE HE WAS AT YOUR BOOTH?

OF COURSE HE DID. WHAT'S YER POINT?

DON'T YOU SEE WHAT HAPPENED? HE MUST HAVE GAINED THAT EXTRA WEIGHT WHEN HE ATE YOUR TAFFY! HE SET US UP!

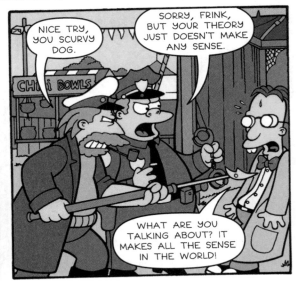

NICE TRY, YOU SCURVY DOG.

SORRY, FRINK, BUT YOUR THEORY JUST DOESN'T MAKE ANY SENSE.

WHAT ARE YOU TALKING ABOUT? IT MAKES ALL THE SENSE IN THE WORLD!

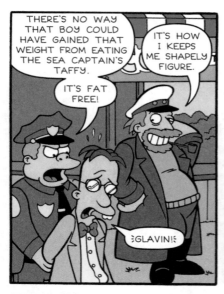

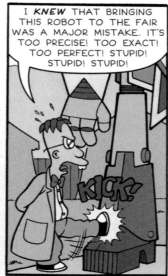

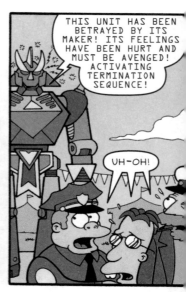

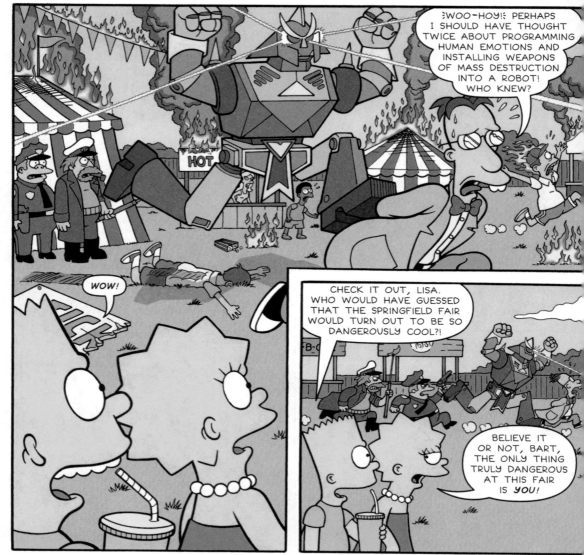

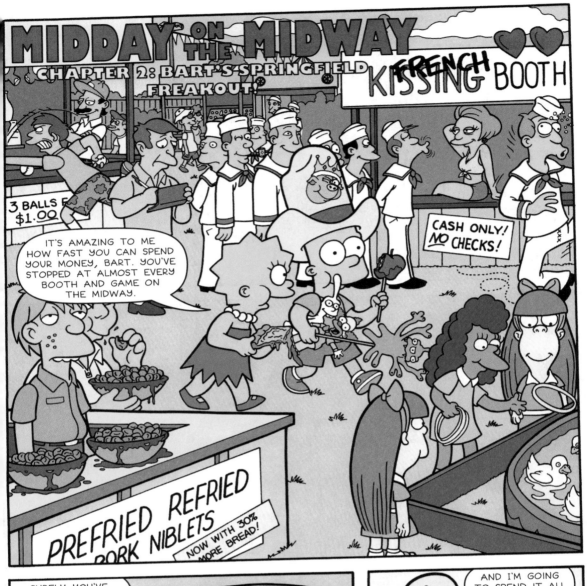

KISSING ~~FRENCH~~ BOOTH

3 BALLS $1.00

CASH ONLY! NO CHECKS!

IT'S AMAZING TO ME HOW FAST YOU CAN SPEND YOUR MONEY, BART. YOU'VE STOPPED AT ALMOST EVERY BOOTH AND GAME ON THE MIDWAY.

PREFRIED REFRIED PORK NIBLETS
NOW WITH 30% MORE BREAD!

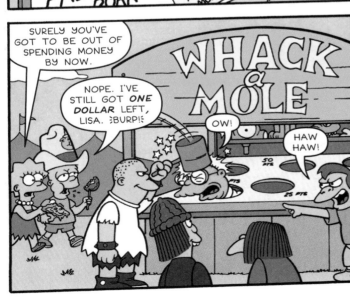

SURELY YOU'VE GOT TO BE OUT OF SPENDING MONEY BY NOW.

NOPE. I'VE STILL GOT ONE DOLLAR LEFT, LISA. :BURP!:

WHACK A MOLE

OW!

HAW HAW!

50 PTS

25 PTS

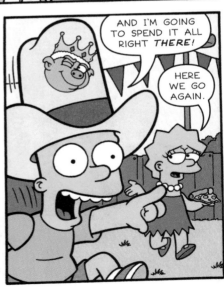

AND I'M GOING TO SPEND IT ALL RIGHT THERE!

HERE WE GO AGAIN.

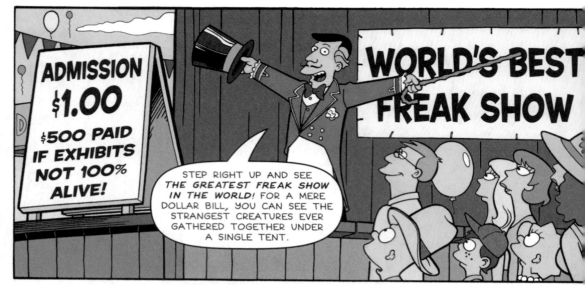

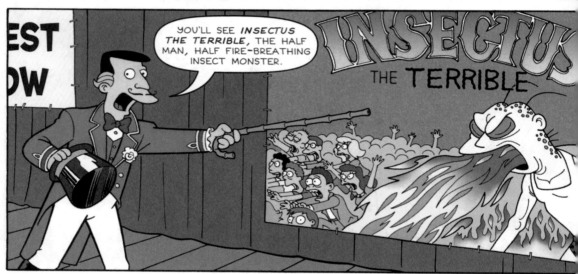

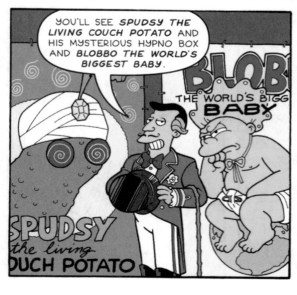

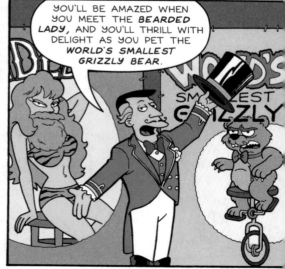

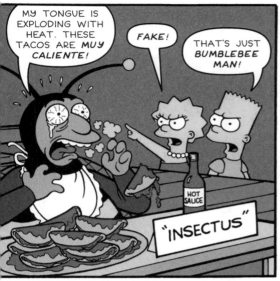

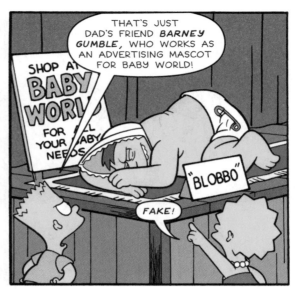

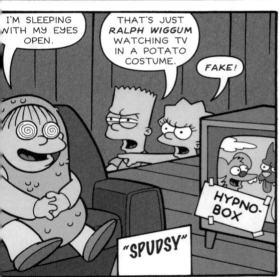

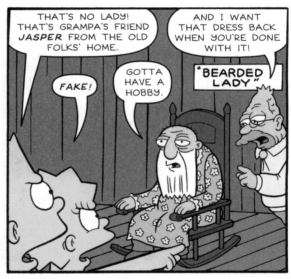

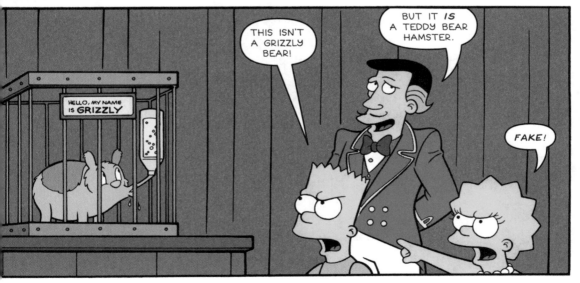

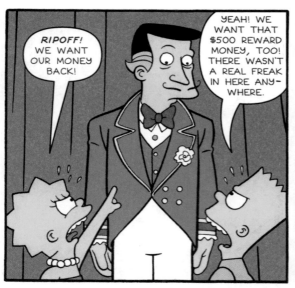

RIPOFF! WE WANT OUR MONEY BACK!

YEAH! WE WANT THAT $500 REWARD MONEY, TOO! THERE WASN'T A REAL FREAK IN HERE ANY-WHERE.

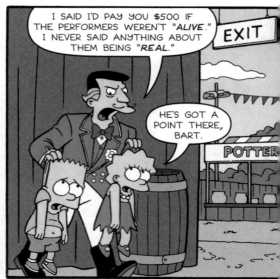

I SAID I'D PAY YOU $500 IF THE PERFORMERS WEREN'T "ALIVE." I NEVER SAID ANYTHING ABOUT THEM BEING "REAL."

HE'S GOT A POINT THERE, BART.

EXIT

POTTER

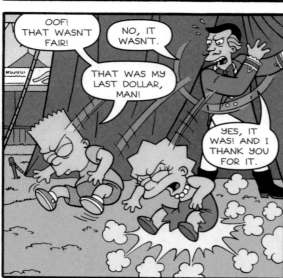

OOF! THAT WASN'T FAIR!

NO, IT WASN'T.

THAT WAS MY LAST DOLLAR, MAN!

YES, IT WAS! AND I THANK YOU FOR IT.

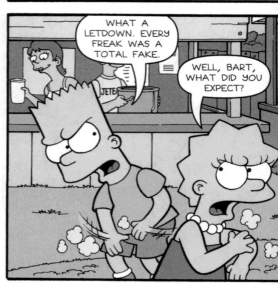

WHAT A LETDOWN. EVERY FREAK WAS A TOTAL FAKE.

WELL, BART, WHAT DID YOU EXPECT?

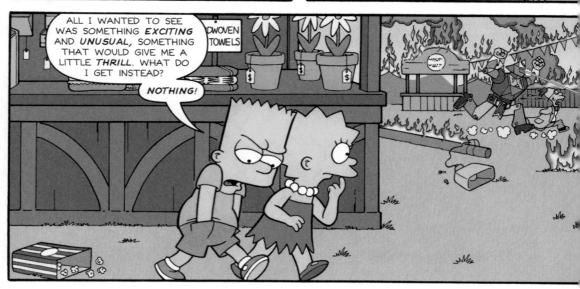

ALL I WANTED TO SEE WAS SOMETHING EXCITING AND UNUSUAL, SOMETHING THAT WOULD GIVE ME A LITTLE THRILL. WHAT DO I GET INSTEAD?

NOTHING!

DWOVEN TOWELS

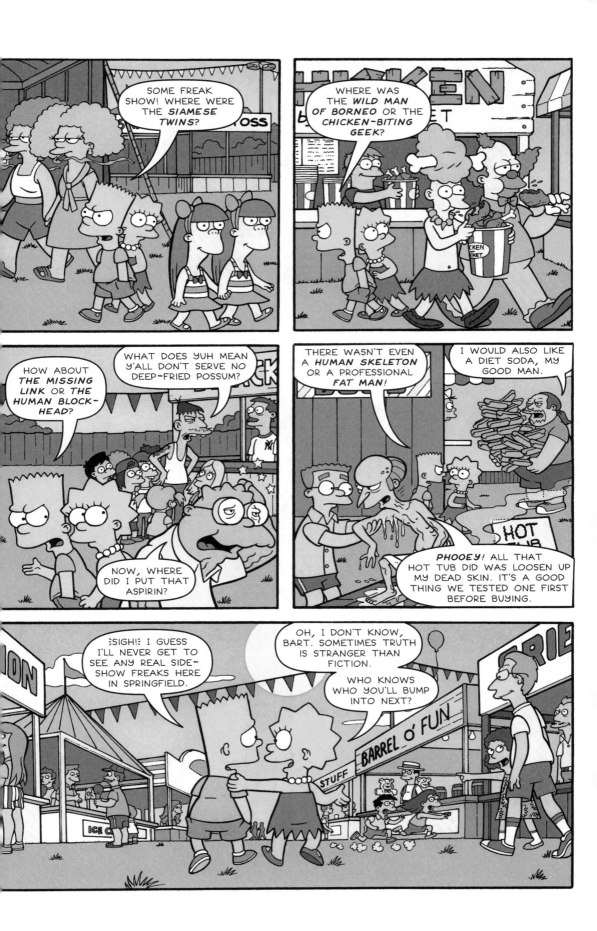

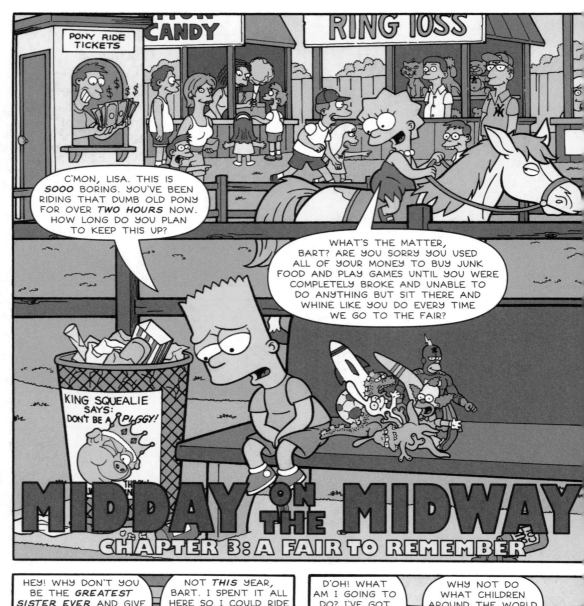

CHAPTER 3: A FAIR TO REMEMBER

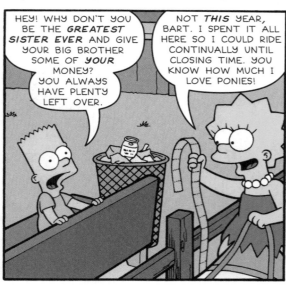

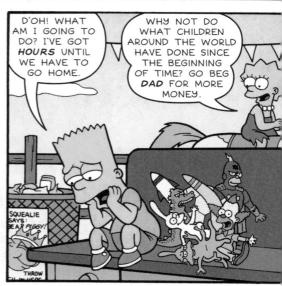

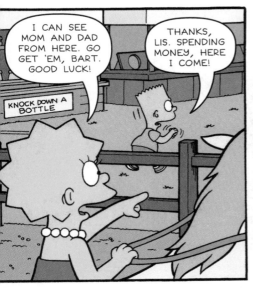

I CAN SEE MOM AND DAD FROM HERE. GO GET 'EM, BART. GOOD LUCK!

THANKS, LIS. SPENDING MONEY, HERE I COME!

KNOCK DOWN A BOTTLE

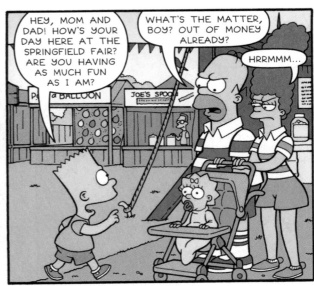

HEY, MOM AND DAD! HOW'S YOUR DAY HERE AT THE SPRINGFIELD FAIR? ARE YOU HAVING AS MUCH FUN AS I AM?

WHAT'S THE MATTER, BOY? OUT OF MONEY ALREADY?

HRRMMM...

PO A BALLOON

JOE'S SPOO

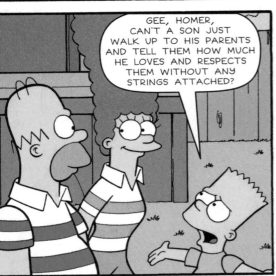

GEE, HOMER, CAN'T A SON JUST WALK UP TO HIS PARENTS AND TELL THEM HOW MUCH HE LOVES AND RESPECTS THEM WITHOUT ANY STRINGS ATTACHED?

BWA-HA-HA! WOO! TEE HEE! SNORT!

AH-HA-HA!

NICE TRY, BART.

WOW! YOU REALLY *ARE* OUT OF MONEY!

HA HA! POOR BOY!

IN YOUR FACE!

JOIN IN, EVERYBODY.

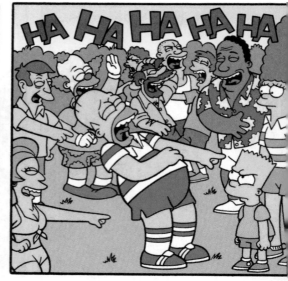

HA HA HA HA HA

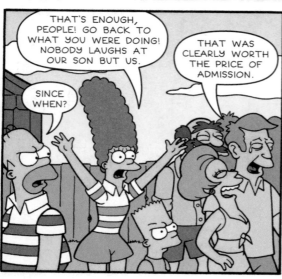

THAT'S ENOUGH, PEOPLE! GO BACK TO WHAT YOU WERE DOING! NOBODY LAUGHS AT OUR SON BUT US.

THAT WAS CLEARLY WORTH THE PRICE OF ADMISSION.

SINCE WHEN?

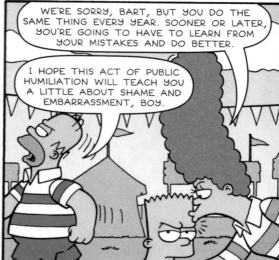

WE'RE SORRY, BART, BUT YOU DO THE SAME THING EVERY YEAR. SOONER OR LATER, YOU'RE GOING TO HAVE TO LEARN FROM YOUR MISTAKES AND DO BETTER.

I HOPE THIS ACT OF PUBLIC HUMILIATION WILL TEACH YOU A LITTLE ABOUT SHAME AND EMBARRASSMENT, BOY.

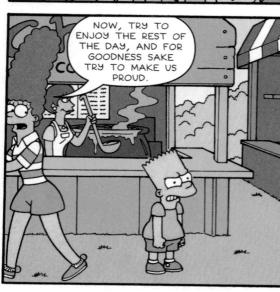

NOW, TRY TO ENJOY THE REST OF THE DAY, AND FOR GOODNESS SAKE TRY TO MAKE US PROUD.

CON

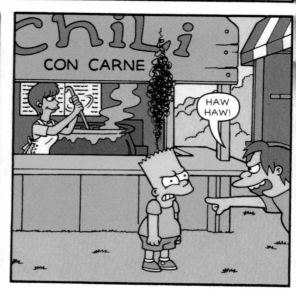

CHILI

CON CARNE

HAW HAW!

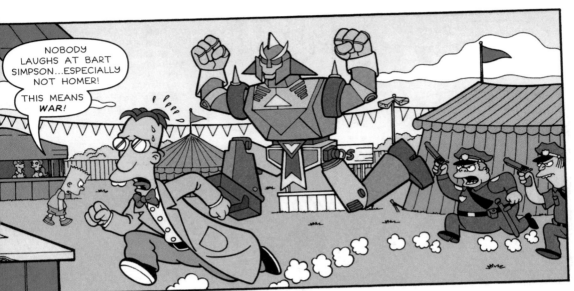

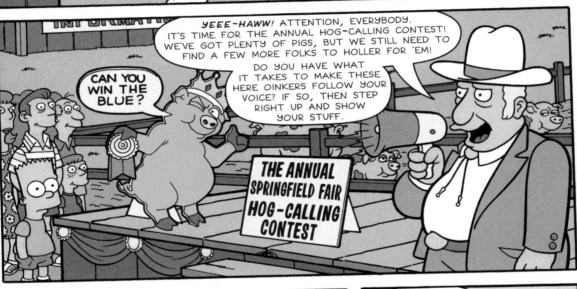

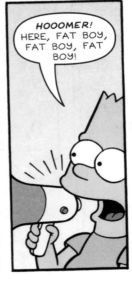

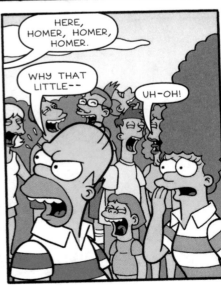

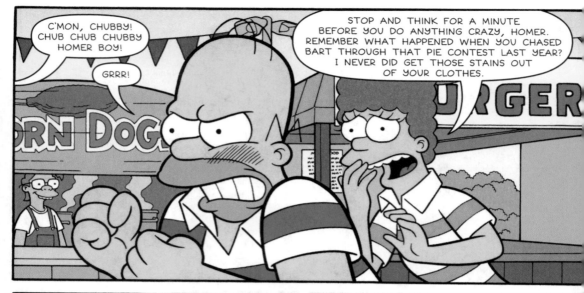
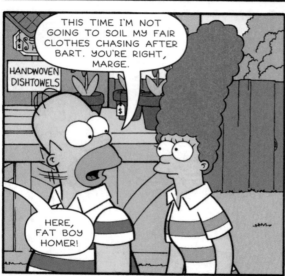

LOOK OUT, PEOPLE! THIS GIANT HOMER HOG IS JUST ABOUT TO MAKE THE WORLD'S MUDDIEST...

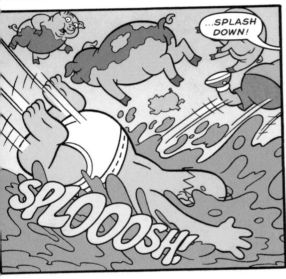

...SPLASH DOWN!

SPLOOOSH!

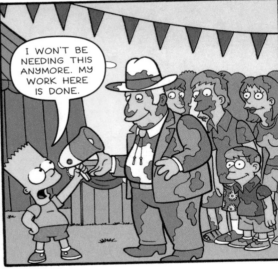

I WON'T BE NEEDING THIS ANYMORE. MY WORK HERE IS DONE.

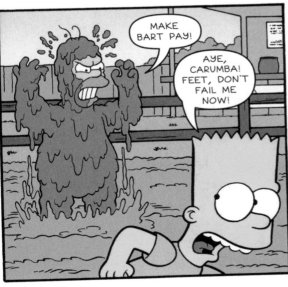

MAKE BART PAY!

AYE, CARUMBA! FEET, DON'T FAIL ME NOW!

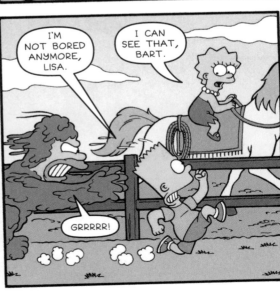

I'M NOT BORED ANYMORE, LISA.

I CAN SEE THAT, BART.

GRRRRR!

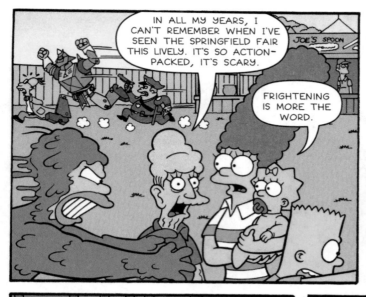

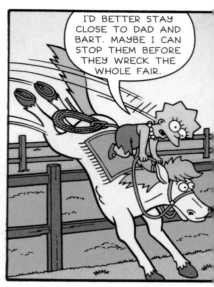

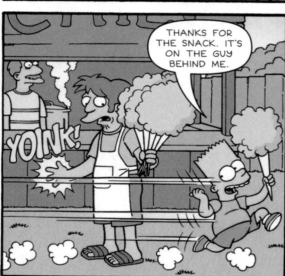

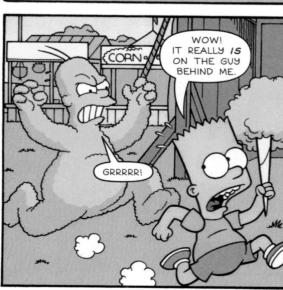

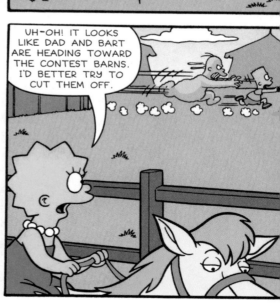

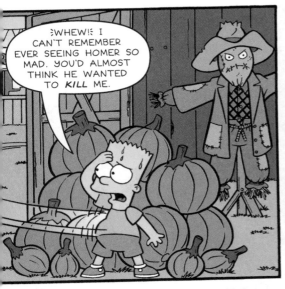

EWHEW!E I CAN'T REMEMBER EVER SEEING HOMER SO MAD. YOU'D ALMOST THINK HE WANTED TO *KILL* ME.

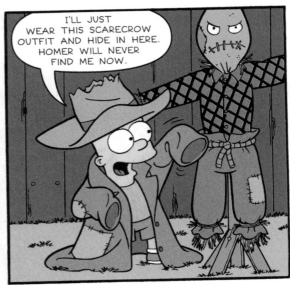

I'LL JUST WEAR THIS SCARECROW OUTFIT AND HIDE IN HERE. HOMER WILL NEVER FIND ME NOW.

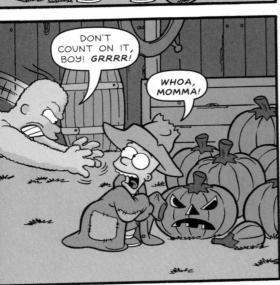

DON'T COUNT ON IT, BOY! *GRRRR!*

WHOA, MOMMA!

BLOOOSHK!

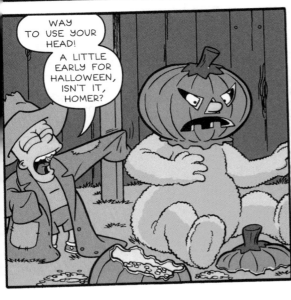

WAY TO USE YOUR HEAD!

A LITTLE EARLY FOR HALLOWEEN, ISN'T IT, HOMER?

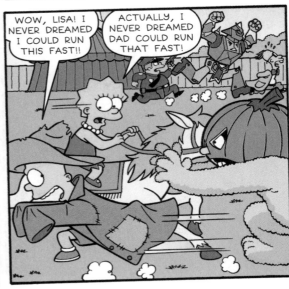

WOW, LISA! I NEVER DREAMED I COULD RUN THIS FAST!!

ACTUALLY, I NEVER DREAMED DAD COULD RUN THAT FAST!

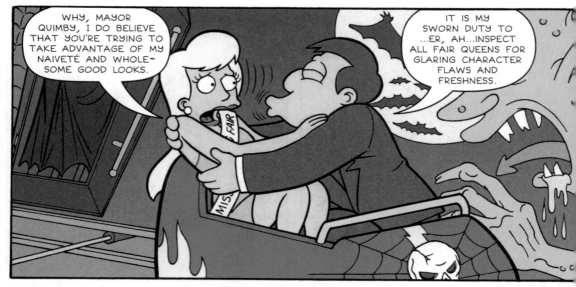

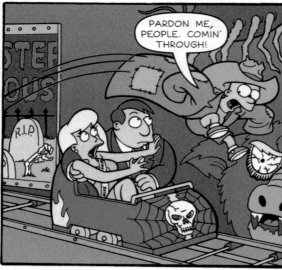

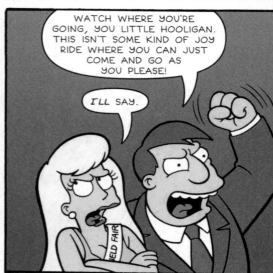

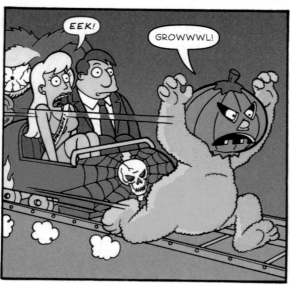

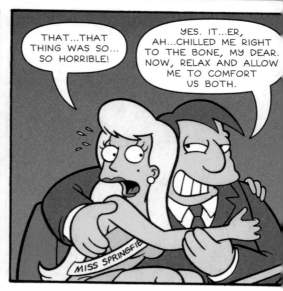

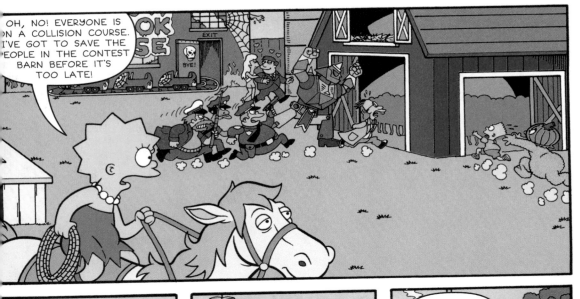

OH, NO! EVERYONE IS ON A COLLISION COURSE. I'VE GOT TO SAVE THE PEOPLE IN THE CONTEST BARN BEFORE IT'S TOO LATE!

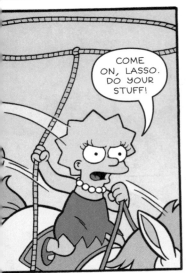

COME ON, LASSO. DO YOUR STUFF!

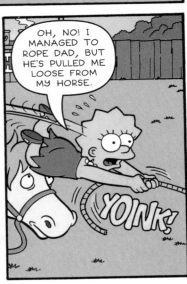

OH, NO! I MANAGED TO ROPE DAD, BUT HE'S PULLED ME LOOSE FROM MY HORSE.

YOINK!

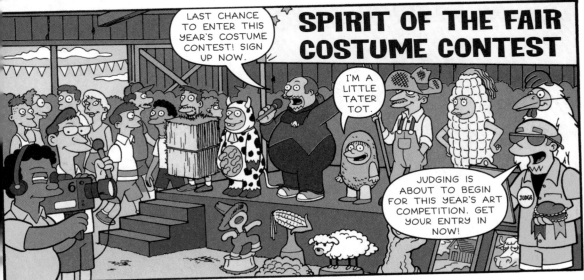

LAST CHANCE TO ENTER THIS YEAR'S COSTUME CONTEST! SIGN UP NOW.

SPIRIT OF THE FAIR COSTUME CONTEST

I'M A LITTLE TATER TOT.

JUDGING IS ABOUT TO BEGIN FOR THIS YEAR'S ART COMPETITION. GET YOUR ENTRY IN NOW!

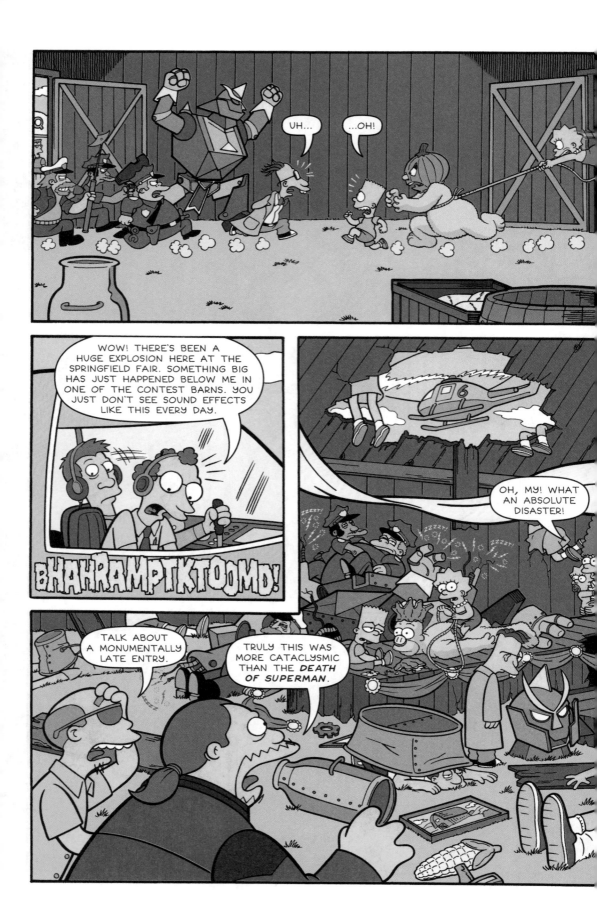

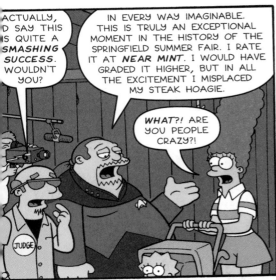

ACTUALLY, I'D SAY THIS IS QUITE A *SMASHING SUCCESS*. WOULDN'T YOU?

IN EVERY WAY IMAGINABLE. THIS IS TRULY AN EXCEPTIONAL MOMENT IN THE HISTORY OF THE SPRINGFIELD SUMMER FAIR. I RATE IT AT *NEAR MINT*. I WOULD HAVE GRADED IT HIGHER, BUT IN ALL THE EXCITEMENT I MISPLACED MY STEAK HOAGIE.

WHAT?! ARE YOU PEOPLE CRAZY?!

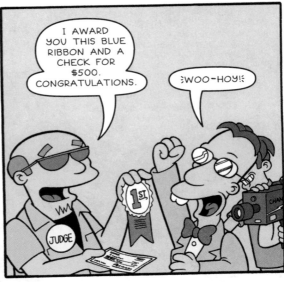

I AWARD YOU THIS BLUE RIBBON AND A CHECK FOR $500. CONGRATULATIONS.

¡WOO-HOY!¡

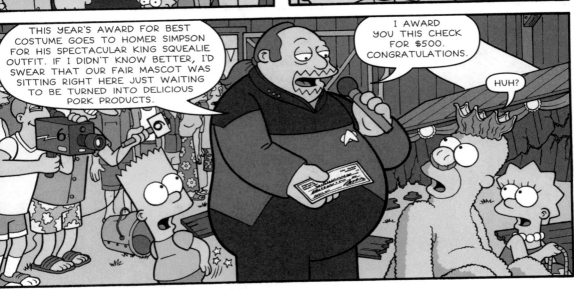

THIS YEAR'S AWARD FOR BEST COSTUME GOES TO HOMER SIMPSON FOR HIS SPECTACULAR KING SQUEALIE OUTFIT. IF I DIDN'T KNOW BETTER, I'D SWEAR THAT OUR FAIR MASCOT WAS SITTING RIGHT HERE JUST WAITING TO BE TURNED INTO DELICIOUS PORK PRODUCTS.

I AWARD YOU THIS CHECK FOR $500. CONGRATULATIONS.

HUH?

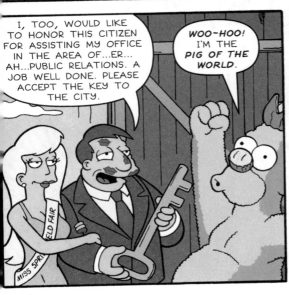

I, TOO, WOULD LIKE TO HONOR THIS CITIZEN FOR ASSISTING MY OFFICE IN THE AREA OF...ER... AH...PUBLIC RELATIONS. A JOB WELL DONE. PLEASE ACCEPT THE KEY TO THE CITY.

WOO-HOO! I'M THE *PIG OF THE WORLD*.

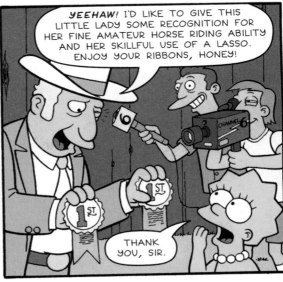

YEEHAW! I'D LIKE TO GIVE THIS LITTLE LADY SOME RECOGNITION FOR HER FINE AMATEUR HORSE RIDING ABILITY AND HER SKILLFUL USE OF A LASSO. ENJOY YOUR RIBBONS, HONEY!

THANK YOU, SIR.

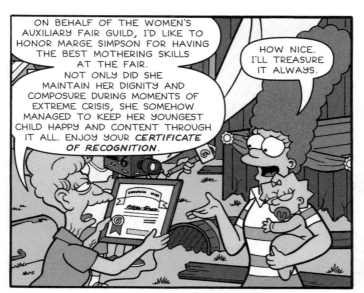

ON BEHALF OF THE WOMEN'S AUXILIARY FAIR GUILD, I'D LIKE TO HONOR MARGE SIMPSON FOR HAVING THE BEST MOTHERING SKILLS AT THE FAIR. NOT ONLY DID SHE MAINTAIN HER DIGNITY AND COMPOSURE DURING MOMENTS OF EXTREME CRISIS, SHE SOMEHOW MANAGED TO KEEP HER YOUNGEST CHILD HAPPY AND CONTENT THROUGH IT ALL. ENJOY YOUR *CERTIFICATE OF RECOGNITION*.

HOW NICE. I'LL TREASURE IT ALWAYS.

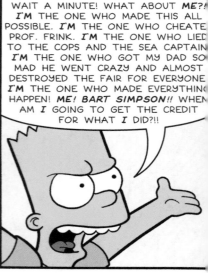

WAIT A MINUTE! WHAT ABOUT *ME?!* *I'M* THE ONE WHO MADE THIS ALL POSSIBLE. *I'M* THE ONE WHO CHEATED PROF. FRINK. *I'M* THE ONE WHO LIED TO THE COPS AND THE SEA CAPTAIN. *I'M* THE ONE WHO GOT MY DAD SO MAD HE WENT CRAZY AND ALMOST DESTROYED THE FAIR FOR EVERYONE. *I'M* THE ONE WHO MADE EVERYTHING HAPPEN! *ME! BART SIMPSON!!* WHEN AM *I* GOING TO GET THE CREDIT FOR WHAT *I* DID?!!

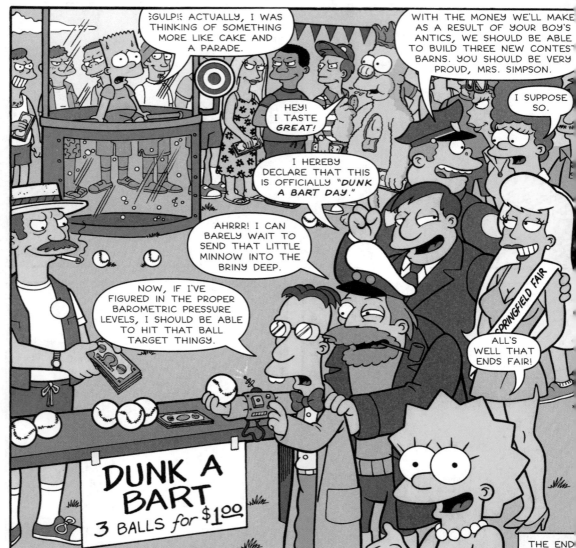

¿GULP!¿ ACTUALLY, I WAS THINKING OF SOMETHING MORE LIKE CAKE AND A PARADE.

WITH THE MONEY WE'LL MAKE AS A RESULT OF YOUR BOY'S ANTICS, WE SHOULD BE ABLE TO BUILD THREE NEW CONTEST BARNS. YOU SHOULD BE VERY PROUD, MRS. SIMPSON.

I SUPPOSE SO.

HEY! I TASTE *GREAT!*

I HEREBY DECLARE THAT THIS IS OFFICIALLY "*DUNK A BART DAY.*"

AHRRR! I CAN BARELY WAIT TO SEND THAT LITTLE MINNOW INTO THE BRINY DEEP.

ALL'S WELL THAT ENDS FAIR!

NOW, IF I'VE FIGURED IN THE PROPER BAROMETRIC PRESSURE LEVELS, I SHOULD BE ABLE TO HIT THAT BALL TARGET THINGY.

SPRINGFIELD FAIR

DUNK A BART
3 BALLS *for* $1.00

THE END

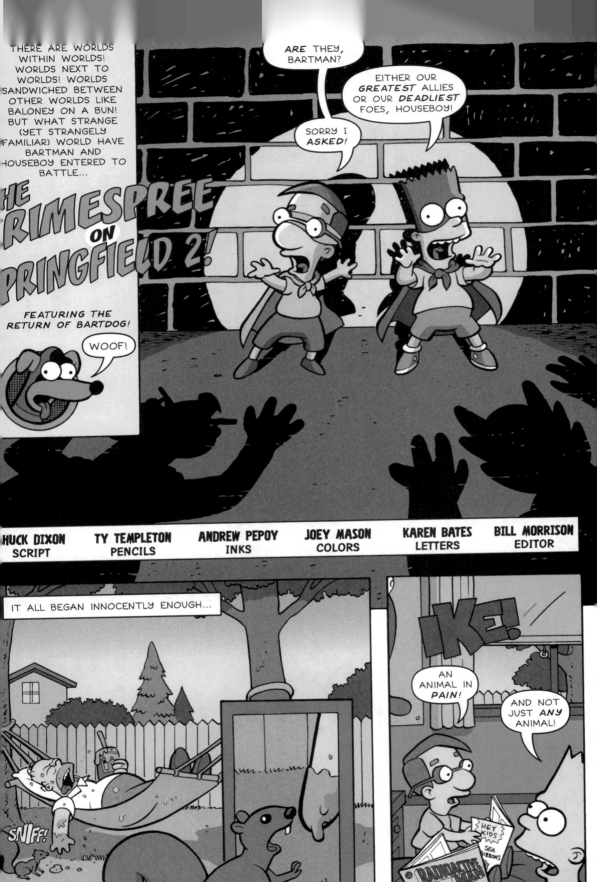

THERE ARE WORLDS WITHIN WORLDS! WORLDS NEXT TO WORLDS! WORLDS SANDWICHED BETWEEN OTHER WORLDS LIKE BALONEY ON A BUN! BUT WHAT STRANGE (YET STRANGELY FAMILIAR) WORLD HAVE BARTMAN AND HOUSEBOY ENTERED TO BATTLE...

THE RIMESPREE ON PRINGFIELD 2!

FEATURING THE RETURN OF BARTDOG!

WOOF!

ARE THEY, BARTMAN?

EITHER OUR *GREATEST* ALLIES OR OUR *DEADLIEST* FOES, HOUSEBOY!

SORRY I *ASKED*!

HUCK DIXON
SCRIPT

TY TEMPLETON
PENCILS

ANDREW PEPOY
INKS

JOEY MASON
COLORS

KAREN BATES
LETTERS

BILL MORRISON
EDITOR

IT ALL BEGAN INNOCENTLY ENOUGH...

SNIFF!

IKE!

AN ANIMAL IN *PAIN*!

AND NOT JUST *ANY* ANIMAL!

HEY KIDS SEA RIBBONS

RADIOACTIVE MAN

HEY

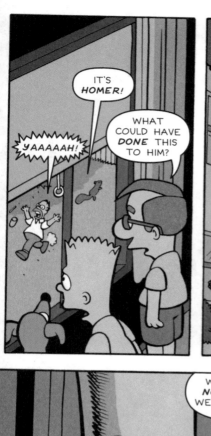

IT'S **HOMER!**

YAAAAAH!

WHAT COULD HAVE **DONE** THIS TO HIM?

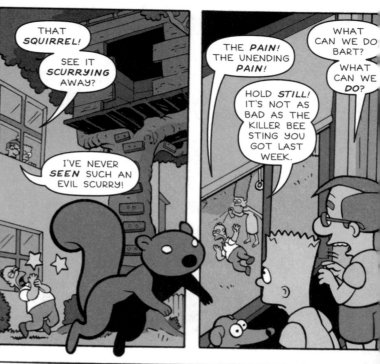

THAT **SQUIRREL!**

SEE IT **SCURRYING** AWAY?

I'VE NEVER **SEEN** SUCH AN EVIL SCURRY!

THE **PAIN!** THE UNENDING **PAIN!**

HOLD **STILL!** IT'S NOT AS BAD AS THE KILLER BEE STING YOU GOT LAST WEEK.

WHAT CAN WE DO BART? WHAT CAN WE DO?

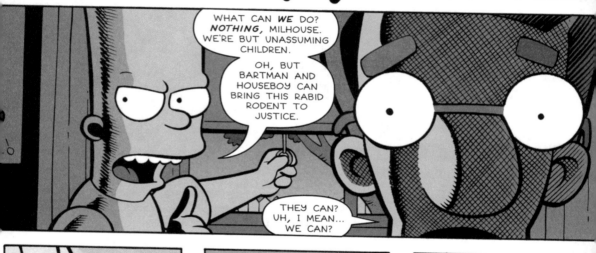

WHAT CAN **WE** DO? **NOTHING,** MILHOUSE. WE'RE BUT UNASSUMING CHILDREN.

OH, BUT BARTMAN AND HOUSEBOY CAN BRING THIS RABID RODENT TO JUSTICE.

THEY CAN? UH, I MEAN... WE CAN?

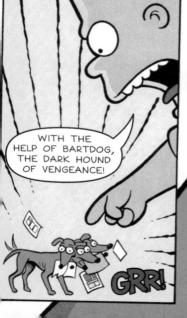

WITH THE HELP OF BARTDOG, THE DARK HOUND OF VENGEANCE!

GRR!

YIPE?!

BEST ISSUE EVER! **RADIOACTIVE MAN**

SPECIAL ISH!

THAT VERY NIGHT...

BEWARE, FURBEARING NUT-HOARDERS...

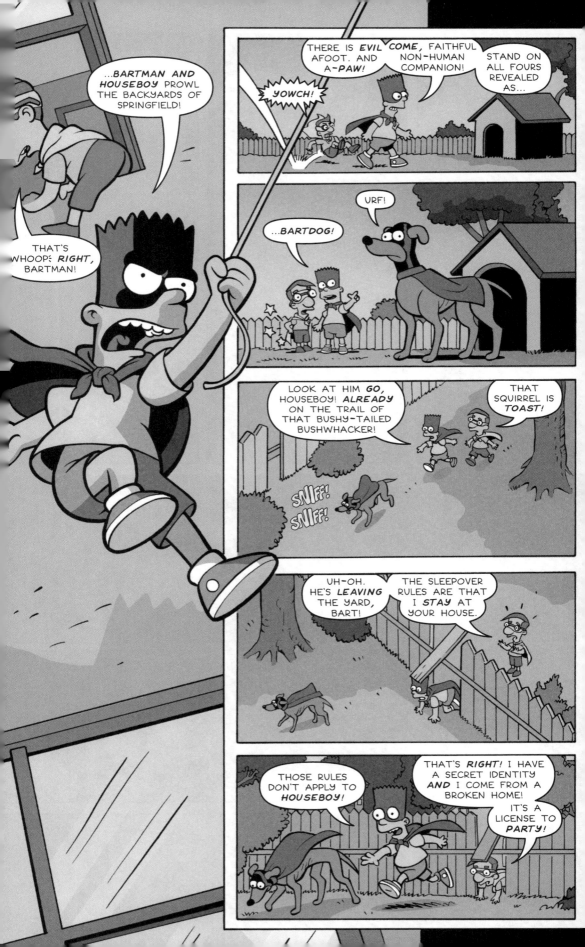

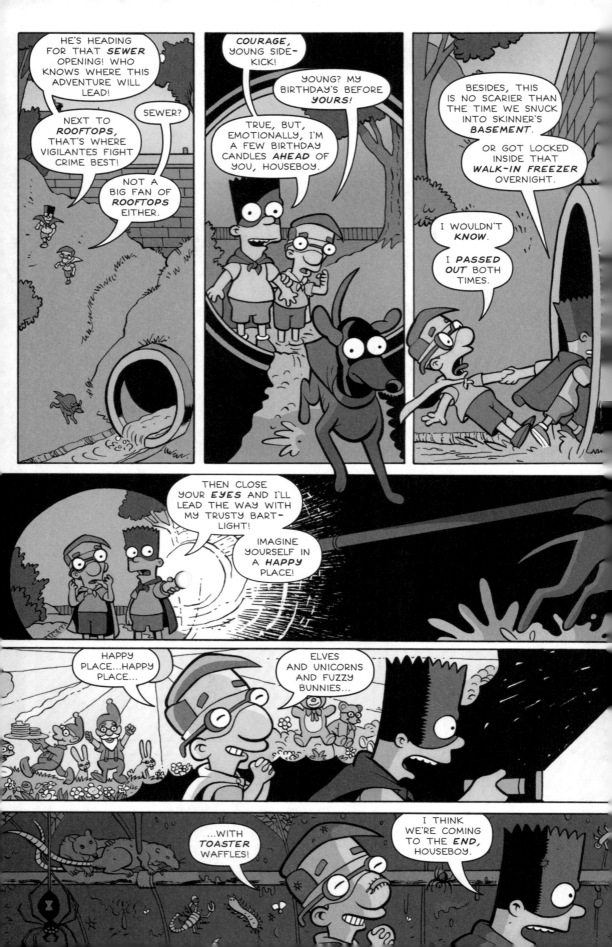

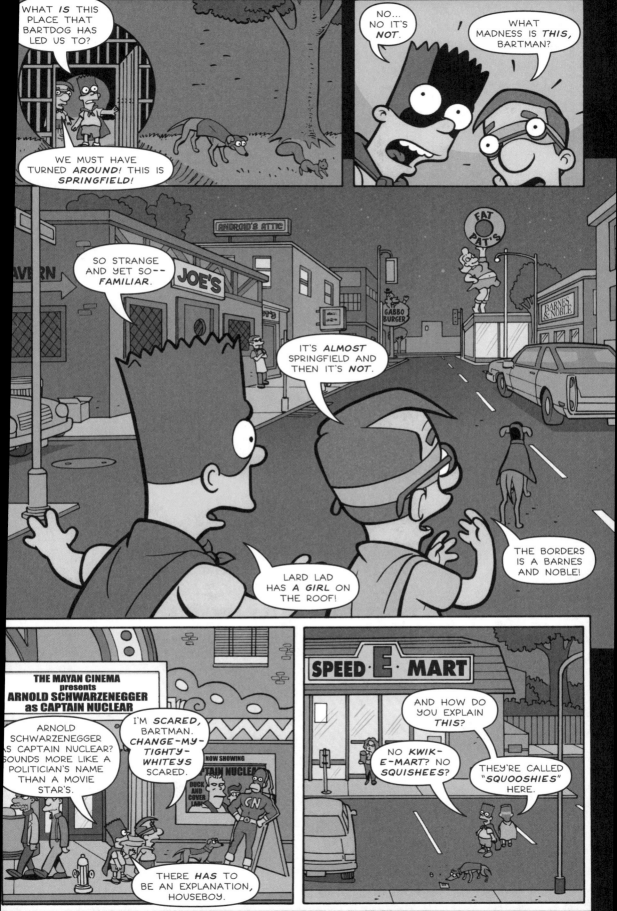

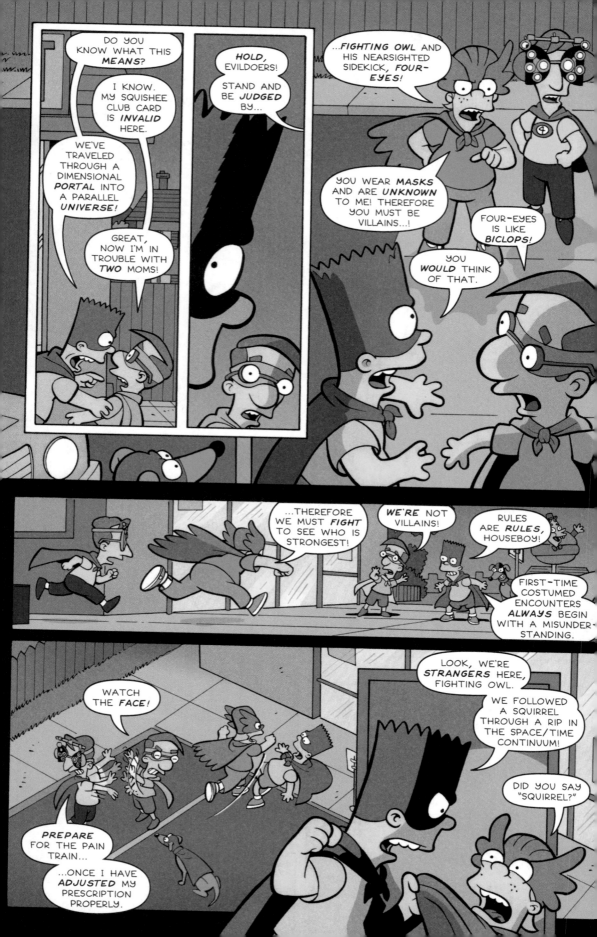

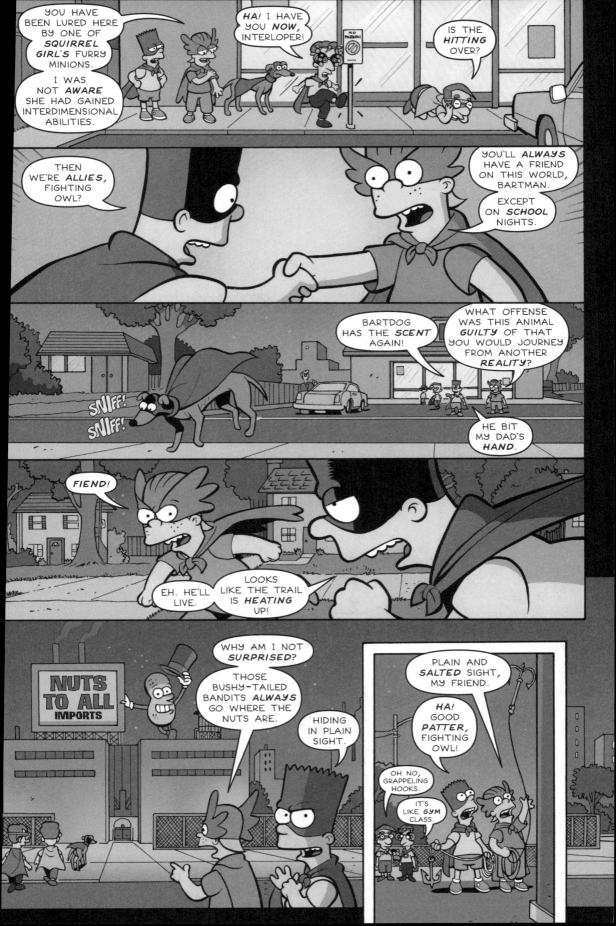

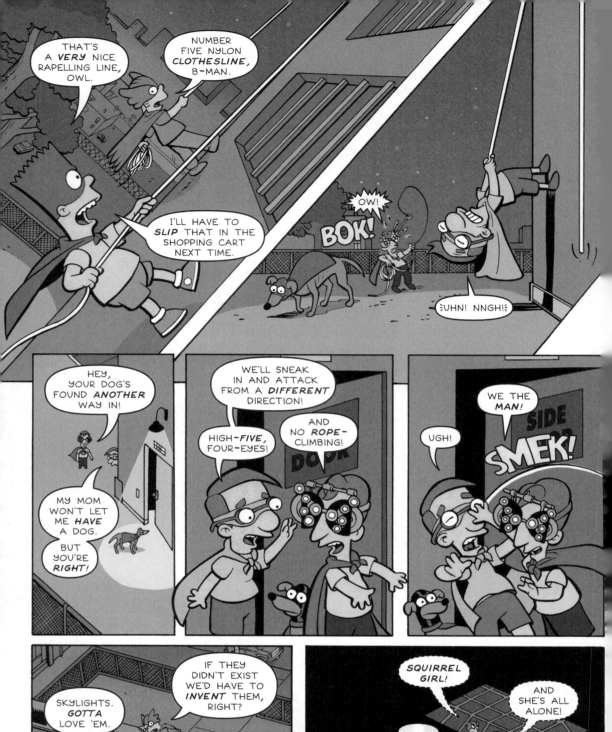

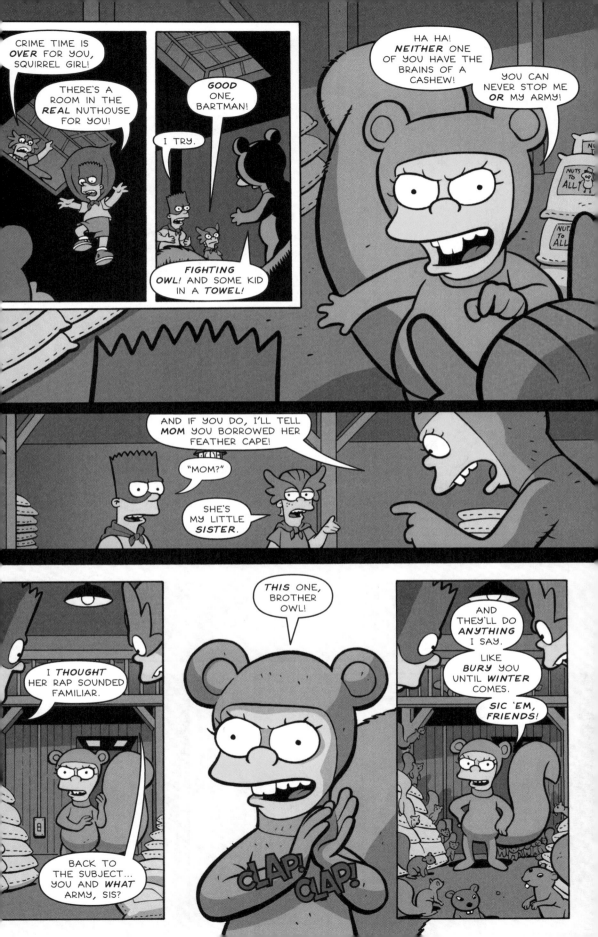

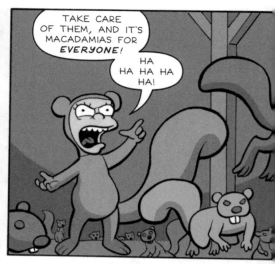

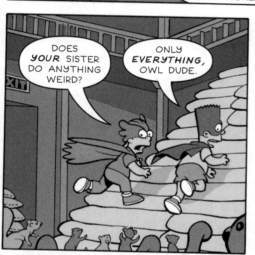

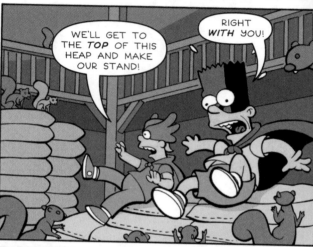

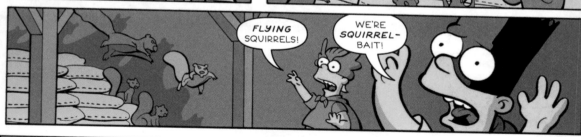

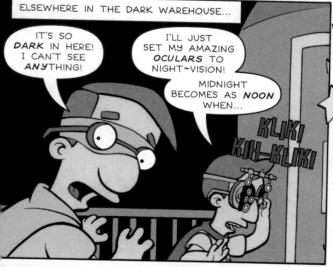

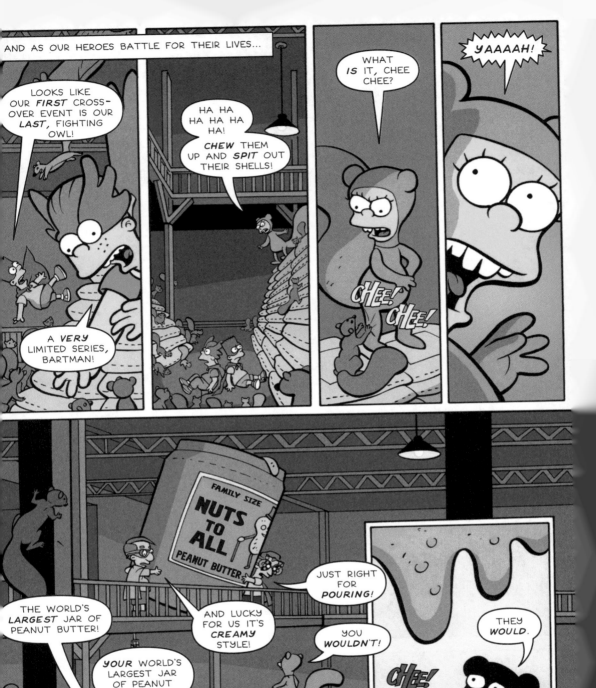

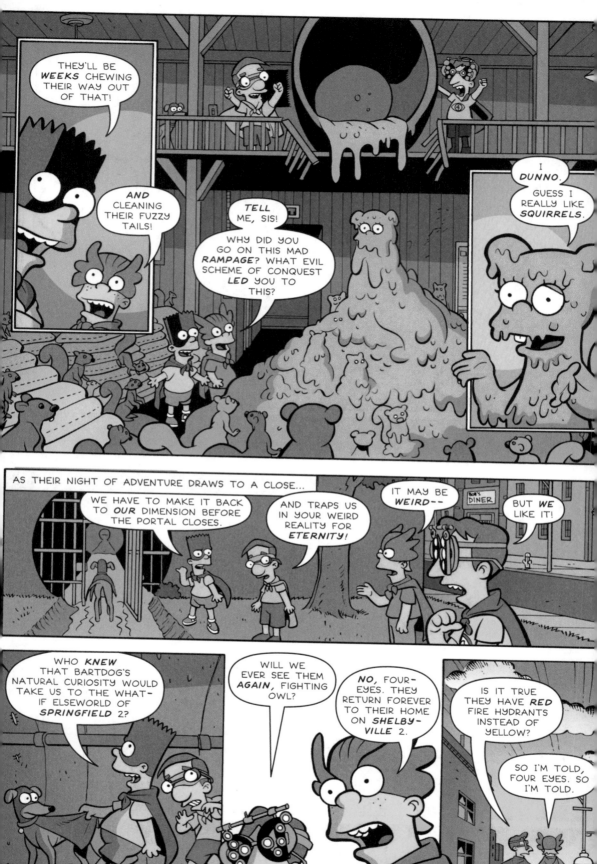

HOW SWEET IT AIN'T

WILLIE'S GONNA SAY TO YA WHAT HIS MOTHER TOLD HIM EVERY NIGHT BEFORE HE WENT T'SLEEP!

I'M *VERY* DISAPPOINTED IN YOU!

MATT GROENING

IAN BOOTHBY
SCRIPT

JOHN DELANEY
PENCILS

DAN DAVIS
INKS

ART VILLANUEVA
COLORS

KAREN BATES
LETTERS

BILL MORRISON
EDITOR

YOU WEE LADS AND LASSIES ARE ALL IN WORSE SHAPE THAN ME GRANDMA'S BAGPIPES!

"YE CANNA KEEP UP IN GYM CLASS!"

⌇WHEEZE⌇ ARE WE THERE YET?

NO, IT'S A HUNDRED-YARD DASH! YOU'VE GOT NINETY-FIVE YARDS TO GO!

"THE BULLIES ARE SLACKIN' OFF!"

YEAH, WE STILL WANT YOUR LUNCH MONEY, BUT WE'VE OUTSOURCED THE BEATINGS.

HAND OVER YOUR EUROS, OR I'LL GIVE YOUR TULIPS SUCH A CLOGGING!

"EVEN THE GEEKS ARE LAZY!"

$528 \times$
301

$3\overline{)2715}$

⌇PANT!⌇ ⌇GROAN!⌇ LONG DIVISION? I'M ALREADY GETTING A CRAMP!

I HAVE A TWO-PART QUESTION. ONE...CAN YOU NOT STAND SO CLOSE TO THE EDGE OF THE STAGE IN THAT *KILT*?
AND TWO... MAYBE WE'RE ALL TIRED, BUT WHAT DO YOU WANT US TO *DO* ABOUT IT?

I'LL *TELL* YA, YE FOUR-EYED PANTS-WEARIN' PRISS!

THE REASON YOU'VE GOT NO ENERGY IS BECAUSE OF ALL THE FATTY, SUGARY JUNK FOOD THE CAFETERIA GIVES YA! IT'S GARBAGE!

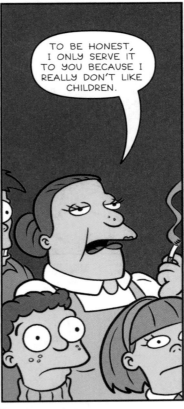

TO BE HONEST, I ONLY SERVE IT TO YOU BECAUSE I REALLY DON'T LIKE CHILDREN.

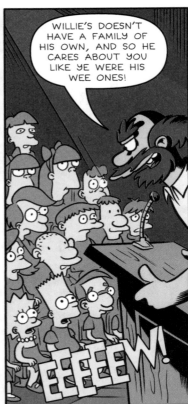

WILLIE'S DOESN'T HAVE A FAMILY OF HIS OWN, AND SO HE CARES ABOUT YOU LIKE YE WERE HIS WEE ONES!

EEEEEW!

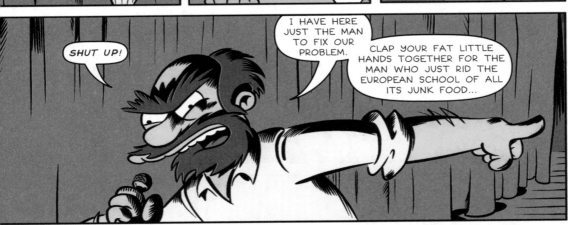

SHUT UP!

I HAVE HERE JUST THE MAN TO FIX OUR PROBLEM.

CLAP YOUR FAT LITTLE HANDS TOGETHER FOR THE MAN WHO JUST RID THE EUROPEAN SCHOOL OF ALL ITS JUNK FOOD...

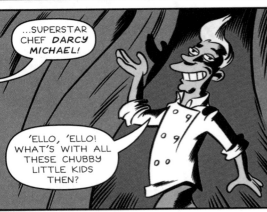

...SUPERSTAR CHEF *DARCY MICHAEL!*

'ELLO, 'ELLO! WHAT'S WITH ALL THESE CHUBBY LITTLE KIDS THEN?

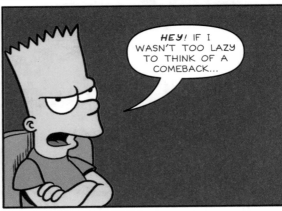

HEY! IF I WASN'T TOO LAZY TO THINK OF A COMEBACK...

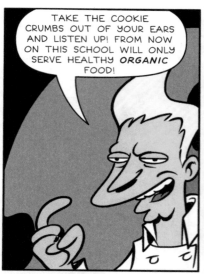

TAKE THE COOKIE CRUMBS OUT OF YOUR EARS AND LISTEN UP! FROM NOW ON THIS SCHOOL WILL ONLY SERVE HEALTHY *ORGANIC* FOOD!

OH *THANK YOU*, MR. MICHAEL! I COULDN'T BE HAPPIER!

WELL, WELL, IT LOOKS LIKE WE'VE GOT OURSELVES A *SARCASTIC SALLY* HERE! FINE! YOU'RE BANNED FROM EATING IN THE SCHOOL FOR SIX MONTHS!

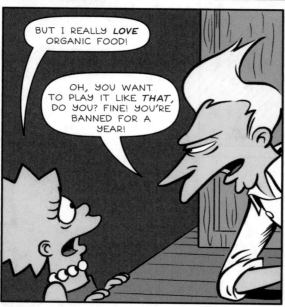

BUT I REALLY *LOVE* ORGANIC FOOD!

OH, YOU WANT TO PLAY IT LIKE *THAT*, DO YOU? FINE! YOU'RE BANNED FOR A YEAR!

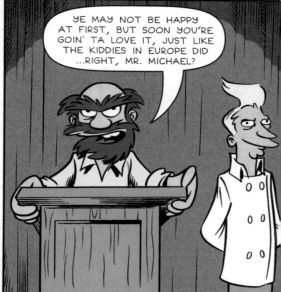

YE MAY NOT BE HAPPY AT FIRST, BUT SOON YOU'RE GOIN' TA LOVE IT, JUST LIKE THE KIDDIES IN EUROPE DID ...RIGHT, MR. MICHAEL?

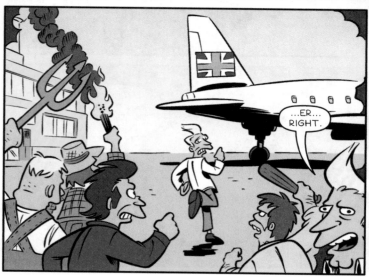

...ER... RIGHT.

WHAT THE--?! WHO CALLED A SCHOOL ASSEMBLY WITHOUT MY PERMISSION?

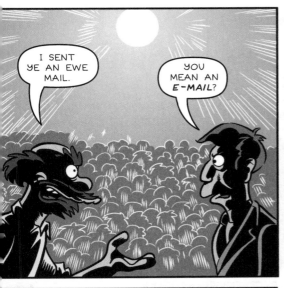

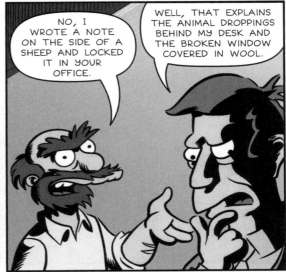

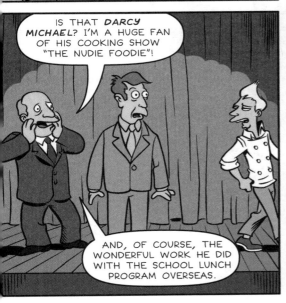

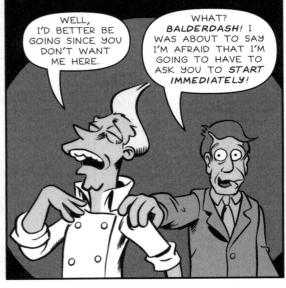

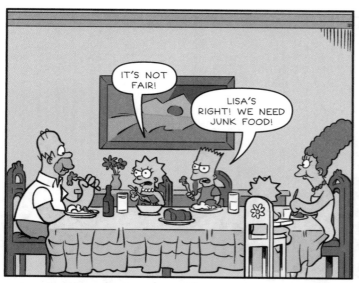

IT'S NOT FAIR!

LISA'S RIGHT! WE NEED JUNK FOOD!

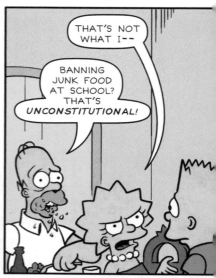

THAT'S NOT WHAT I--

BANNING JUNK FOOD AT SCHOOL? THAT'S *UNCONSTITUTIONAL!*

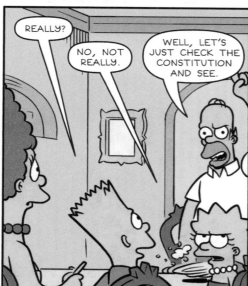

REALLY?

NO, NOT REALLY.

WELL, LET'S JUST CHECK THE CONSTITUTION AND SEE.

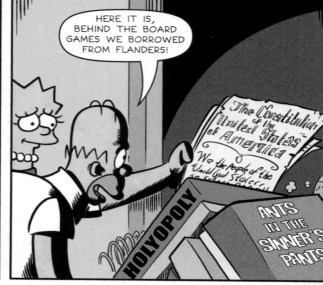

HERE IT IS, BEHIND THE BOARD GAMES WE BORROWED FROM FLANDERS!

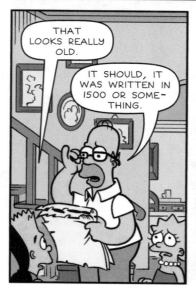

THAT LOOKS REALLY OLD.

IT SHOULD, IT WAS WRITTEN IN 1500 OR SOME-THING.

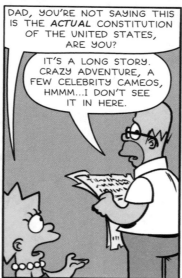

DAD, YOU'RE NOT SAYING THIS IS THE *ACTUAL* CONSTITUTION OF THE UNITED STATES, ARE YOU?

IT'S A LONG STORY. CRAZY ADVENTURE, A FEW CELEBRITY CAMEOS, HMMM...I DON'T SEE IT IN HERE.

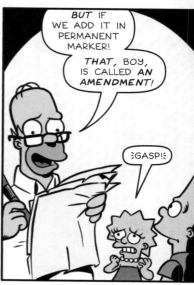

BUT IF WE ADD IT IN PERMANENT MARKER!

THAT, BOY, IS CALLED *AN AMENDMENT!*

:GASP!:

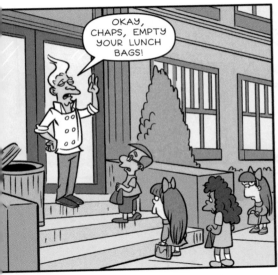

OKAY, CHAPS, EMPTY YOUR LUNCH BAGS!

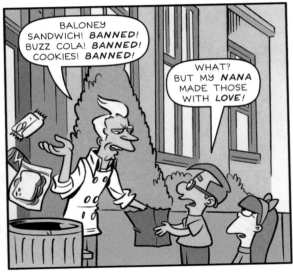

BALONEY SANDWICH! *BANNED!* BUZZ COLA! *BANNED!* COOKIES! *BANNED!*

WHAT? BUT MY *NANA* MADE THOSE WITH *LOVE!*

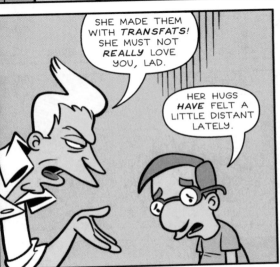

SHE MADE THEM WITH *TRANSFATS!* SHE MUST NOT *REALLY* LOVE YOU, LAD.

HER HUGS *HAVE* FELT A LITTLE DISTANT LATELY.

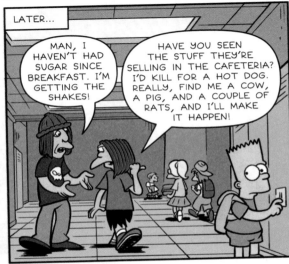

LATER...

MAN, I HAVEN'T HAD SUGAR SINCE BREAKFAST. I'M GETTING THE SHAKES!

HAVE YOU SEEN THE STUFF THEY'RE SELLING IN THE CAFETERIA? I'D KILL FOR A HOT DOG. REALLY, FIND ME A COW, A PIG, AND A COUPLE OF RATS, AND I'LL MAKE IT HAPPEN!

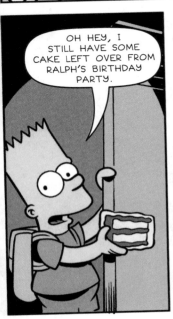

OH HEY, I STILL HAVE SOME CAKE LEFT OVER FROM RALPH'S BIRTHDAY PARTY.

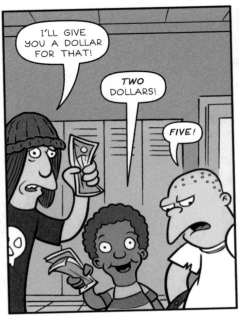

I'LL GIVE YOU A DOLLAR FOR THAT!

TWO DOLLARS!

FIVE!

HMMMMMM....

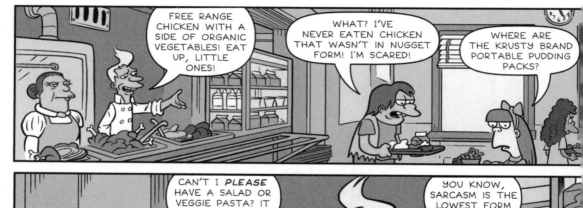

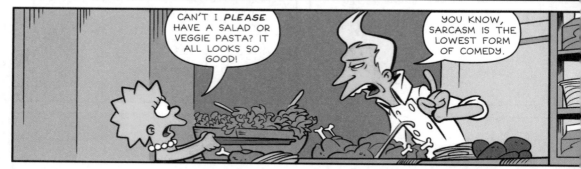

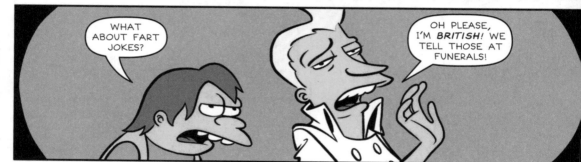

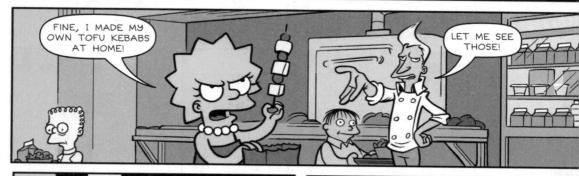

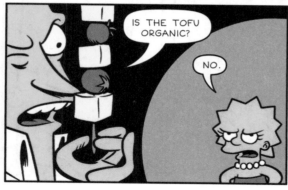

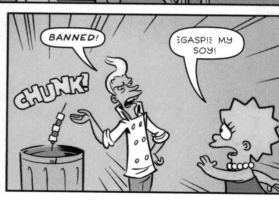

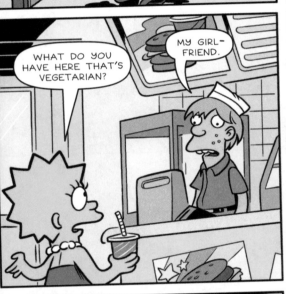

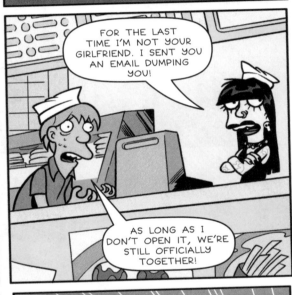

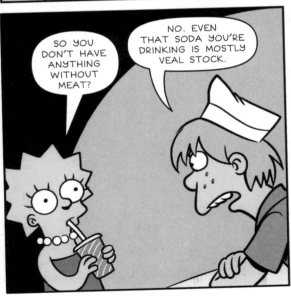

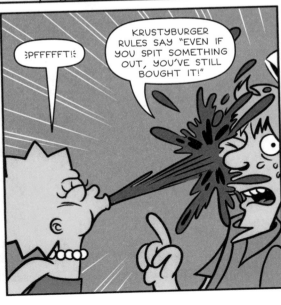

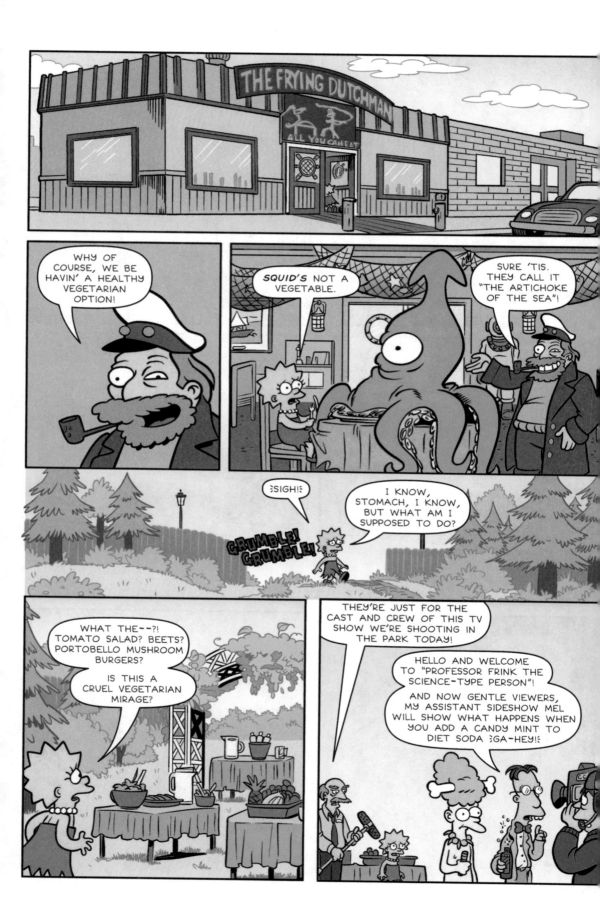

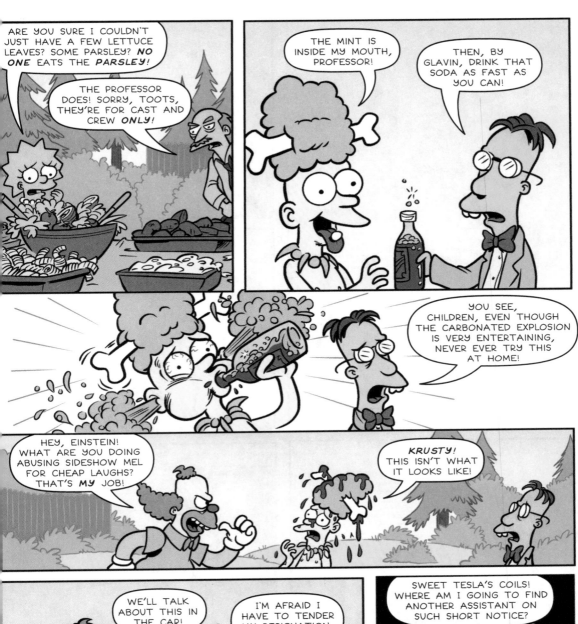

ARE YOU SURE I COULDN'T JUST HAVE A FEW LETTUCE LEAVES? SOME PARSLEY? *NO ONE* EATS THE *PARSLEY*!

THE PROFESSOR DOES! SORRY, TOOTS, THEY'RE FOR CAST AND CREW *ONLY*!

THE MINT IS INSIDE MY MOUTH, PROFESSOR!

THEN, BY GLAVIN, DRINK THAT SODA AS FAST AS YOU CAN!

YOU SEE, CHILDREN, EVEN THOUGH THE CARBONATED EXPLOSION IS VERY ENTERTAINING, NEVER EVER TRY THIS AT HOME!

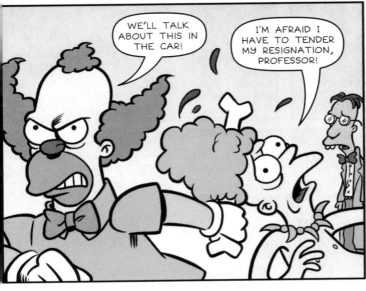

HEY, EINSTEIN! WHAT ARE YOU DOING ABUSING SIDESHOW MEL FOR CHEAP LAUGHS? THAT'S *MY* JOB!

KRUSTY! THIS ISN'T WHAT IT LOOKS LIKE!

WE'LL TALK ABOUT THIS IN THE CAR!

I'M AFRAID I HAVE TO TENDER MY RESIGNATION, PROFESSOR!

SWEET TESLA'S COILS! WHERE AM I GOING TO FIND ANOTHER ASSISTANT ON SUCH SHORT NOTICE?

AHEM!

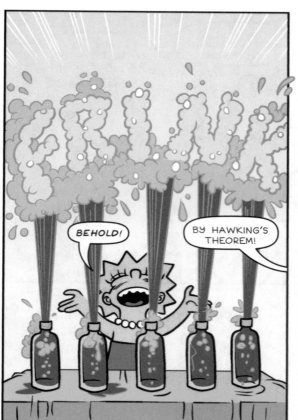

BEHOLD!

BY HAWKING'S THEOREM!

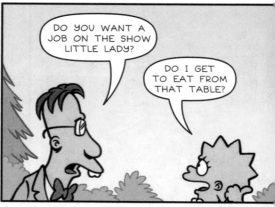

DO YOU WANT A JOB ON THE SHOW LITTLE LADY?

DO I GET TO EAT FROM THAT TABLE?

WELL, OF COURSE. NOW LET'S DISCUSS YOUR SALARY. WE DON'T HAVE MUCH MONEY, IT'D BE MORE OF AN INTERN POSITION AND...

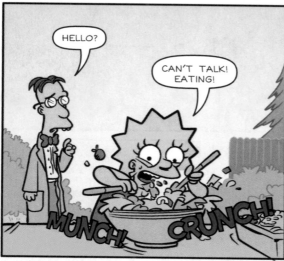

HELLO?

CAN'T TALK! EATING!

MUNCH! CRUNCH!

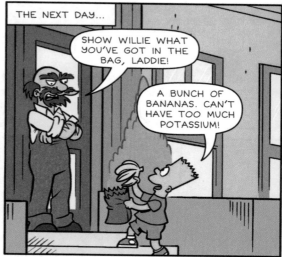

THE NEXT DAY...

SHOW WILLIE WHAT YOU'VE GOT IN THE BAG, LADDIE!

A BUNCH OF BANANAS. CAN'T HAVE TOO MUCH POTASSIUM!

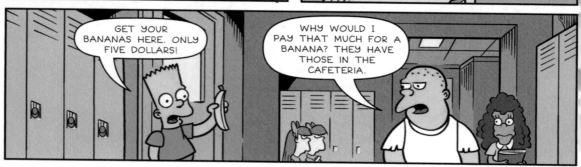

GET YOUR BANANAS HERE. ONLY FIVE DOLLARS!

WHY WOULD I PAY THAT MUCH FOR A BANANA? THEY HAVE THOSE IN THE CAFETERIA.

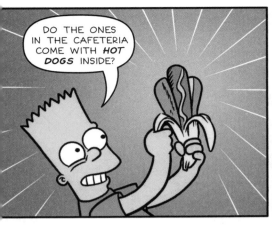

DO THE ONES IN THE CAFETERIA COME WITH *HOT DOGS* INSIDE?

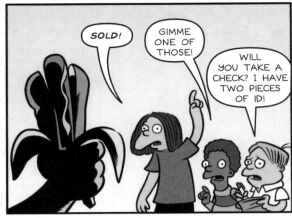

SOLD!

GIMME ONE OF THOSE!

WILL YOU TAKE A CHECK? I HAVE TWO PIECES OF ID!

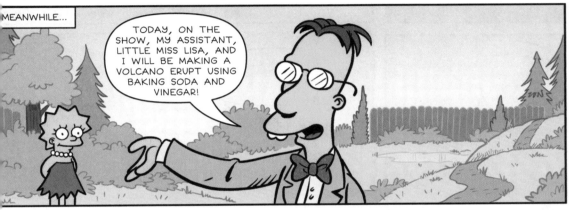

MEANWHILE...

TODAY, ON THE SHOW, MY ASSISTANT, LITTLE MISS LISA, AND I WILL BE MAKING A VOLCANO ERUPT USING BAKING SODA AND VINEGAR!

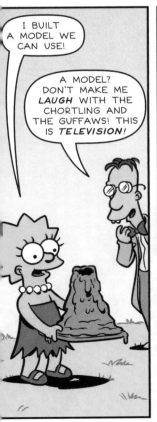

I BUILT A MODEL WE CAN USE!

A MODEL? DON'T MAKE ME *LAUGH* WITH THE CHORTLING AND THE GUFFAWS! THIS IS *TELEVISION*!

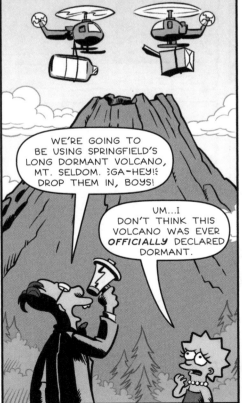

WE'RE GOING TO BE USING SPRINGFIELD'S LONG DORMANT VOLCANO, MT. SELDOM. GA-HEY!? DROP THEM IN, BOYS!

UM...I DON'T THINK THIS VOLCANO WAS EVER *OFFICIALLY* DECLARED DORMANT.

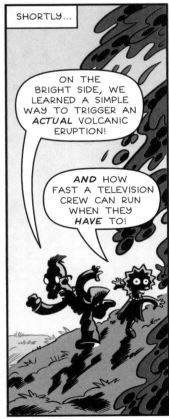

SHORTLY...

ON THE BRIGHT SIDE, WE LEARNED A SIMPLE WAY TO TRIGGER AN *ACTUAL* VOLCANIC ERUPTION!

AND HOW FAST A TELEVISION CREW CAN RUN WHEN THEY *HAVE* TO!

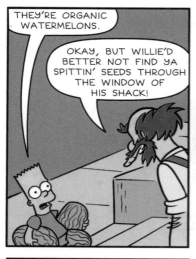

THEY'RE ORGANIC WATERMELONS.

OKAY, BUT WILLIE'D BETTER NOT FIND YA SPITTIN' SEEDS THROUGH THE WINDOW OF HIS SHACK!

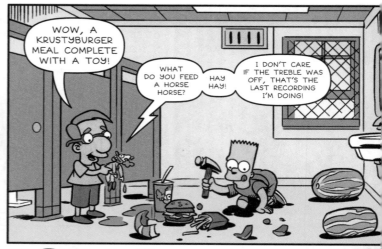

WOW, A KRUSTYBURGER MEAL COMPLETE WITH A TOY!

WHAT DO YOU FEED A HORSE HORSE?

HAY HAY!

I DON'T CARE IF THE TREBLE WAS OFF, THAT'S THE LAST RECORDING I'M DOING!

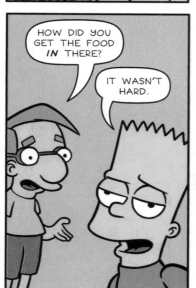

HOW DID YOU GET THE FOOD *IN* THERE?

IT WASN'T HARD.

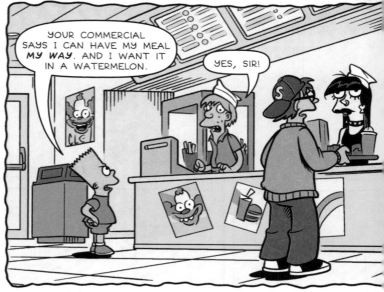

YOUR COMMERCIAL SAYS I CAN HAVE MY MEAL *MY WAY*. AND I WANT IT IN A WATERMELON.

YES, SIR!

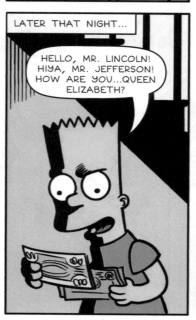

LATER THAT NIGHT...

HELLO, MR. LINCOLN! HIYA, MR. JEFFERSON! HOW ARE YOU...QUEEN ELIZABETH?

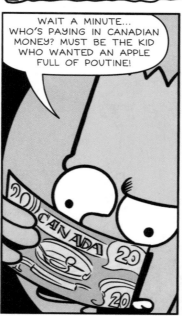

WAIT A MINUTE... WHO'S PAYING IN CANADIAN MONEY? MUST BE THE KID WHO WANTED AN APPLE FULL OF POUTINE!

BART, I KNOW WHAT YOU'VE BEEN UP TO!

≷GULP!≷

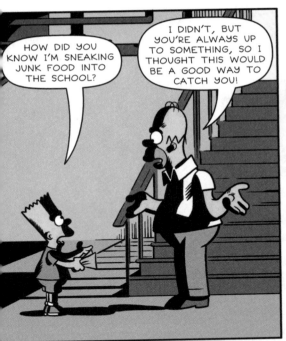

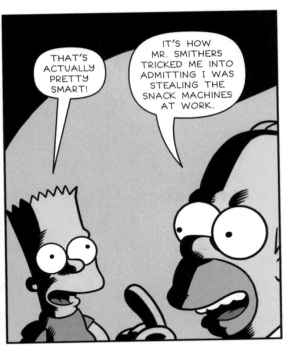

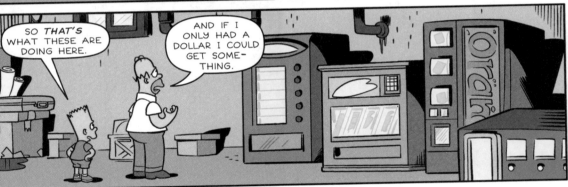

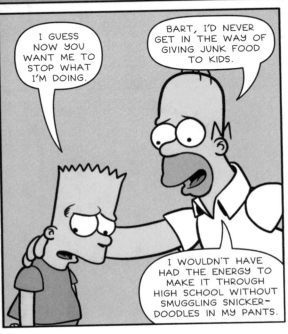

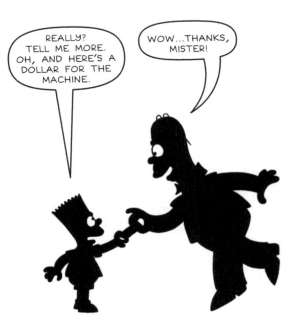

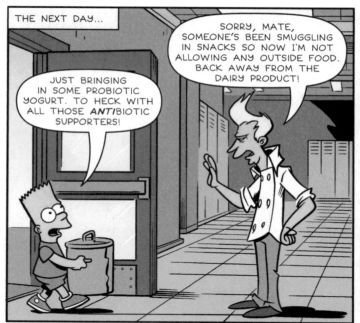

THE NEXT DAY...

JUST BRINGING IN SOME PROBIOTIC YOGURT. TO HECK WITH ALL THOSE *ANTI*BIOTIC SUPPORTERS!

SORRY, MATE, SOMEONE'S BEEN SMUGGLING IN SNACKS SO NOW I'M NOT ALLOWING ANY OUTSIDE FOOD. BACK AWAY FROM THE DAIRY PRODUCT!

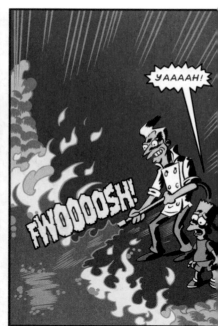

YAAAAH!

F'WOOOOSH!

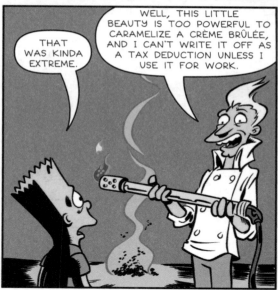

THAT WAS KINDA EXTREME.

WELL, THIS LITTLE BEAUTY IS TOO POWERFUL TO CARAMELIZE A CRÈME BRÛLÉE, AND I CAN'T WRITE IT OFF AS A TAX DEDUCTION UNLESS I USE IT FOR WORK.

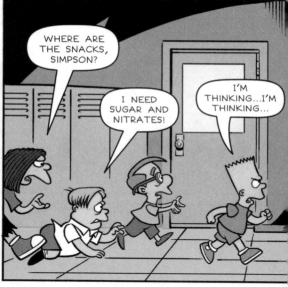

WHERE ARE THE SNACKS, SIMPSON?

I NEED SUGAR AND NITRATES!

I'M THINKING...I'M THINKING...

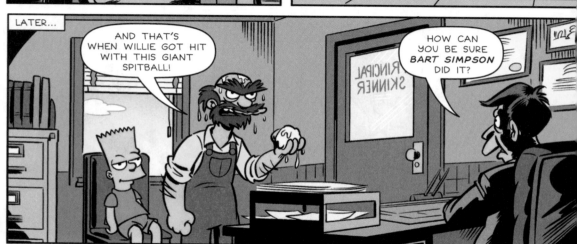

LATER...

AND THAT'S WHEN WILLIE GOT HIT WITH THIS GIANT SPITBALL!

HOW CAN YOU BE SURE *BART SIMPSON* DID IT?

PRINCIPAL SKINNER

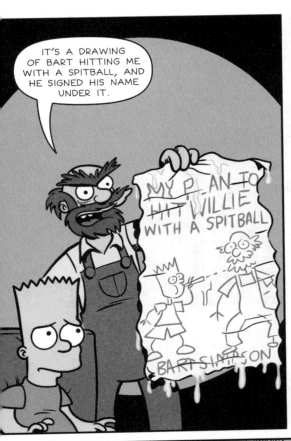

IT'S A DRAWING OF BART HITTING ME WITH A SPITBALL, AND HE SIGNED HIS NAME UNDER IT.

MY PLAN TO HIT WILLIE WITH A SPITBALL

BART SIMPSON

PLEASE, PLEASE DON'T CALL MY DAD!

I DON'T EVEN THINK I HAVE YOUR FATHER'S WORK NUMBER.

IT'S ON THE BACK OF THE DRAWING.

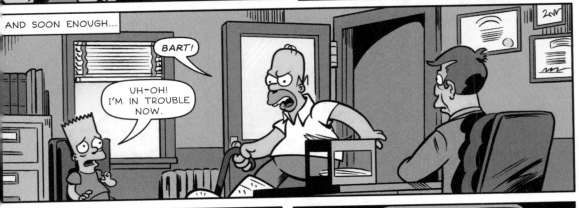

AND SOON ENOUGH...

BART!

UH-OH! I'M IN TROUBLE NOW.

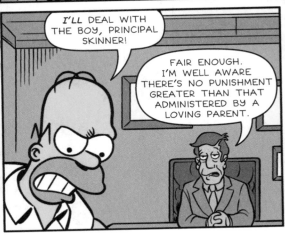

I'LL DEAL WITH THE BOY, PRINCIPAL SKINNER!

FAIR ENOUGH. I'M WELL AWARE THERE'S NO PUNISHMENT GREATER THAN THAT ADMINISTERED BY A LOVING PARENT.

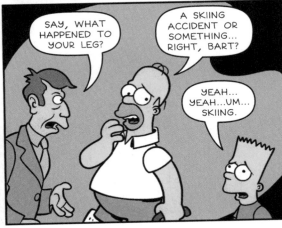

SAY, WHAT HAPPENED TO YOUR LEG?

A SKIING ACCIDENT OR SOMETHING... RIGHT, BART?

YEAH... YEAH...UM... SKIING.

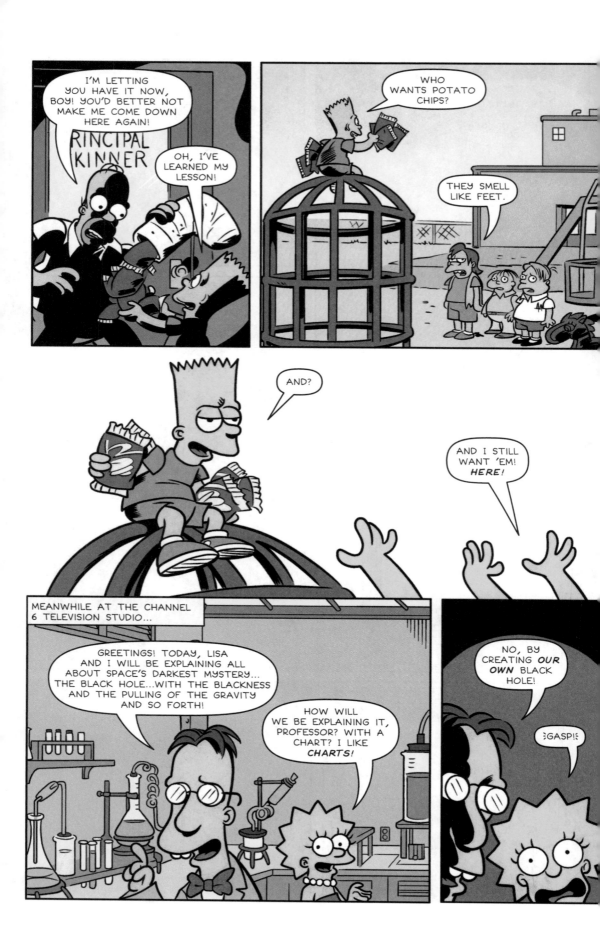

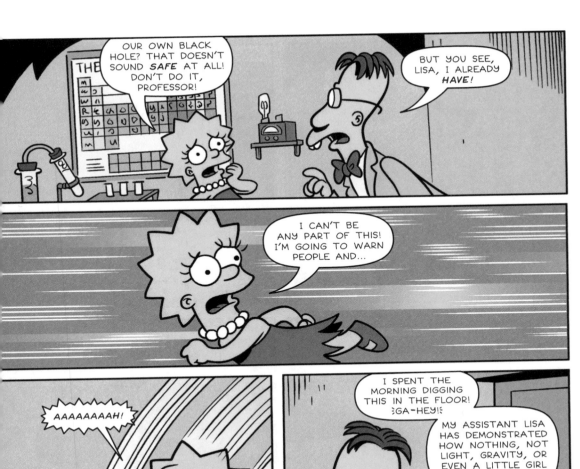

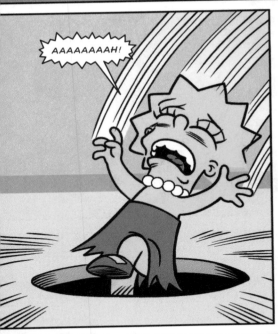

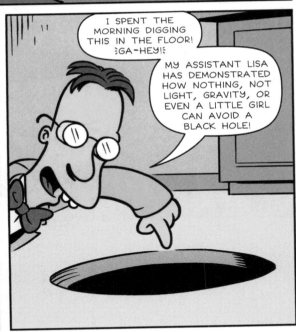

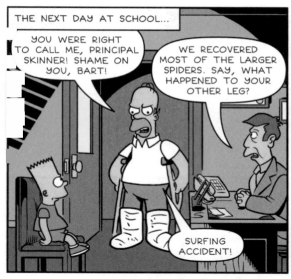

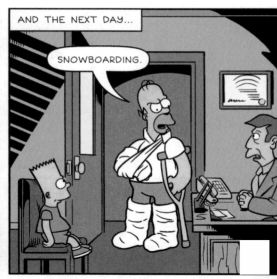

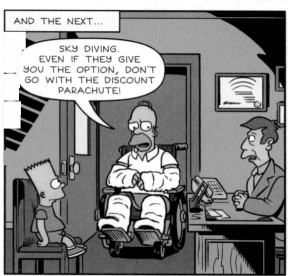

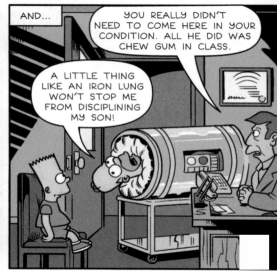

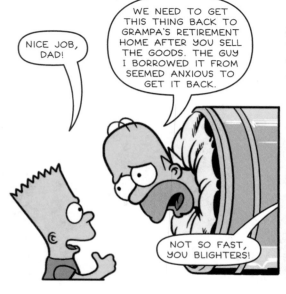

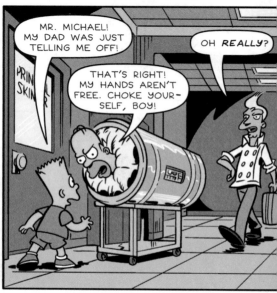

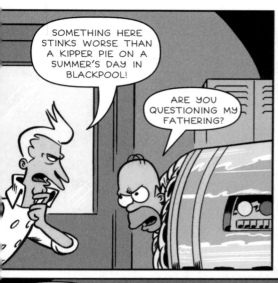

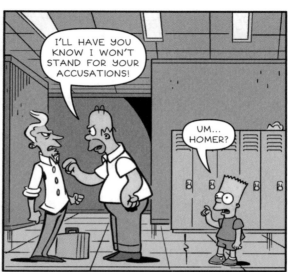

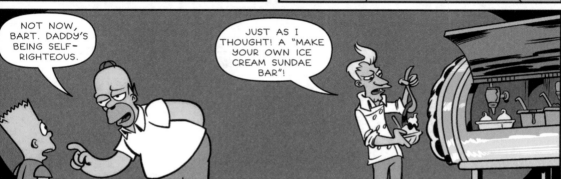

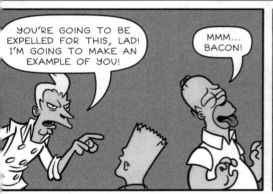

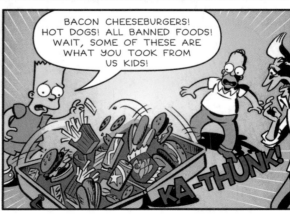

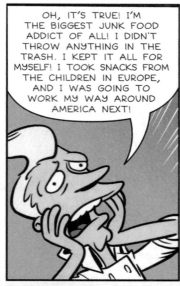

OH, IT'S TRUE! I'M THE BIGGEST JUNK FOOD ADDICT OF ALL! I DIDN'T THROW ANYTHING IN THE TRASH. I KEPT IT ALL FOR MYSELF! I TOOK SNACKS FROM THE CHILDREN IN EUROPE, AND I WAS GOING TO WORK MY WAY AROUND AMERICA NEXT!

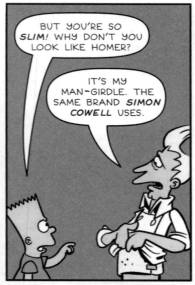

BUT YOU'RE SO *SLIM!* WHY DON'T YOU LOOK LIKE HOMER?

IT'S MY MAN-GIRDLE. THE SAME BRAND *SIMON COWELL* USES.

AWWW...THAT'S A *RELIEF!*

RRRRRRIP!

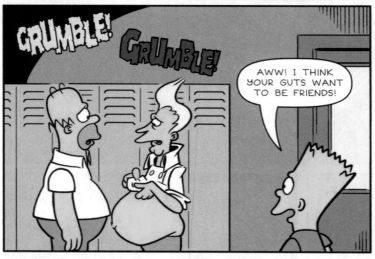

GRUMBLE!

GRUMBLE!

AWW! I THINK YOUR GUTS WANT TO BE FRIENDS!

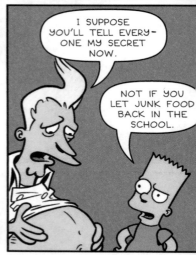

I SUPPOSE YOU'LL TELL EVERY-ONE MY SECRET NOW.

NOT IF YOU LET JUNK FOOD BACK IN THE SCHOOL.

DEAL! AND YOU AND YOUR FATHER CAN EVEN HAVE *HALF* OF THE SNACKS IN MY BRIEF...

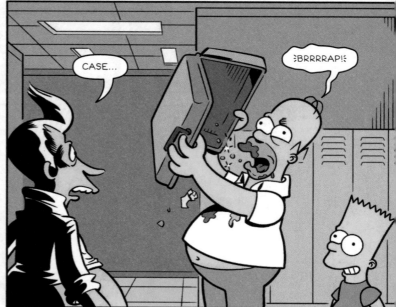

CASE...

⋮BRRRRAP!⋮

MEANWHILE, BACK AT THE CHANNEL 6 STUDIOS...

YOU FED YOUR LAB MONKEYS NOTHING BUT HELIUM FOR A WEEK?

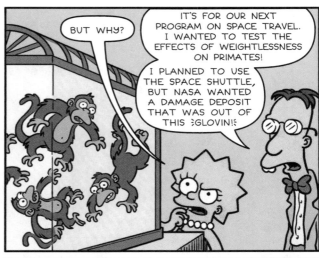

BUT WHY?

IT'S FOR OUR NEXT PROGRAM ON SPACE TRAVEL. I WANTED TO TEST THE EFFECTS OF WEIGHTLESSNESS ON PRIMATES!

I PLANNED TO USE THE SPACE SHUTTLE, BUT NASA WANTED A DAMAGE DEPOSIT THAT WAS OUT OF THIS :GLOVIN!:

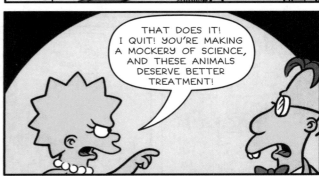

THAT DOES IT! I QUIT! YOU'RE MAKING A MOCKERY OF SCIENCE, AND THESE ANIMALS DESERVE BETTER TREATMENT!

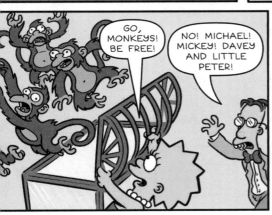

GO, MONKEYS! BE FREE!

NO! MICHAEL! MICKEY! DAVEY AND LITTLE PETER!

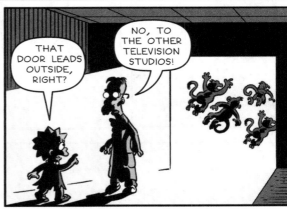

THAT DOOR LEADS OUTSIDE, RIGHT?

NO, TO THE OTHER TELEVISION STUDIOS!

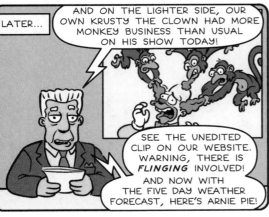

LATER...

AND ON THE LIGHTER SIDE, OUR OWN KRUSTY THE CLOWN HAD MORE MONKEY BUSINESS THAN USUAL ON HIS SHOW TODAY!

SEE THE UNEDITED CLIP ON OUR WEBSITE. WARNING, THERE IS *FLINGING* INVOLVED! AND NOW WITH THE FIVE DAY WEATHER FORECAST, HERE'S ARNIE PIE!

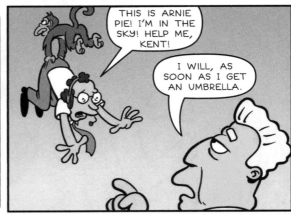

THIS IS ARNIE PIE! I'M IN THE SKY! HELP ME, KENT!

I WILL, AS SOON AS I GET AN UMBRELLA.

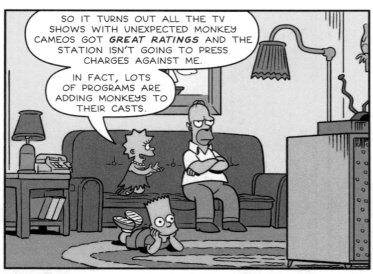

SO IT TURNS OUT ALL THE TV SHOWS WITH UNEXPECTED MONKEY CAMEOS GOT *GREAT RATINGS* AND THE STATION ISN'T GOING TO PRESS CHARGES AGAINST ME.

IN FACT, LOTS OF PROGRAMS ARE ADDING MONKEYS TO THEIR CASTS.

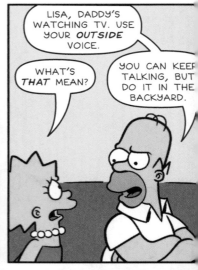

LISA, DADDY'S WATCHING TV. USE YOUR *OUTSIDE* VOICE.

WHAT'S *THAT* MEAN?

YOU CAN KEEP TALKING, BUT DO IT IN THE BACKYARD.

WE NOW RETURN TO "CSI: MONKEY"!

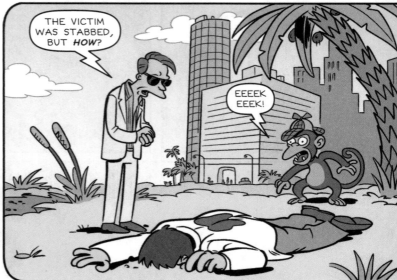

THE VICTIM WAS STABBED, BUT *HOW*?

EEEEK EEEK!

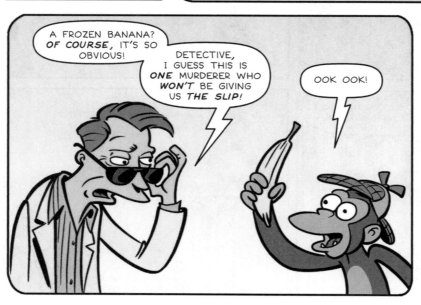

A FROZEN BANANA? *OF COURSE*, IT'S SO OBVIOUS!

DETECTIVE, I GUESS THIS IS *ONE* MURDERER WHO *WON'T* BE GIVING US *THE SLIP*!

OOK OOK!

DINNER'S READY!

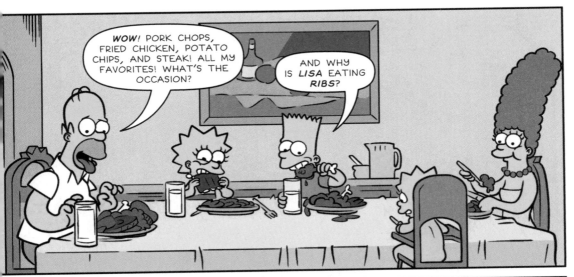

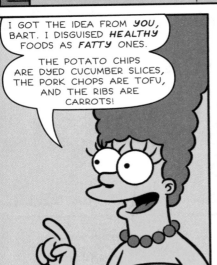

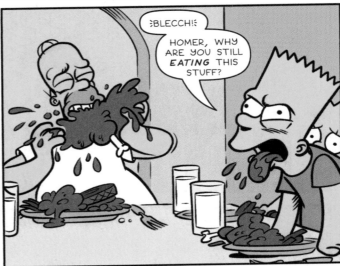

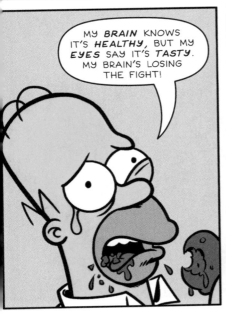

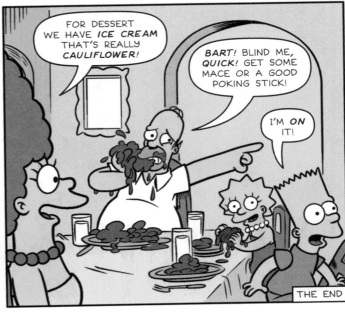

THE END

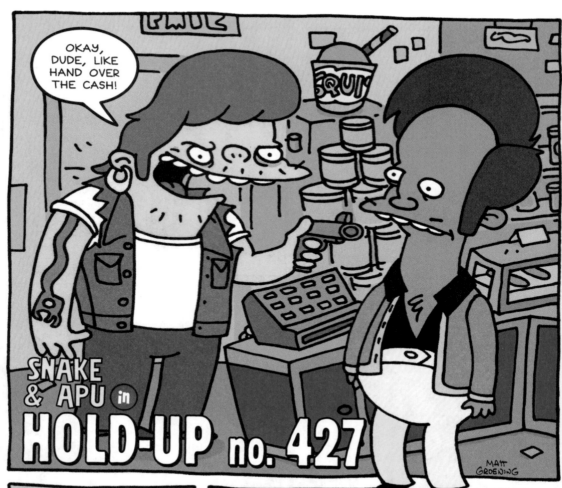

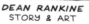

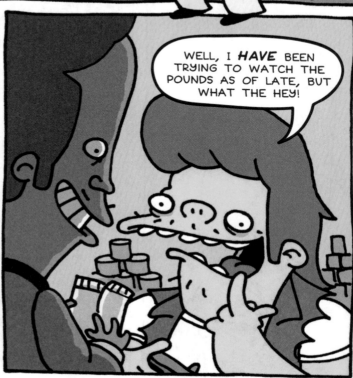

DEAN RANKINE
STORY & ART

KAREN BATES
LETTERS

BILL MORRISON
EDITOR

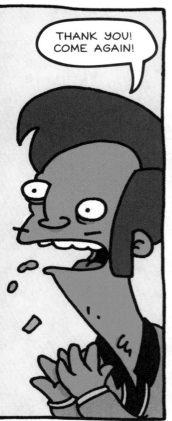

THE END

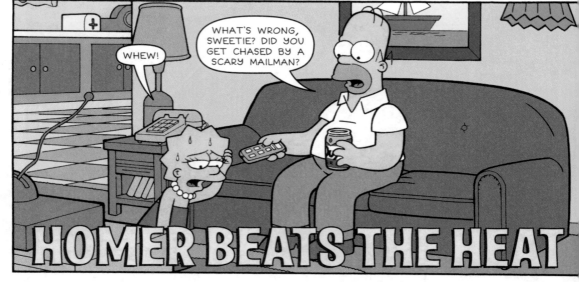

WHEW!

WHAT'S WRONG, SWEETIE? DID YOU GET CHASED BY A SCARY MAILMAN?

HOMER BEATS THE HEAT

WHAT? NO. IT'S JUST THAT IT'S SO HOT. I DON'T KNOW HOW I'M GOING TO GET THROUGH ANOTHER SUMMER WITH ALL THIS *GLOBAL WARMING*.

WELL, DON'T YOU WORRY! I'M NOT GONNA LET SOME STUPID BALL OF FIRE IN THE SKY OR THE POST OFFICE RUIN MY DAUGHTER'S SUMMER!

C'MON! I'M GONNA SHOW YOU HOW TO BE *COOL!*

DON'T YOU MEAN *KEEP* COOL?

YEAH, THAT.

SEE, HONEY? DADDY JUST PUTS THESE ICE CUBES IN HIS POCKET, AND HE'S COOL!

DAD, I DON'T *HAVE* POCKETS.

D'OH!

TONY DIGEROLAMO
SCRIPT

PHIL ORTIZ
PENCILS

MIKE DECARLO
INKS

ROBERT STANLEY
COLORS

KAREN BATES
LETTERS

BILL MORRISON
EDITOR

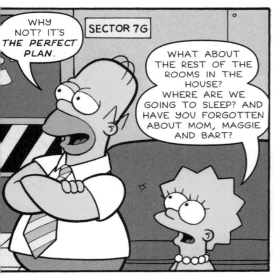

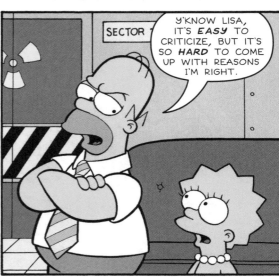

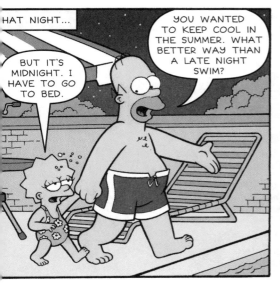

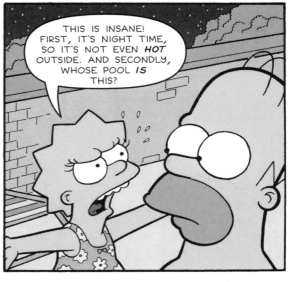

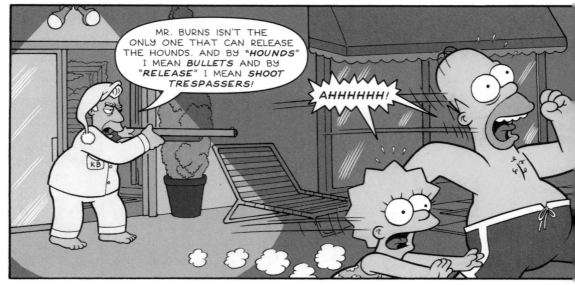

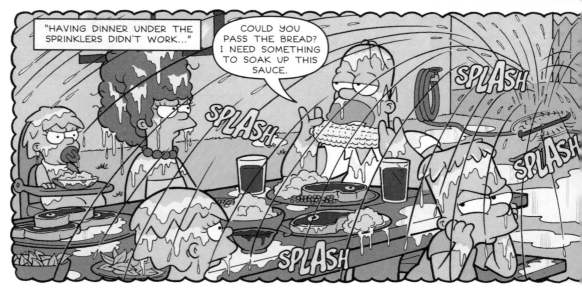

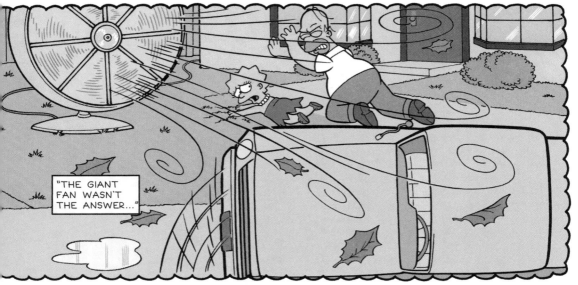

"THE GIANT FAN WASN'T THE ANSWER..."

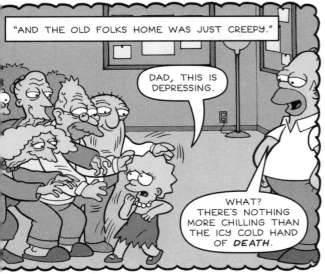

"AND THE OLD FOLKS HOME WAS JUST CREEPY."

DAD, THIS IS DEPRESSING.

WHAT? THERE'S NOTHING MORE CHILLING THAN THE ICY COLD HAND OF *DEATH*.

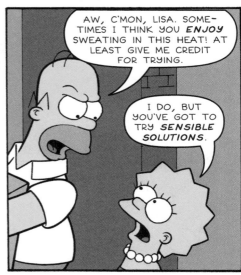

AW, C'MON, LISA. SOMETIMES I THINK YOU *ENJOY* SWEATING IN THIS HEAT! AT LEAST GIVE ME CREDIT FOR TRYING.

I DO, BUT YOU'VE GOT TO TRY *SENSIBLE SOLUTIONS*.

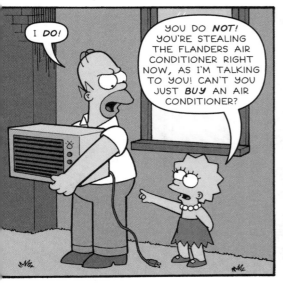

I *DO!*

YOU DO *NOT!* YOU'RE STEALING THE FLANDERS AIR CONDITIONER RIGHT NOW, AS I'M TALKING TO YOU! CAN'T YOU JUST *BUY* AN AIR CONDITIONER?

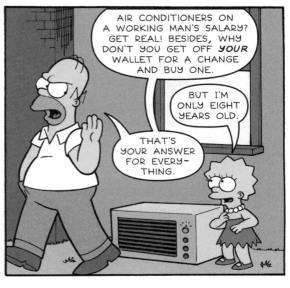

AIR CONDITIONERS ON A WORKING MAN'S SALARY? GET REAL! BESIDES, WHY DON'T YOU GET OFF *YOUR* WALLET FOR A CHANGE AND BUY ONE.

BUT I'M ONLY EIGHT YEARS OLD.

THAT'S YOUR ANSWER FOR EVERYTHING.

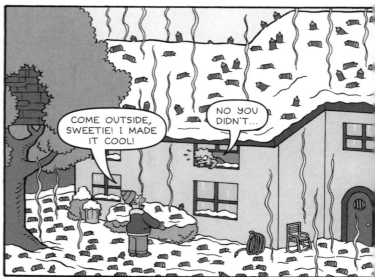

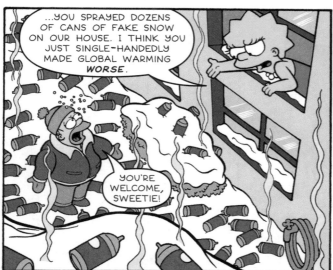

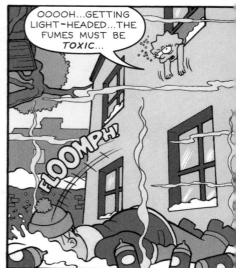

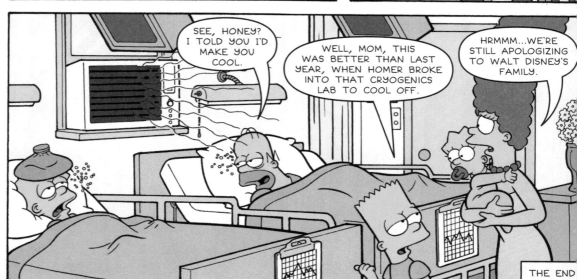

THE END

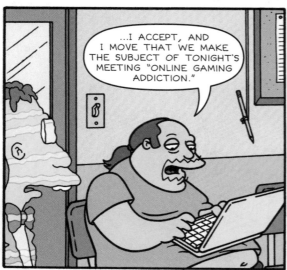

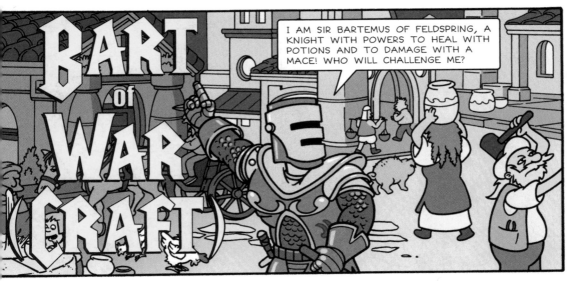

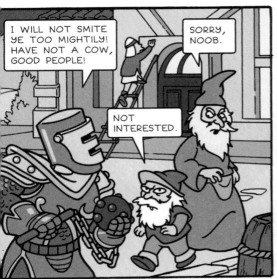

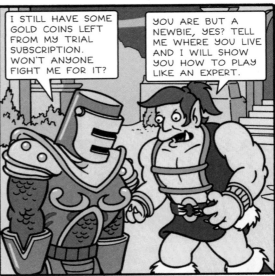

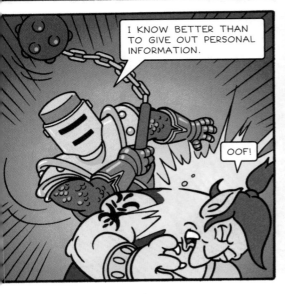

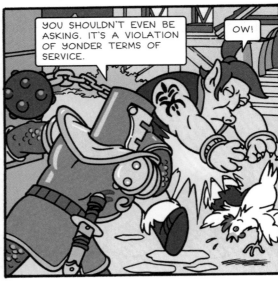

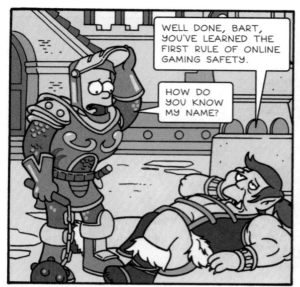

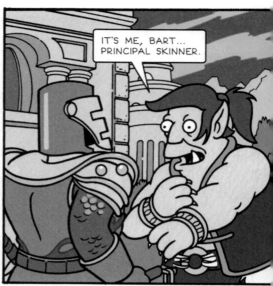

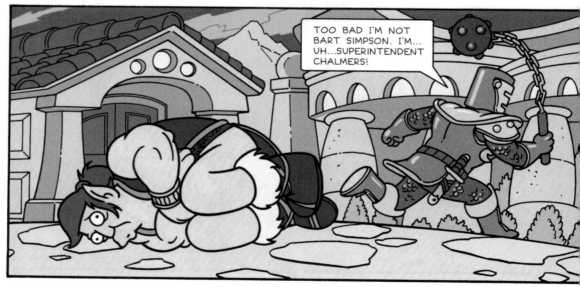

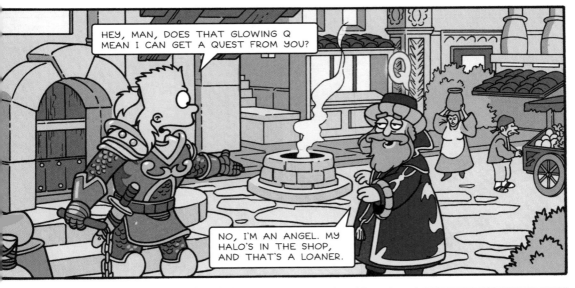

HEY, MAN, DOES THAT GLOWING Q MEAN I CAN GET A QUEST FROM YOU?

NO, I'M AN ANGEL. MY HALO'S IN THE SHOP, AND THAT'S A LOANER.

WHAT?

NEVER MIND. THEY HIRED OUT-OF-WORK COMEDY WRITERS TO WRITE MY LINES. BUT INDEED, I AM THE QUEST MASTER. HERE IS YOUR QUEST...

RUN DOWN TO YE OLDE DELICATESSEN AND PICK ME UP A BOWL OF MATZO BALL SOUP AND SOME KUGEL.

I DON'T THINK--

NEVERMIND. AGAIN, IT'S THE WRITERS. FIND A FOUR-LEGGED BORT, RIDE IT TO THE CAVES OF FROTHLICK, DEFEAT THE UGH MONSTER THAT DWELLS WITHIN, AND BRING ME BACK HIS TUNIC.

BORT, FROTHLICK CAVE, UGH MONSTER TUNIC. GOT IT.

AND WOULD IT KILL YOU TO BRING BACK A KNISH?

Bort ✓
Frothlick Cave ✓
Ugh Monster ✓

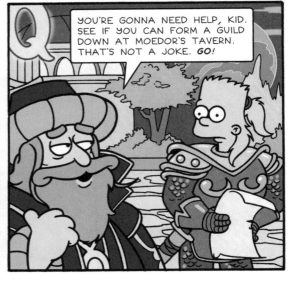

YOU'RE GONNA NEED HELP, KID. SEE IF YOU CAN FORM A GUILD DOWN AT MOEDOR'S TAVERN. THAT'S NOT A JOKE. *GO!*

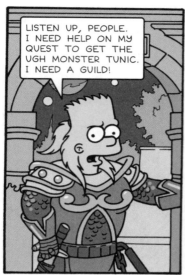

LISTEN UP, PEOPLE. I NEED HELP ON MY QUEST TO GET THE UGH MONSTER TUNIC. I NEED A GUILD!

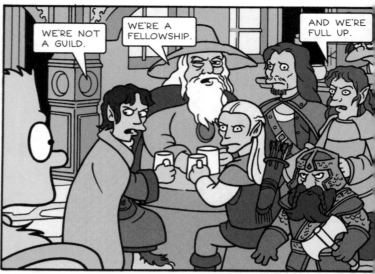

WE'RE NOT A GUILD.

WE'RE A FELLOWSHIP.

AND WE'RE FULL UP.

HOW ABOUT YOU GUYS?

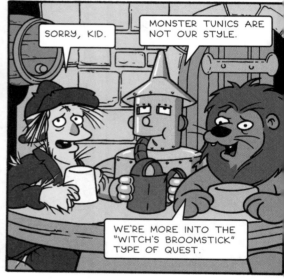

SORRY, KID.

MONSTER TUNICS ARE NOT OUR STYLE.

WE'RE MORE INTO THE "WITCH'S BROOMSTICK" TYPE OF QUEST.

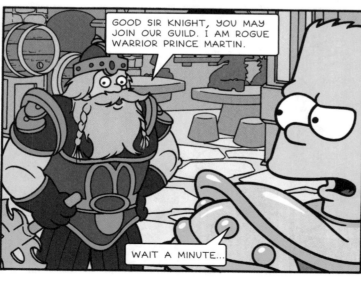

GOOD SIR KNIGHT, YOU MAY JOIN OUR GUILD. I AM ROGUE WARRIOR PRINCE MARTIN.

WAIT A MINUTE...

...YOU'RE MARTIN PRINCE FROM MY CLASS.

SHUSH, BART...MY MOTHER DOESN'T KNOW I PLAY THIS GAME.

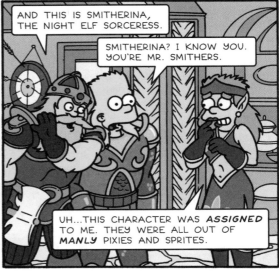

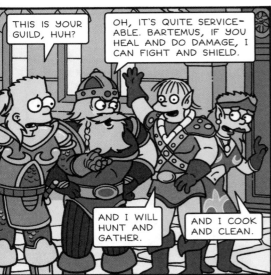

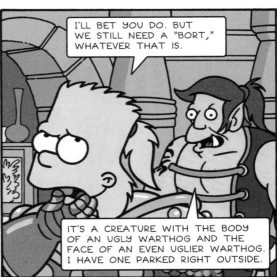

THIS IS THE WORST SMELLING THING I'VE EVER RIDDEN. AND I RODE THE TILT-A-WHIRL AFTER WENDELL BARFED IN IT.

HEY! I'M GONNA TELL YOUR FATHER NEXT TIME I SEE HIM AT MOE'S.

BARNEY, IS THAT YOU? WHEN DID YOU GET A COMPUTER?

COMPUTER?

FROTHLICK CAVES
IF YOU WERE A HIDEOUS, REPTILIAN FREAK, YOU'D BE HOME BY NOW

YOUR QUEST IS OVER LEST YOU FAIL THE TEST!

TELL US MORE ABOUT THIS TEST, DRAGON!

'TIS A MATH TEST FROM MRS. KRABAPPEL TOMORROW, AND MARTIN MUST STUDY!

YES, MOTHER.

POOR MARTIN.

POOR MARTIN? WHAT ABOUT US? WE CAN'T TAKE ON AN UGH MONSTER WITHOUT SOMEONE WHO CAN FIGHT AND SHIELD.

I CAN FIGHT AND SHIELD!

ALRIGHT, BUT AS SOON AS WE BEAT THIS THING, I'M GOING TO SMITE YOU AGAIN.

UNDERSTOOD.

ANYBODY KNOW WHY THEY CALL IT AN UGH MONSTER?

I DO.

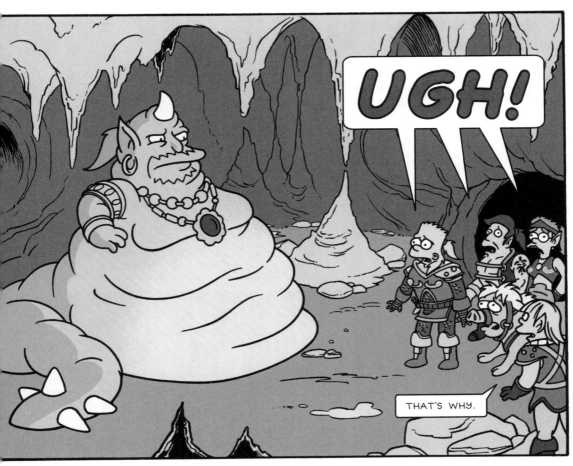

UGH!

THAT'S WHY.

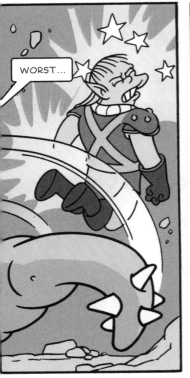

WORST...

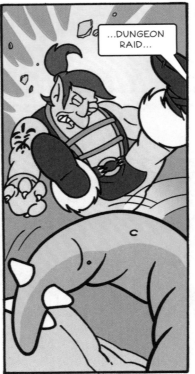

...DUNGEON RAID...

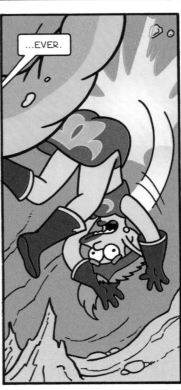

...EVER.

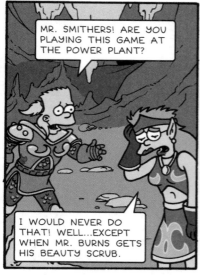

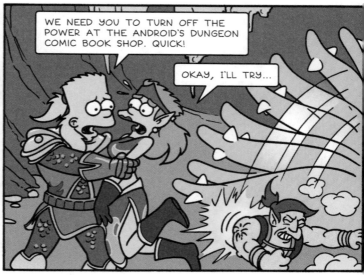

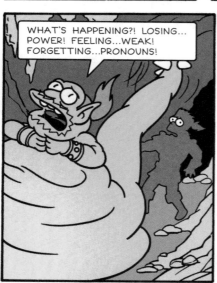

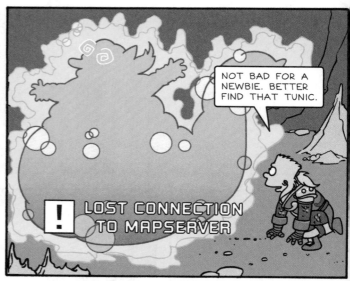

THE END

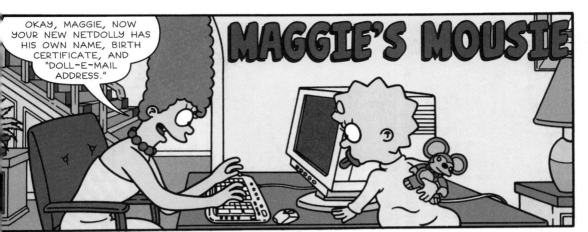

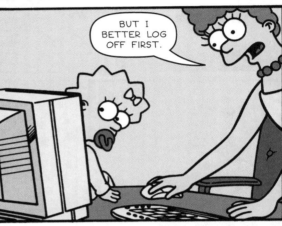

WELCOME

J.M. KIOL,
CEO OF
NETDOLLY
INDUSTRIES

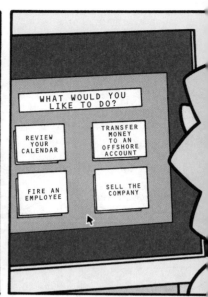

WHAT WOULD YOU
LIKE TO DO?

REVIEW
YOUR
CALENDAR

TRANSFER
MONEY
TO AN
OFFSHORE
ACCOUNT

FIRE AN
EMPLOYEE

SELL THE
COMPANY

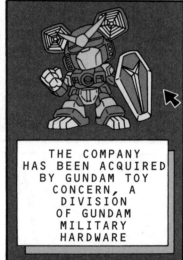

THE COMPANY
HAS BEEN ACQUIRED
BY GUNDAM TOY
CONCERN, A
DIVISION
OF GUNDAM
MILITARY
HARDWARE

AS A MEMBER OF
THE BOARD OF
DIRECTORS OF
GUNDAM MILITARY
HARDWARE, YOU CAN
AUTHORIZE THE TEST
FIRING OF ITS
SURFACE-TO-AIR
MISSILES. HOW MANY
WOULD YOU LIKE TO
LAUNCH?

0_____

. HOW MA

U LIKE

LAUNCH?

9999

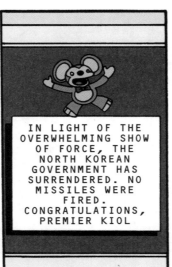

IN LIGHT OF THE OVERWHMING SHOW OF FORCE, THE NORTH KOREAN GOVERNMENT HAS SURRENDERED. NO MISSILES WERE FIRED. CONGRATULATIONS, PREMIER KIOL

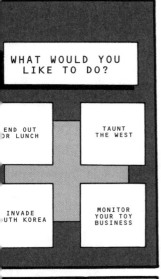

WHAT WOULD YOU LIKE TO DO?

END OUT
OR LUNCH

TAUNT
THE WEST

INVADE
UTH KOREA

MONITOR
YOUR TOY
BUSINESS

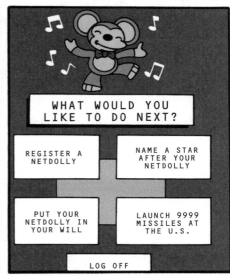

WHAT WOULD YOU LIKE TO DO NEXT?

REGISTER A
NETDOLLY

NAME A STAR
AFTER YOUR
NETDOLLY

PUT YOUR
NETDOLLY IN
YOUR WILL

LAUNCH 9999
MISSILES AT
THE U.S.

LOG OFF

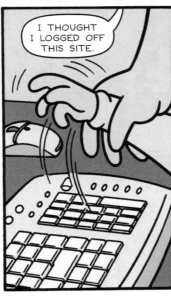

I THOUGHT I LOGGED OFF THIS SITE.

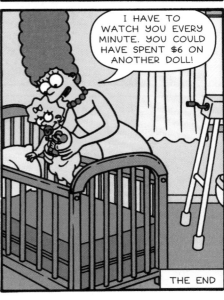

I HAVE TO WATCH YOU EVERY MINUTE. YOU COULD HAVE SPENT $6 ON ANOTHER DOLL!

THE END

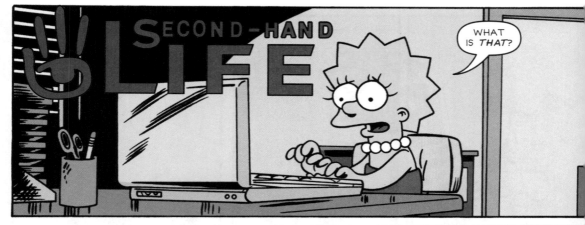

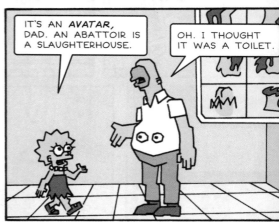

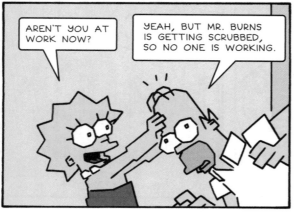

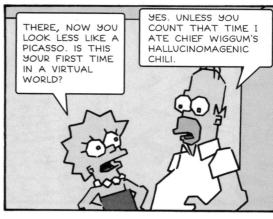

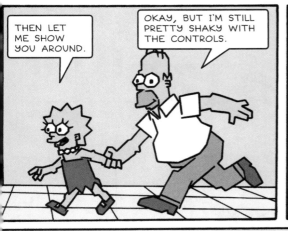

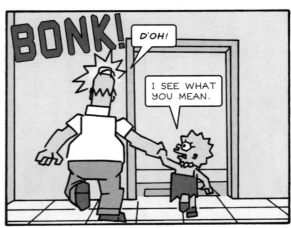

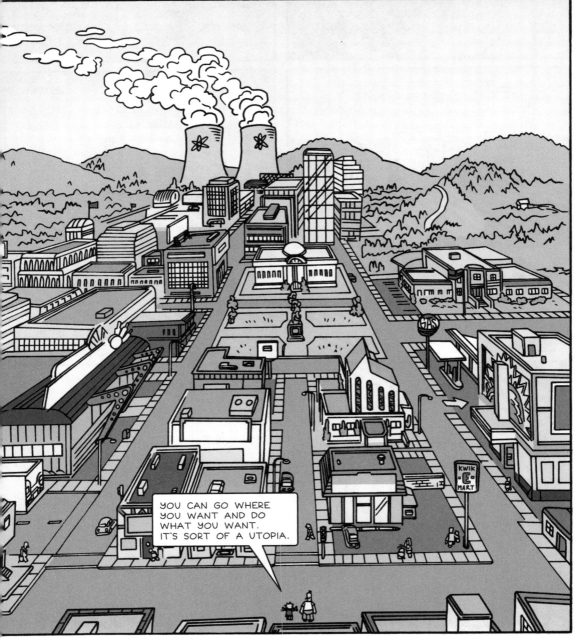

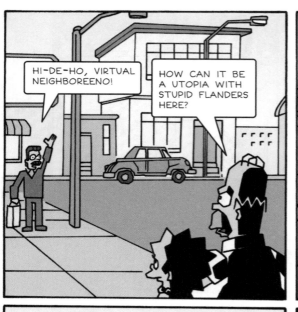

HI-DE-HO, VIRTUAL NEIGHBOREENO!

HOW CAN IT BE A UTOPIA WITH STUPID FLANDERS HERE?

OOH! CAN I SMITE HIM WITH MY MACE AND CLUB?

IT'S NOT THAT KIND OF GAME, DAD.

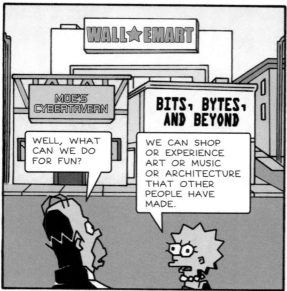

WALL★EMART

MOE'S CYBERTAVERN

BITS, BYTES, AND BEYOND

WELL, WHAT CAN WE DO FOR FUN?

WE CAN SHOP OR EXPERIENCE ART OR MUSIC OR ARCHITECTURE THAT OTHER PEOPLE HAVE MADE.

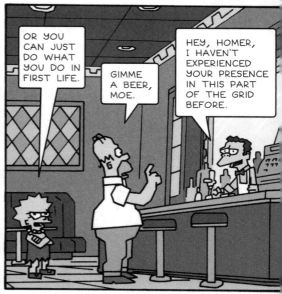

OR YOU CAN JUST DO WHAT YOU DO IN FIRST LIFE.

GIMME A BEER, MOE.

HEY, HOMER, I HAVEN'T EXPERIENCED YOUR PRESENCE IN THIS PART OF THE GRID BEFORE.

FIRST TIME.

AND HE DOESN'T HAVE ANY CYBERCASH.

THEN YOU'RE OUT ON YOUR CYBERASS.

JUST AS WELL. VIRTUAL MOE WATERS DOWN HIS BEER JUST LIKE THE REAL MOE.

DAD, I DON'T THINK YOU CAN GET DRUNK ON BINARY CODE.

IT WAS WORTH A TRY.

ARTY SMARTY'S SMART ART

OOH, LET'S GO IN THERE.

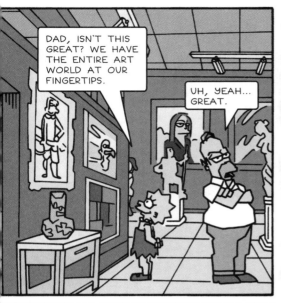

DAD, ISN'T THIS GREAT? WE HAVE THE ENTIRE ART WORLD AT OUR FINGERTIPS.

UH, YEAH... GREAT.

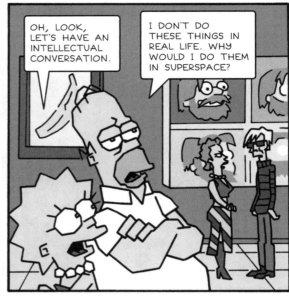

OH, LOOK, LET'S HAVE AN INTELLECTUAL CONVERSATION.

I DON'T DO THESE THINGS IN REAL LIFE. WHY WOULD I DO THEM IN SUPERSPACE?

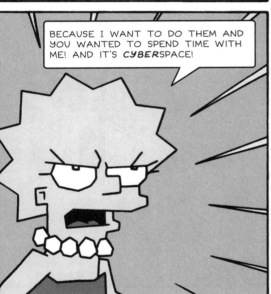

BECAUSE I WANT TO DO THEM AND YOU WANTED TO SPEND TIME WITH ME! AND IT'S *CYBER*SPACE!

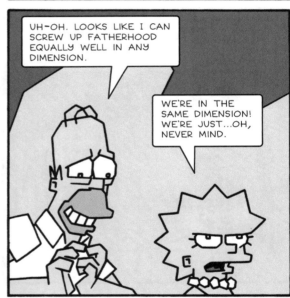

UH-OH. LOOKS LIKE I CAN SCREW UP FATHERHOOD EQUALLY WELL IN ANY DIMENSION.

WE'RE IN THE SAME DIMENSION! WE'RE JUST...OH, NEVER MIND.

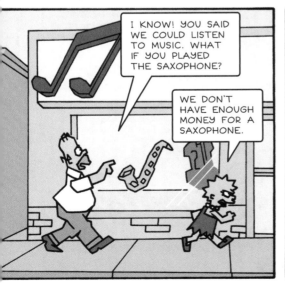

I KNOW! YOU SAID WE COULD LISTEN TO MUSIC. WHAT IF YOU PLAYED THE SAXOPHONE?

WE DON'T HAVE ENOUGH MONEY FOR A SAXOPHONE.

WAIT RIGHT HERE. DON'T LOG OVER.

YOU MEAN "LOG OFF."

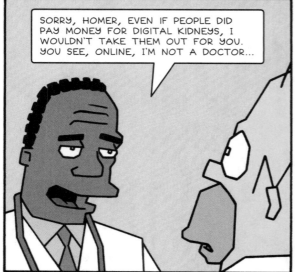

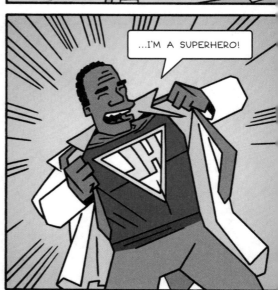

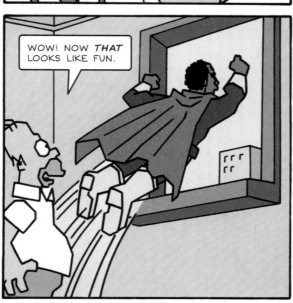

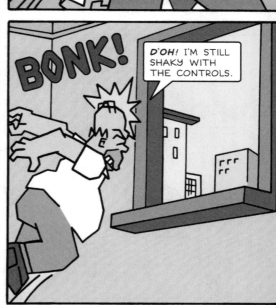

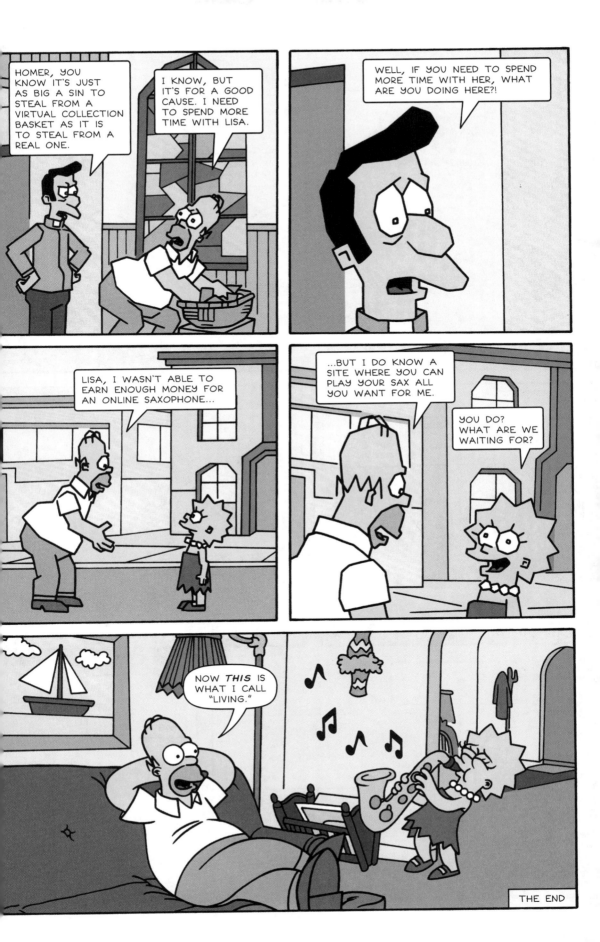

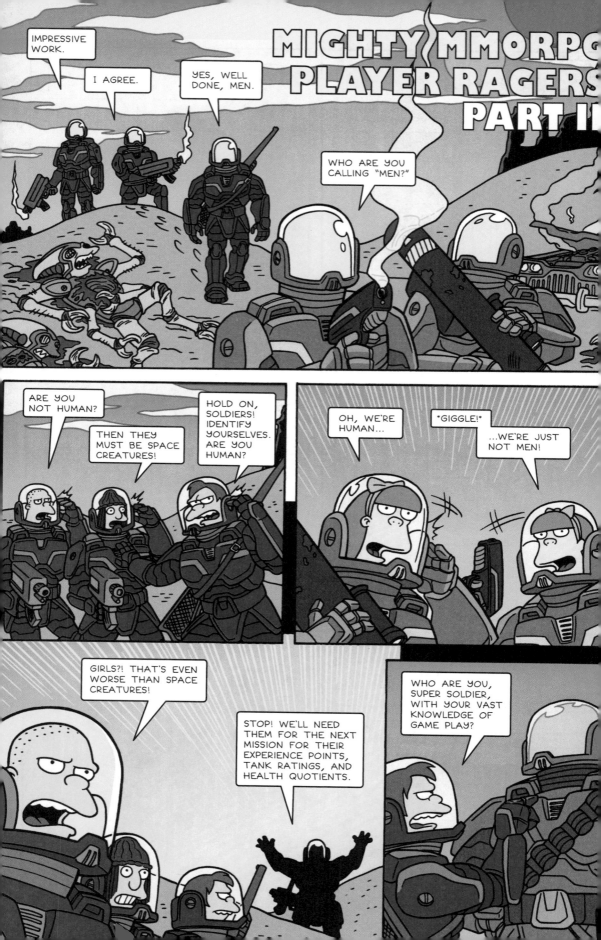

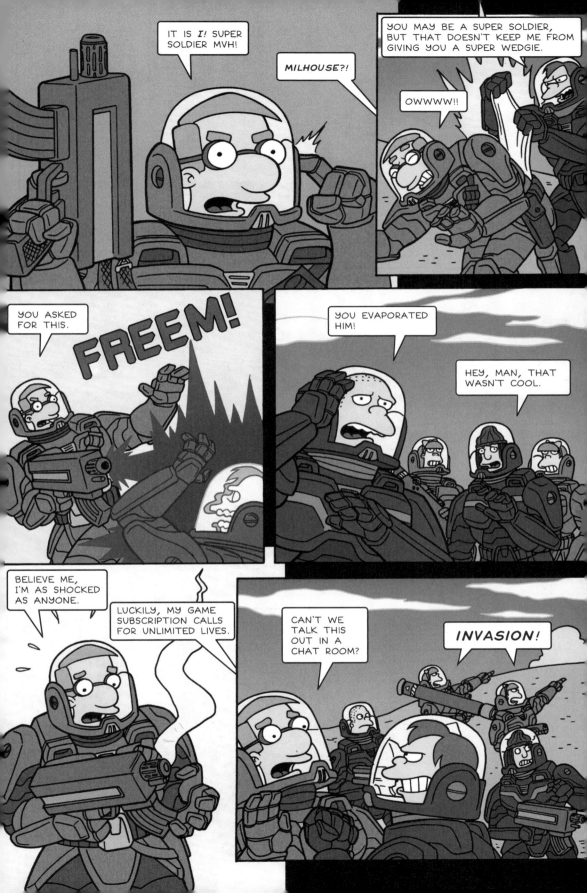

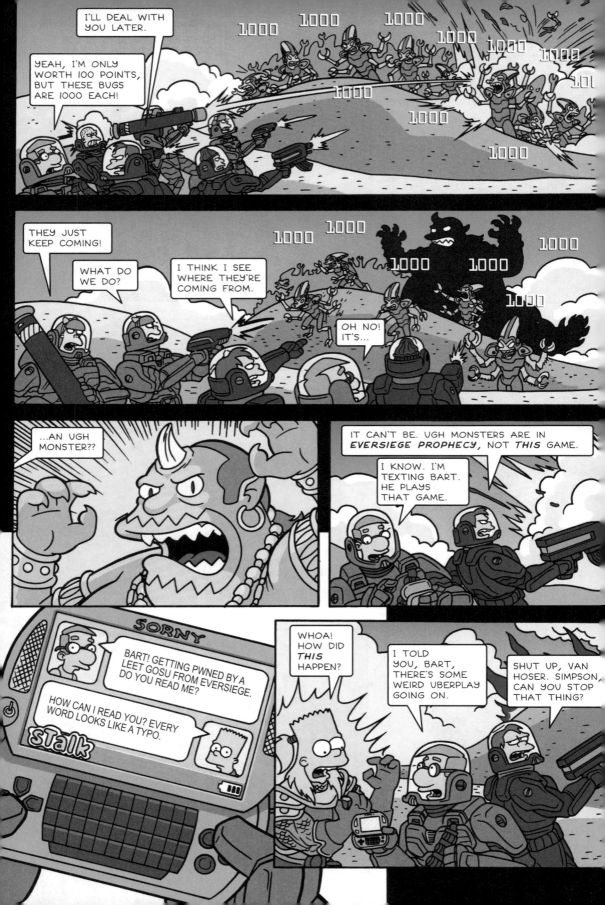

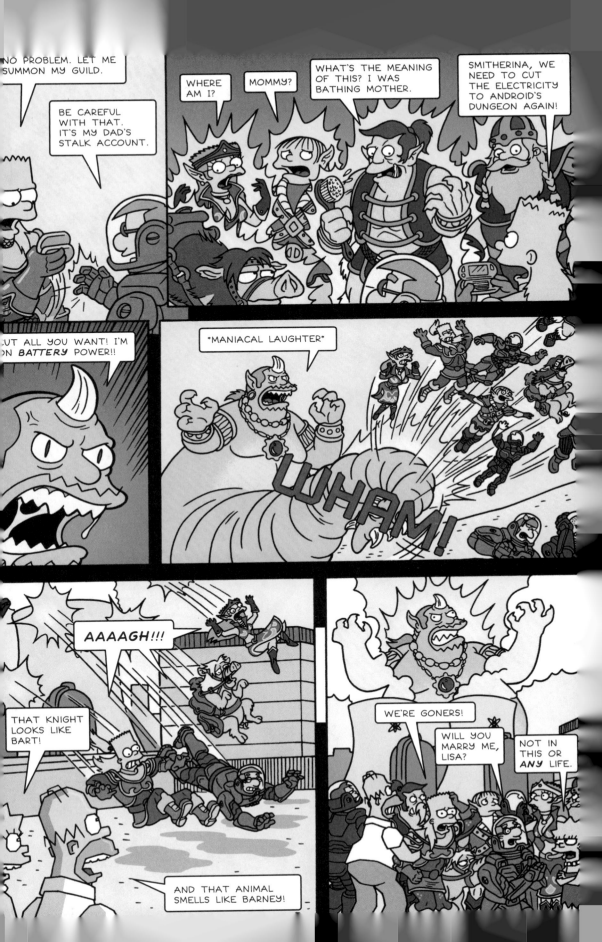

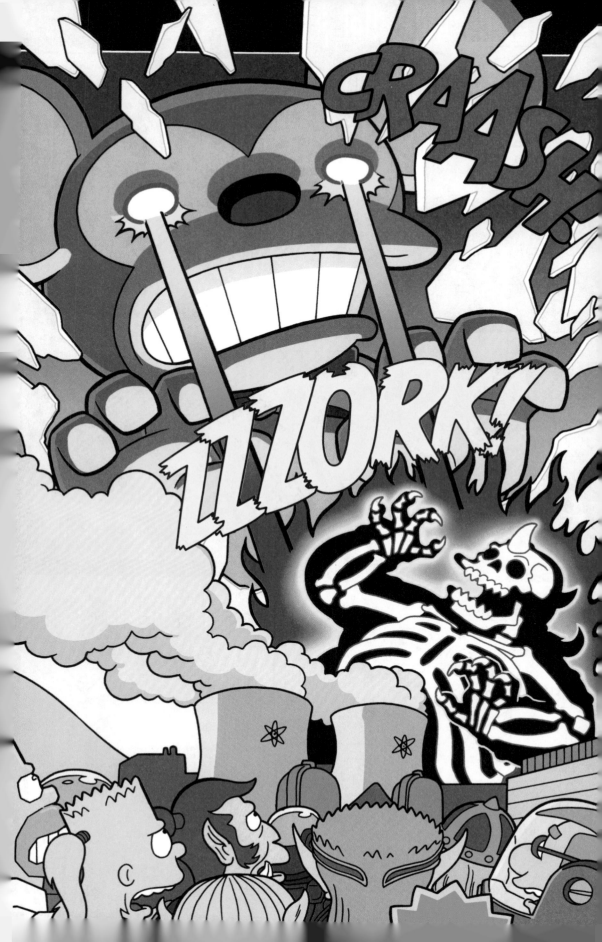

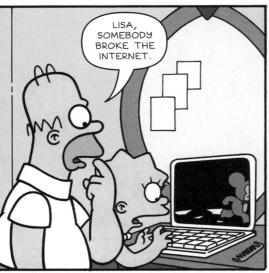

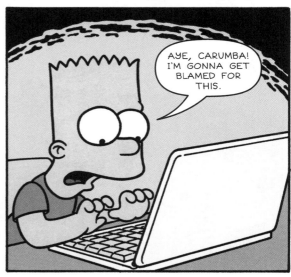

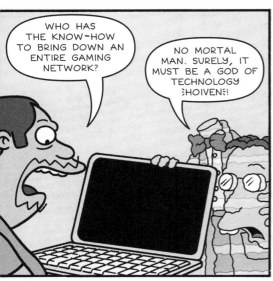

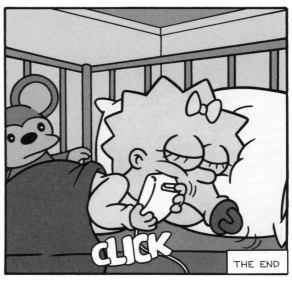

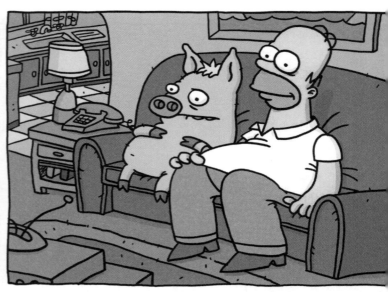

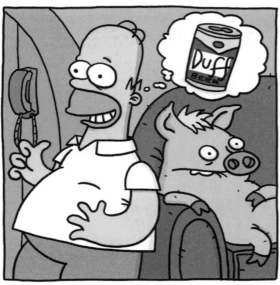

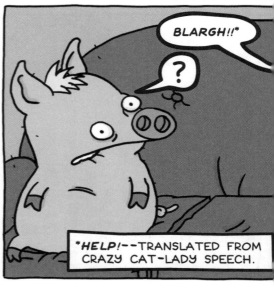

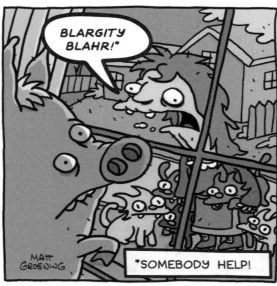

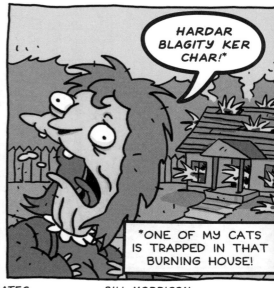

DEAN RANKINE
STORY & ART

KAREN BATES
LETTERS

BILL MORRISON
EDITOR

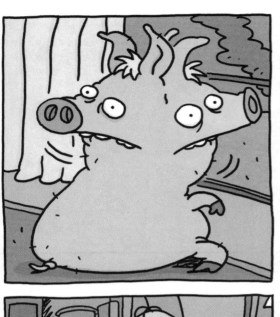
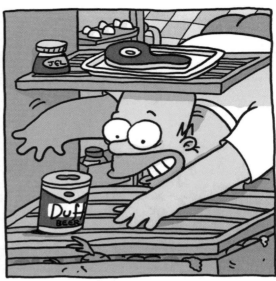

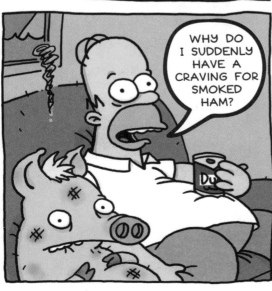

END

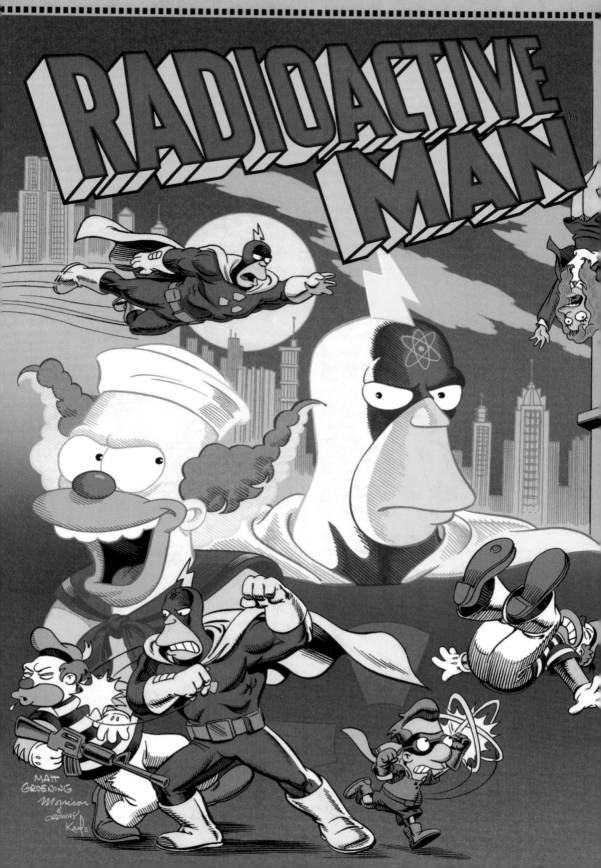

RADIOACTIVE MAN

MATT GROENING

Morrison & ORDWAY KATE

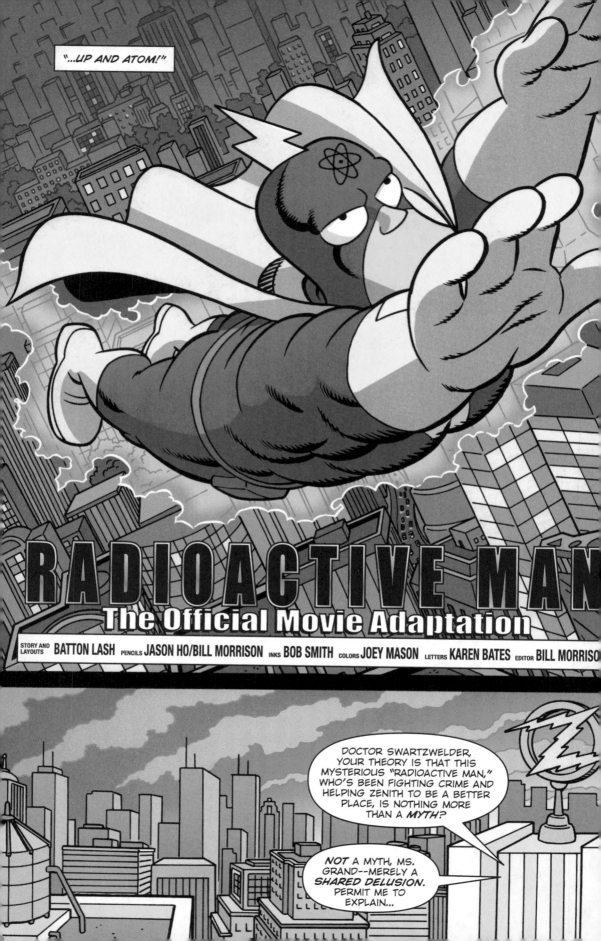

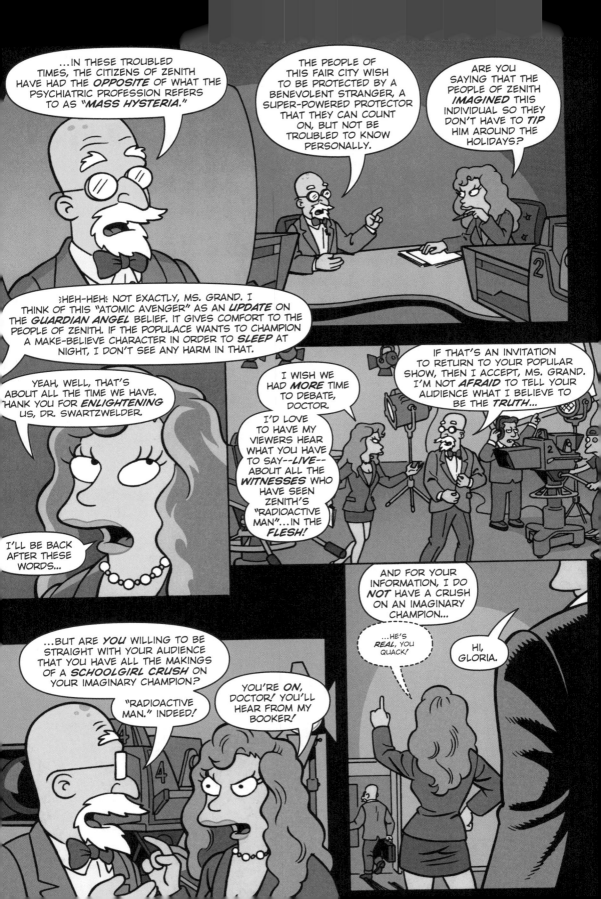

...IN THESE TROUBLED TIMES, THE CITIZENS OF ZENITH HAVE HAD THE *OPPOSITE* OF WHAT THE PSYCHIATRIC PROFESSION REFERS TO AS *"MASS HYSTERIA."*

THE PEOPLE OF THIS FAIR CITY WISH TO BE PROTECTED BY A BENEVOLENT STRANGER, A SUPER-POWERED PROTECTOR THAT THEY CAN COUNT ON, BUT NOT BE TROUBLED TO KNOW PERSONALLY.

ARE YOU SAYING THAT THE PEOPLE OF ZENITH *IMAGINED* THIS INDIVIDUAL SO THEY DON'T HAVE TO *TIP* HIM AROUND THE HOLIDAYS?

:HEH-HEH: NOT EXACTLY, MS. GRAND. I THINK OF THIS "ATOMIC AVENGER" AS AN *UPDATE* ON THE *GUARDIAN ANGEL* BELIEF. IT GIVES COMFORT TO THE PEOPLE OF ZENITH. IF THE POPULACE WANTS TO CHAMPION A MAKE-BELIEVE CHARACTER IN ORDER TO *SLEEP* AT NIGHT, I DON'T SEE ANY HARM IN THAT.

YEAH, WELL, THAT'S ABOUT ALL THE TIME WE HAVE. THANK YOU FOR *ENLIGHTENING* US, DR. SWARTZWELDER.

I'LL BE BACK AFTER THESE WORDS...

I WISH WE HAD *MORE* TIME TO DEBATE, DOCTOR.

I'D LOVE TO HAVE MY VIEWERS HEAR WHAT YOU HAVE TO SAY--*LIVE*--ABOUT ALL THE *WITNESSES* WHO HAVE SEEN ZENITH'S "RADIOACTIVE MAN"...IN THE *FLESH!*

IF THAT'S AN INVITATION TO RETURN TO YOUR POPULAR SHOW, THEN I ACCEPT, MS. GRAND. I'M NOT *AFRAID* TO TELL YOUR AUDIENCE WHAT I BELIEVE TO BE THE *TRUTH*...

...BUT ARE *YOU* WILLING TO BE STRAIGHT WITH YOUR AUDIENCE THAT YOU HAVE ALL THE MAKINGS OF A *SCHOOLGIRL CRUSH* ON YOUR IMAGINARY CHAMPION?

"RADIOACTIVE MAN." INDEED!

YOU'RE *ON,* DOCTOR! YOU'LL HEAR FROM MY BOOKER!

AND FOR YOUR INFORMATION, I DO *NOT* HAVE A CRUSH ON AN IMAGINARY CHAMPION...

...HE'S *REAL,* YOU QUACK!

HI, GLORIA.

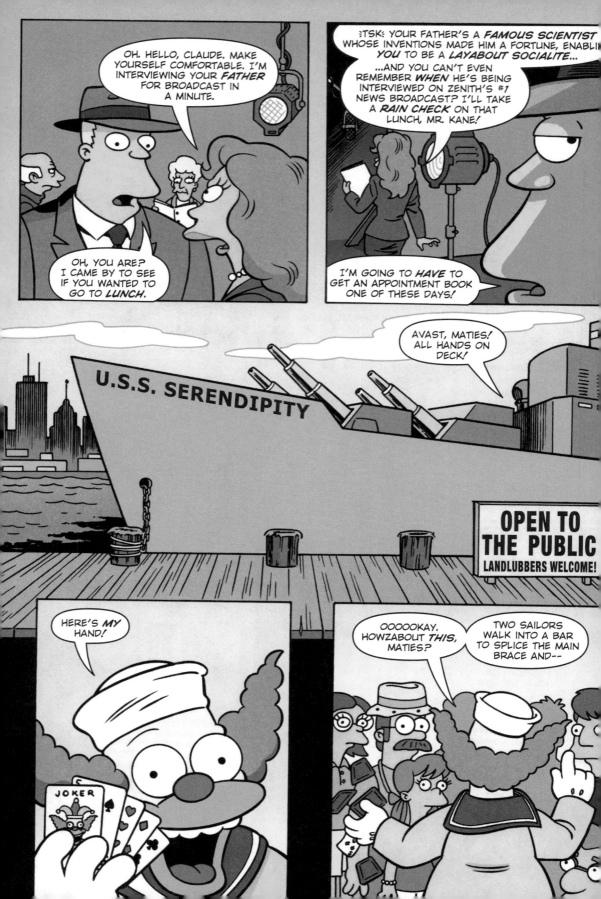

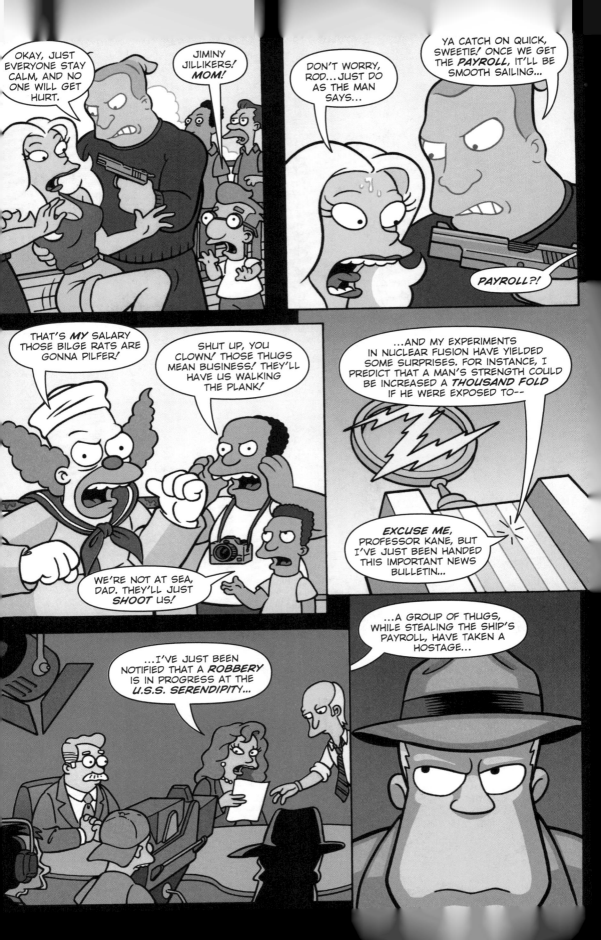

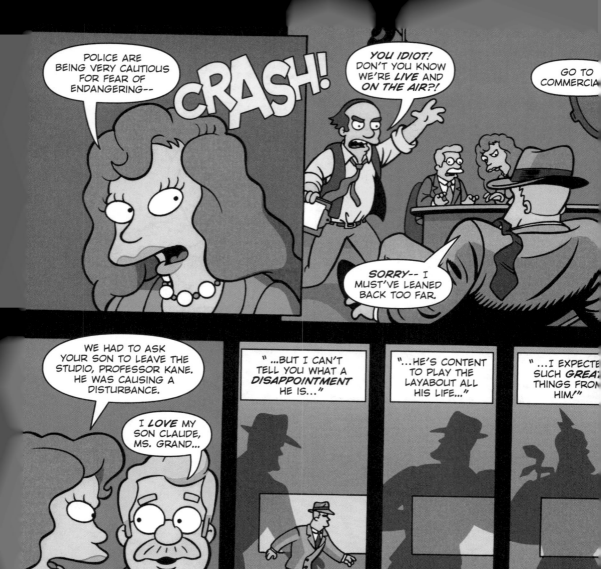

POLICE ARE BEING VERY CAUTIOUS FOR FEAR OF ENDANGERING--

CRASH!

YOU IDIOT! DON'T YOU KNOW WE'RE *LIVE* AND *ON THE AIR*?!

GO TO COMMERCIA

SORRY-- I MUST'VE LEANED BACK TOO FAR.

WE HAD TO ASK YOUR SON TO LEAVE THE STUDIO, PROFESSOR KANE. HE WAS CAUSING A DISTURBANCE.

I *LOVE* MY SON CLAUDE, MS. GRAND...

"...BUT I CAN'T TELL YOU WHAT A *DISAPPOINTMENT* HE IS..."

"...HE'S CONTENT TO PLAY THE LAYABOUT ALL HIS LIFE..."

"...I EXPECTE SUCH *GREA* THINGS FROM HIM!"

NOW HEAR THIS, ME HEARTIES...

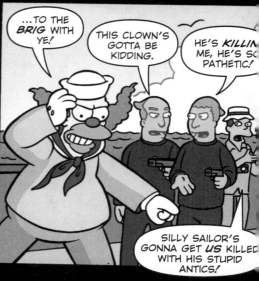

...TO THE *BRIG* WITH YE!

THIS CLOWN'S GOTTA BE KIDDING.

HE'S *KILLIN* ME, HE'S S PATHETIC!

SILLY SAILOR'S GONNA GET *US* KILLED WITH HIS STUPID ANTICS!

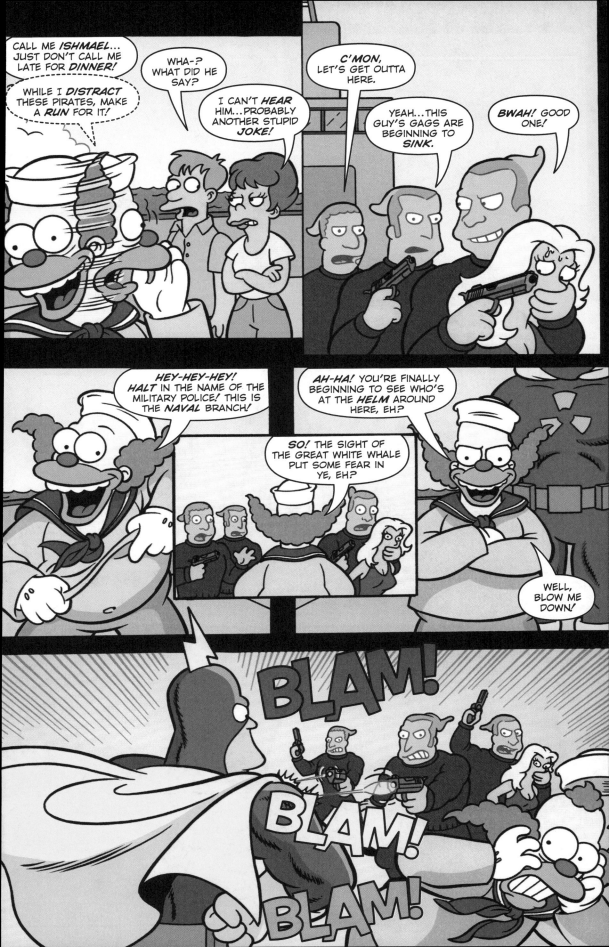

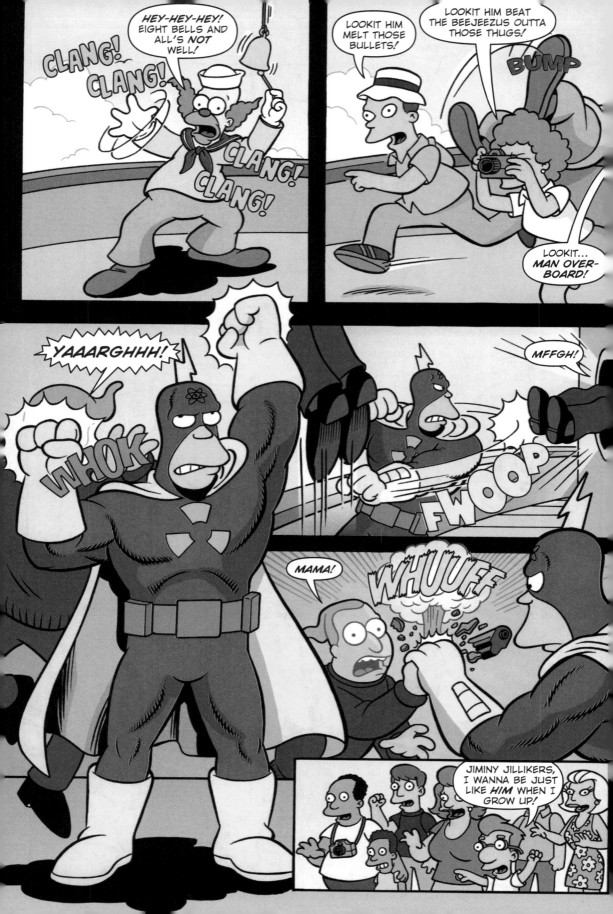

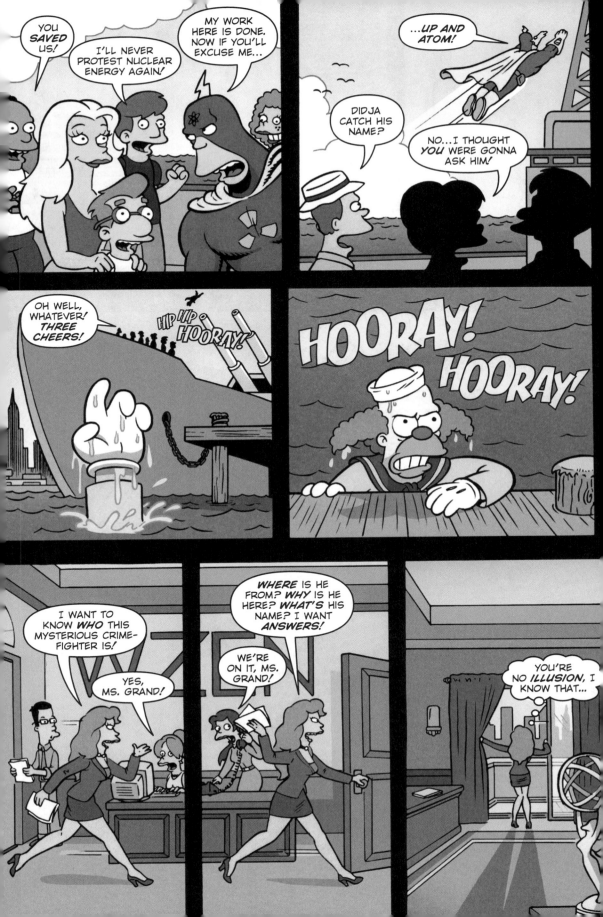

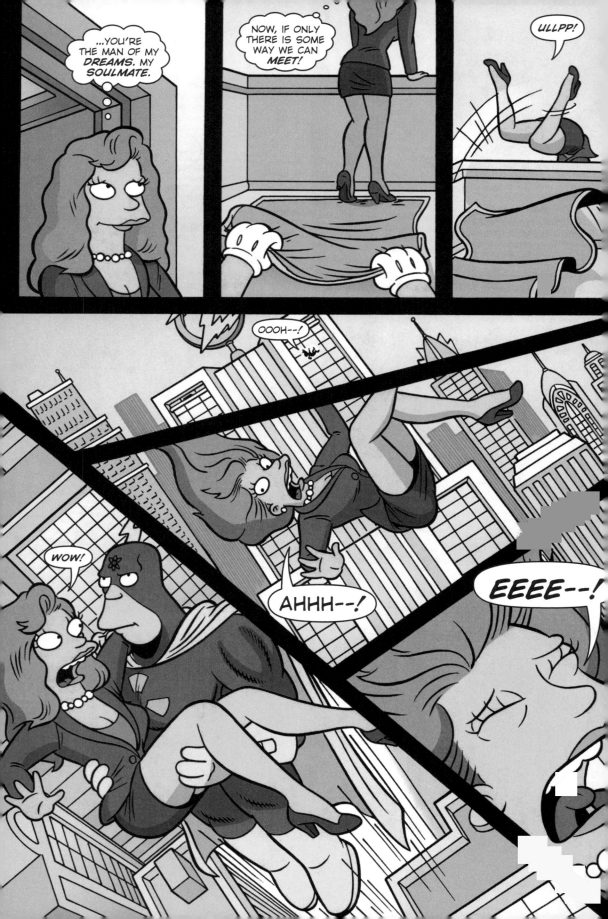

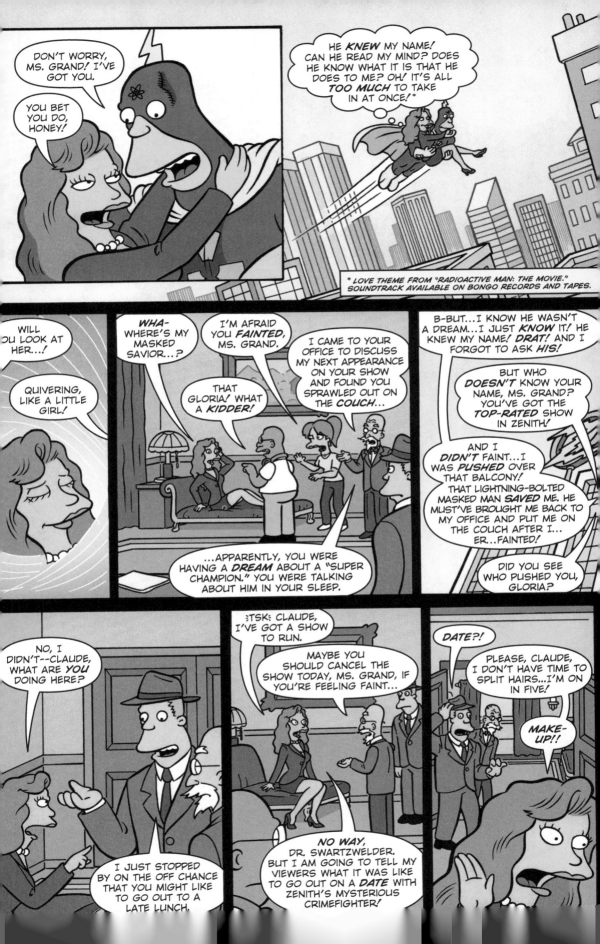

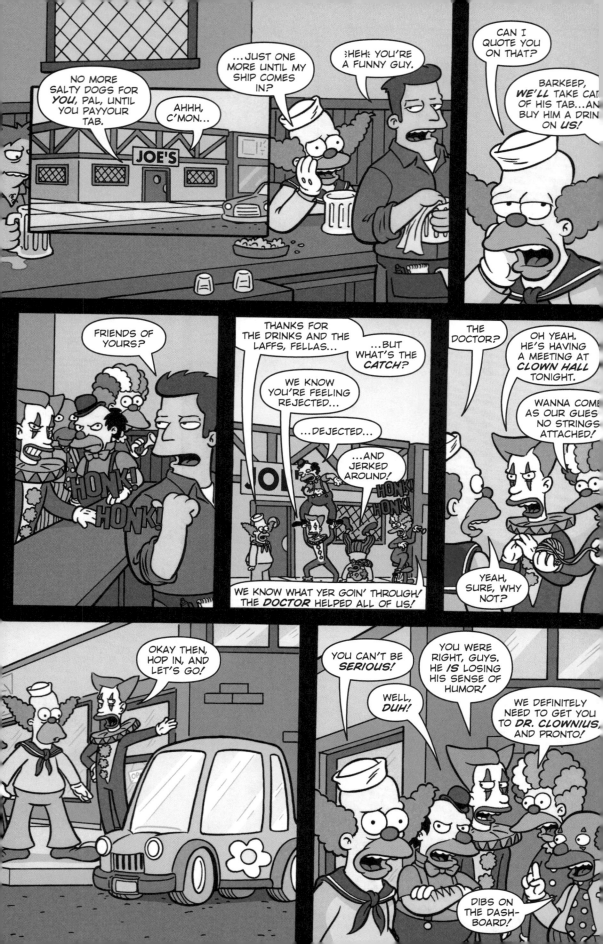

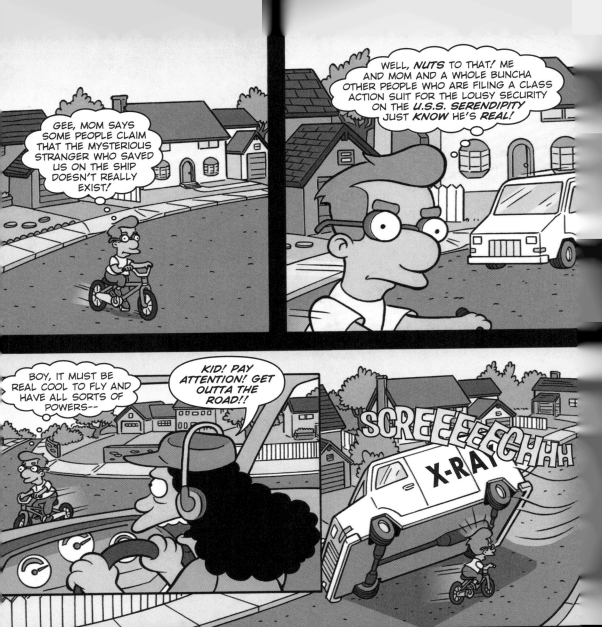

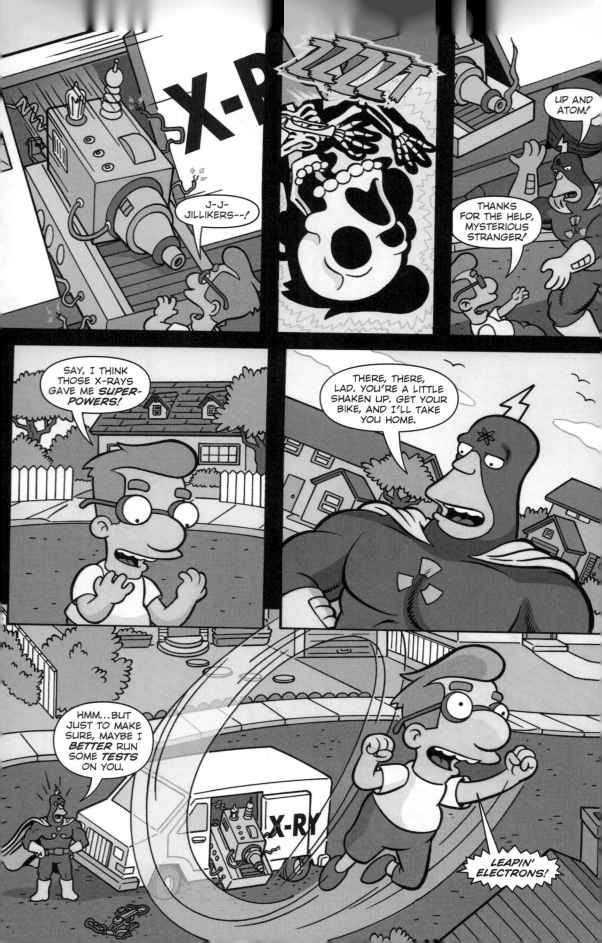

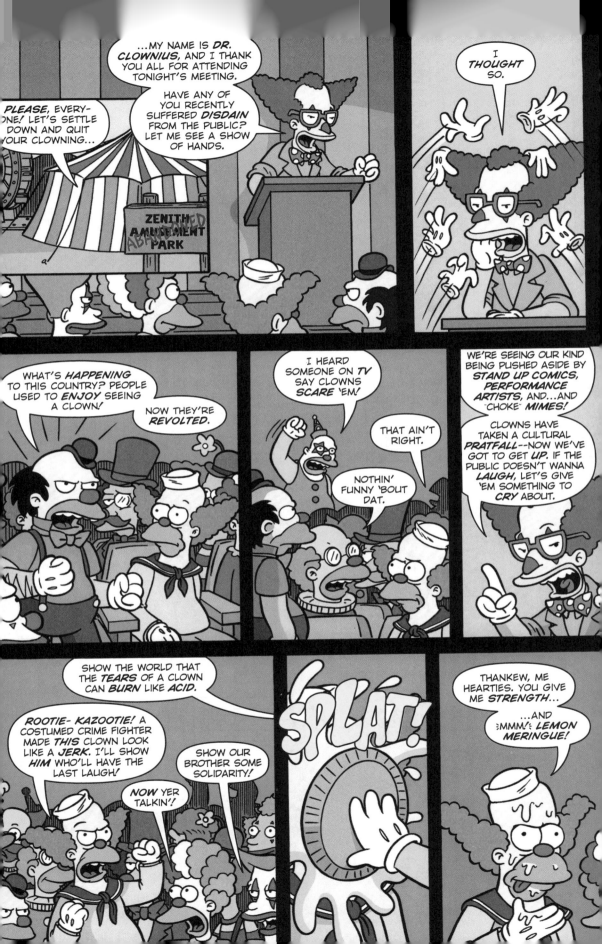

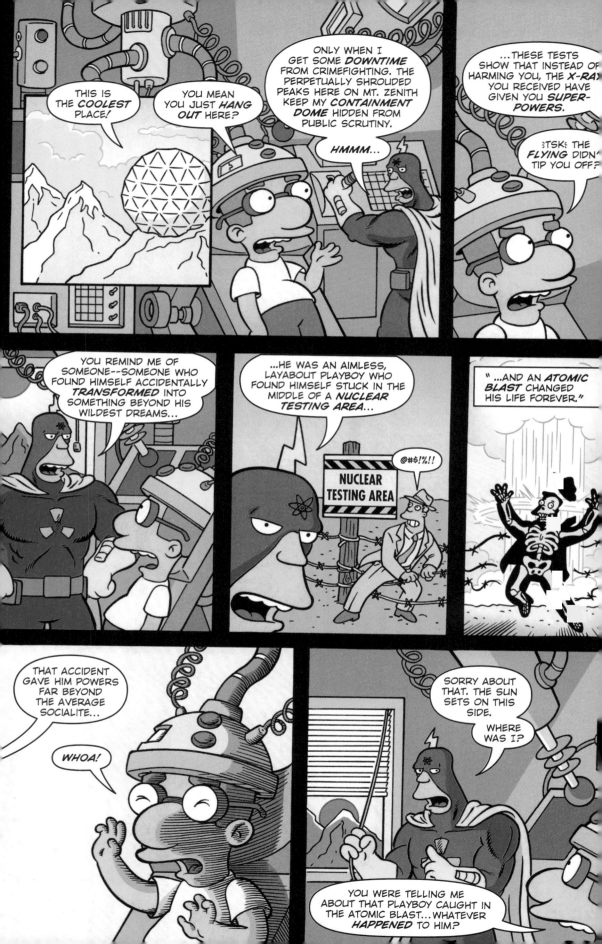

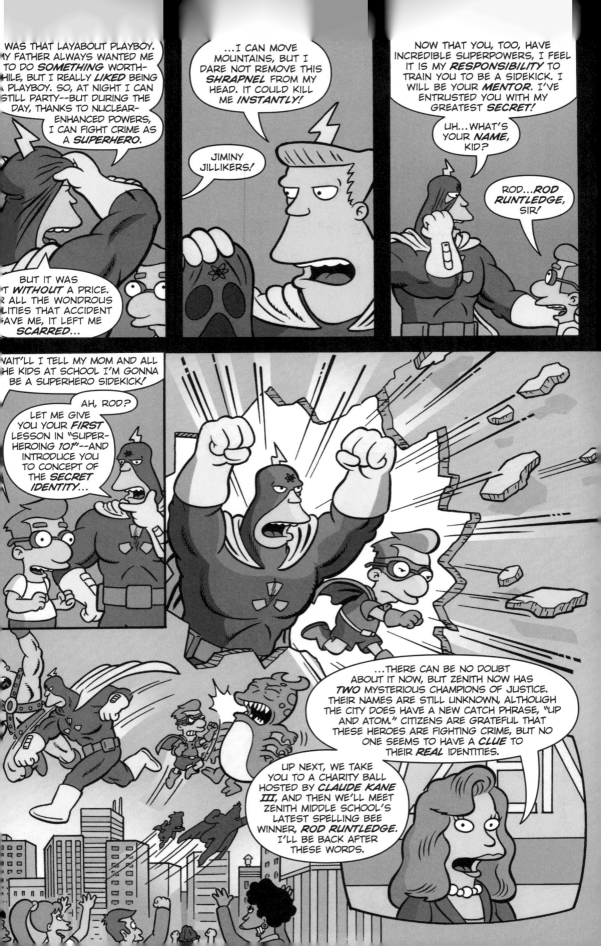

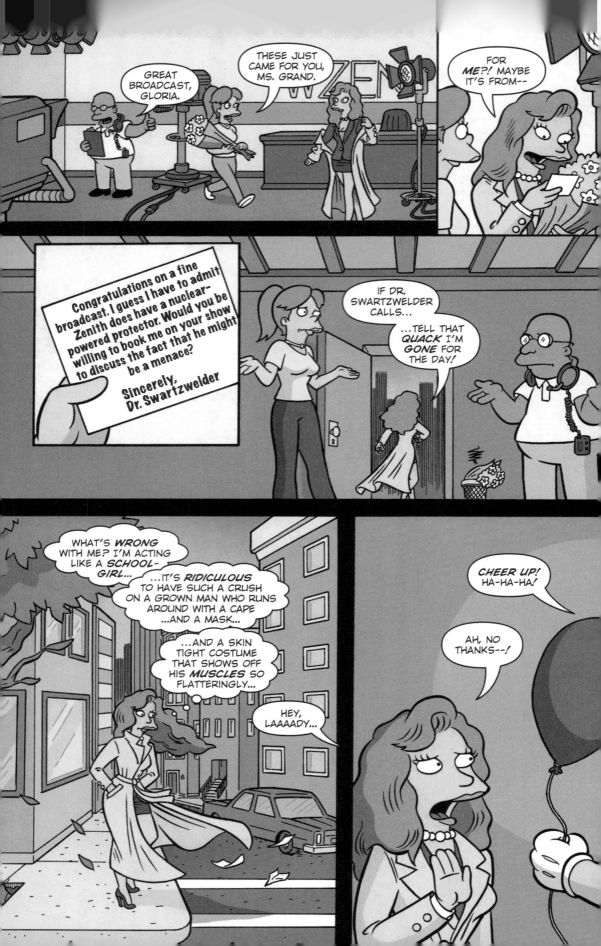

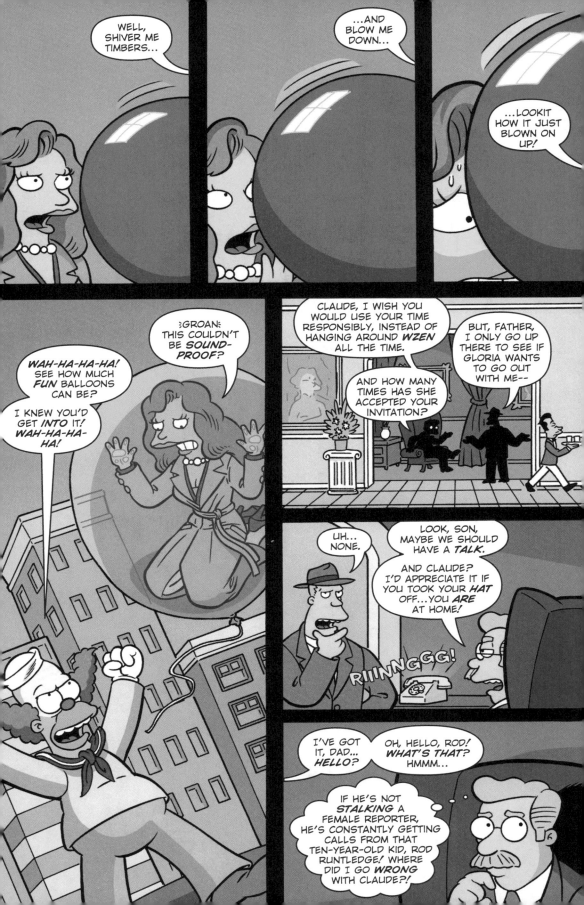

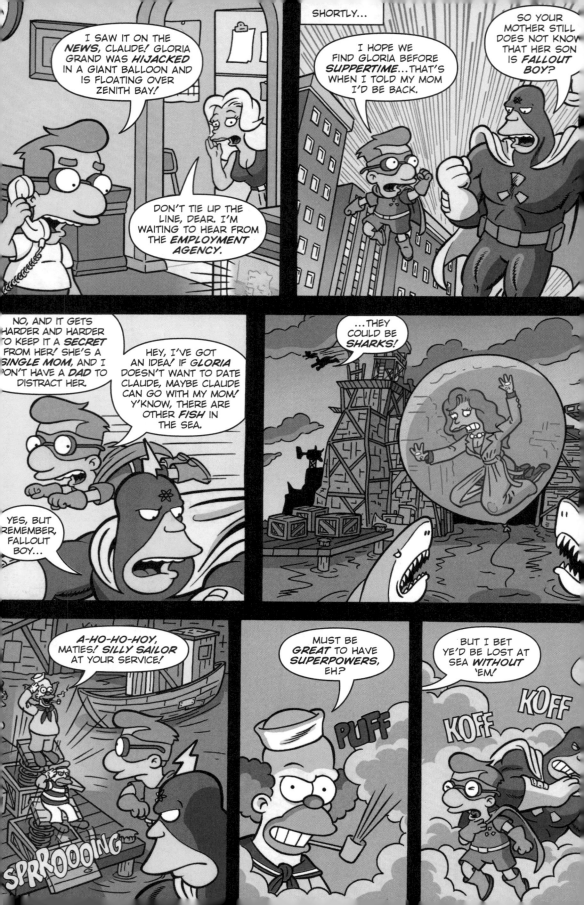

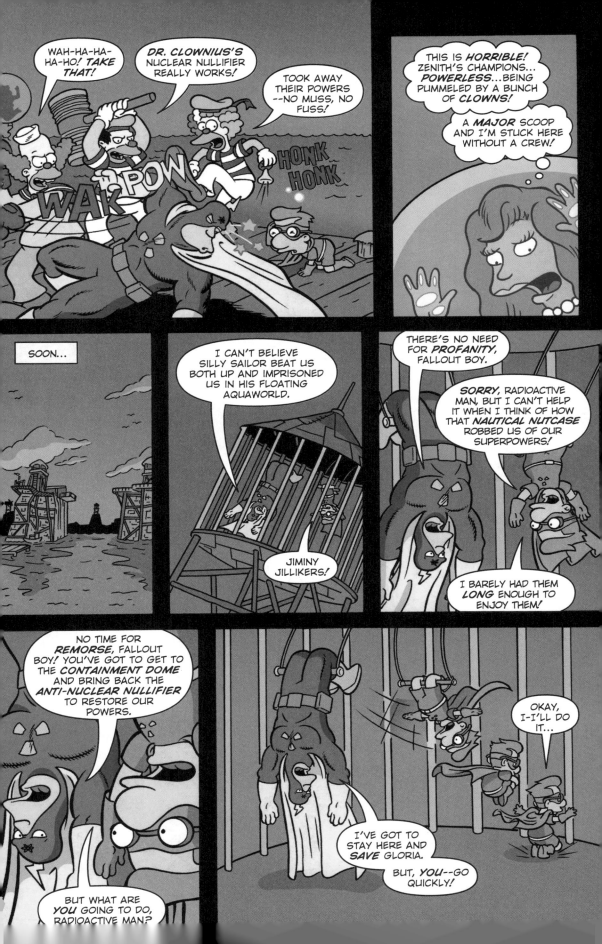

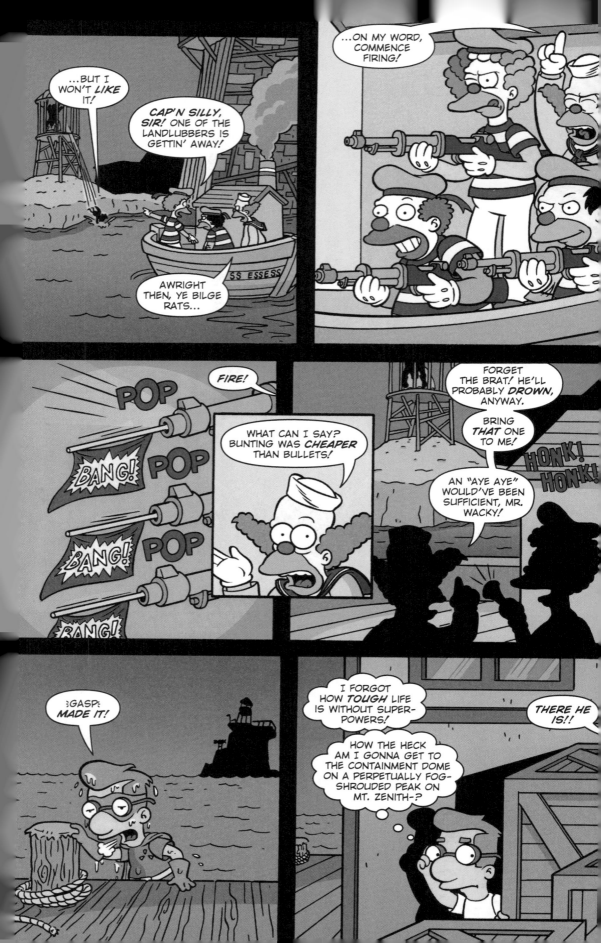

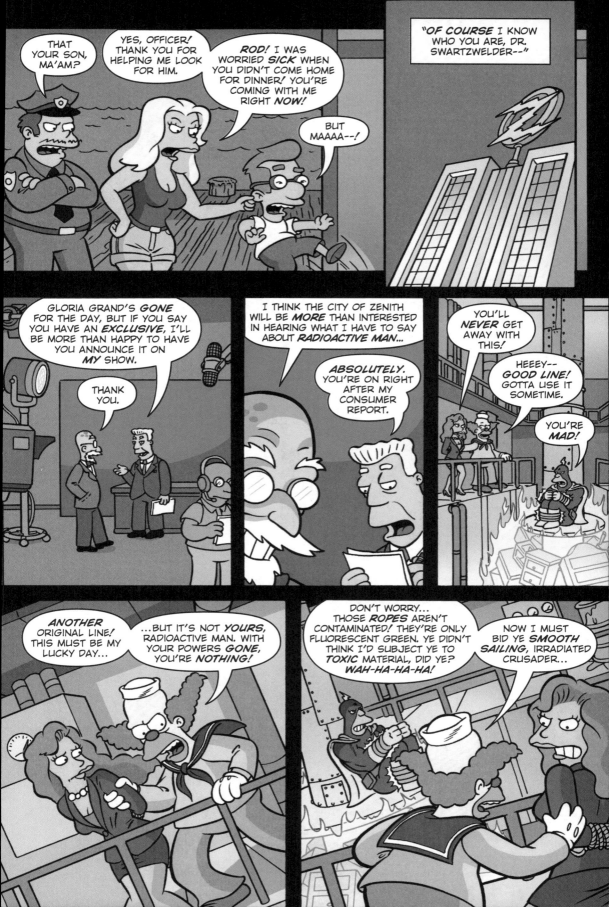

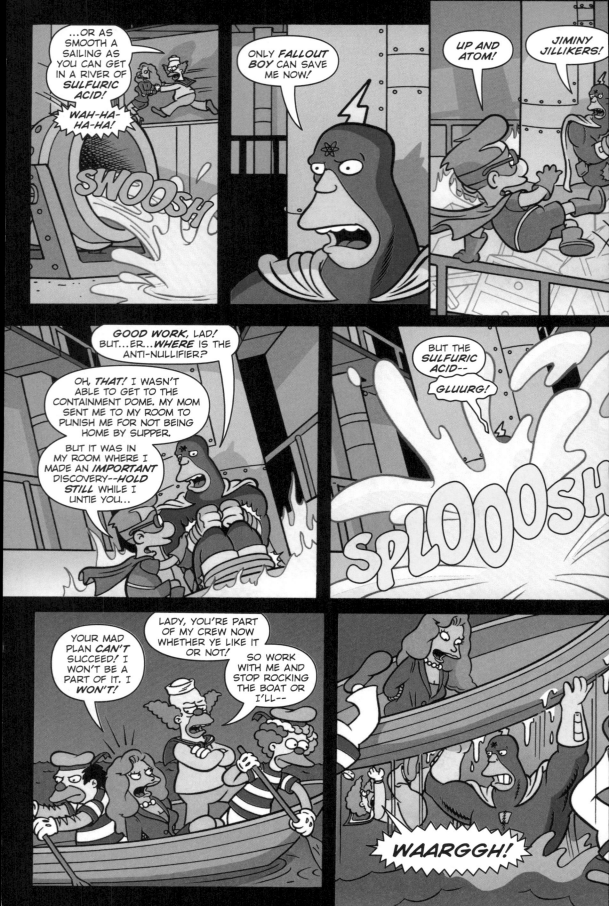

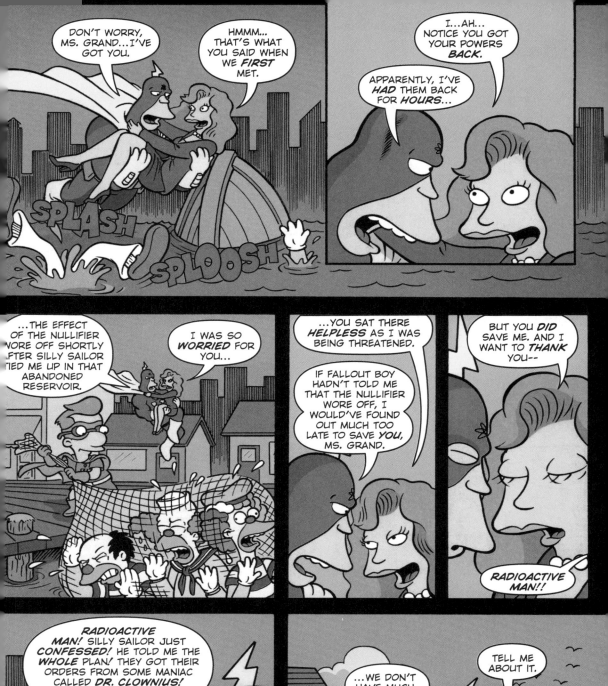

DON'T WORRY, MS. GRAND...I'VE GOT YOU.

HMMM... THAT'S WHAT YOU SAID WHEN WE *FIRST* MET.

SPLASH

SPLOOSH

I...AH... NOTICE YOU GOT YOUR POWERS *BACK.*

APPARENTLY, I'VE *HAD* THEM BACK FOR *HOURS...*

...THE EFFECT OF THE NULLIFIER WORE OFF SHORTLY AFTER SILLY SAILOR TIED ME UP IN THAT ABANDONED RESERVOIR.

I WAS SO *WORRIED* FOR YOU...

...YOU SAT THERE *HELPLESS* AS I WAS BEING THREATENED.

IF FALLOUT BOY HADN'T TOLD ME THAT THE NULLIFIER WORE OFF, I WOULD'VE FOUND OUT MUCH TOO LATE TO SAVE *YOU*, MS. GRAND.

BUT YOU *DID* SAVE ME. AND I WANT TO *THANK* YOU--

RADIOACTIVE MAN!!

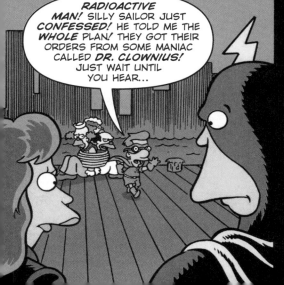

RADIOACTIVE MAN! SILLY SAILOR JUST *CONFESSED!* HE TOLD ME THE *WHOLE* PLAN! THEY GOT THEIR ORDERS FROM SOME MANIAC CALLED *DR. CLOWNIUS!* JUST WAIT UNTIL YOU HEAR...

...WE DON'T HAVE MUCH *TIME!*

TELL ME ABOUT IT.

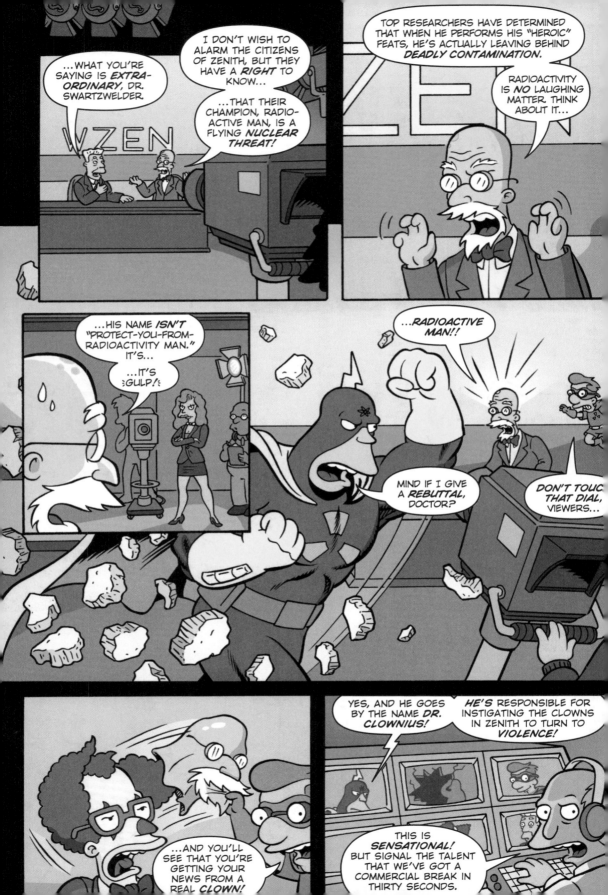

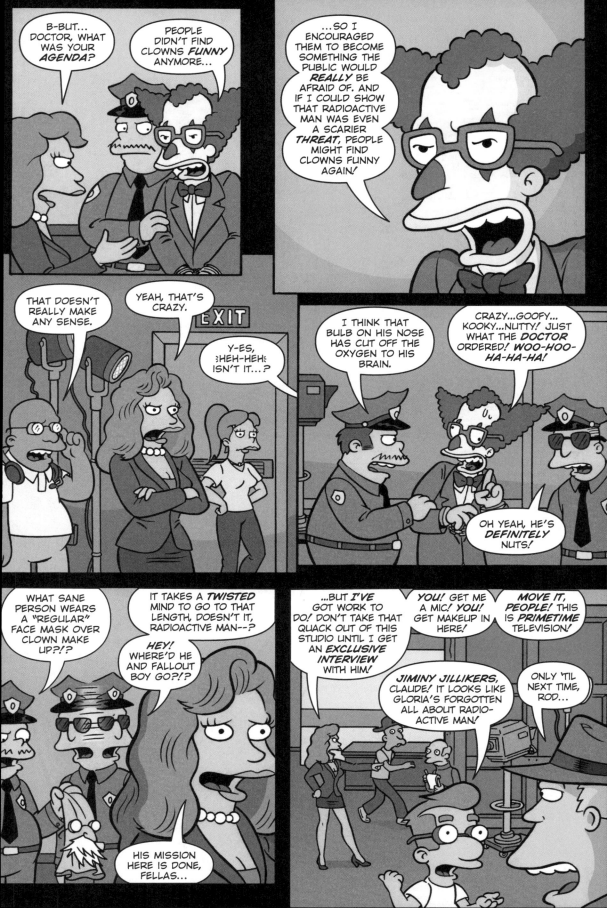

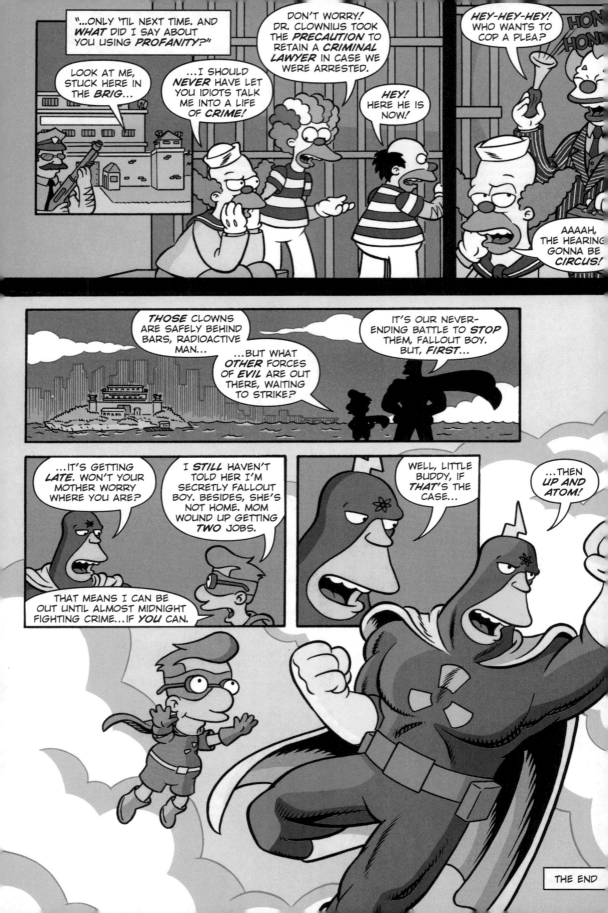

THE END

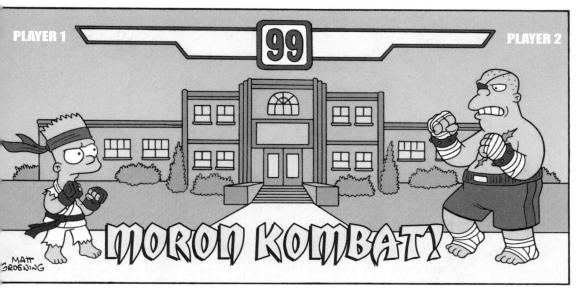

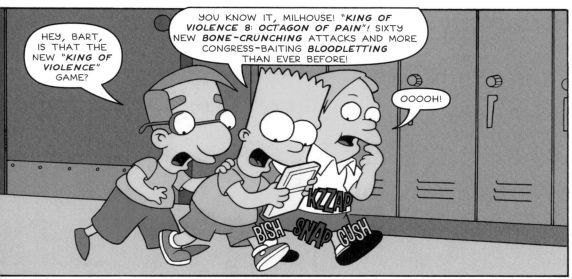

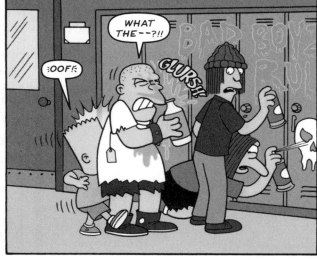

EVAN DORKIN
SCRIPT

PHIL ORTIZ
PENCILS

SHANE GLINES
INKS

RICK REESE
COLORS

KAREN BATES
LETTERS

BILL MORRISON
EDITOR

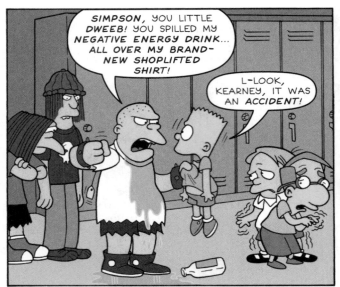

SIMPSON, YOU LITTLE *DWEEB!* YOU SPILLED MY *NEGATIVE ENERGY DRINK...* ALL OVER MY BRAND-NEW SHOPLIFTED SHIRT!

L-LOOK, KEARNEY, IT WAS AN *ACCIDENT!*

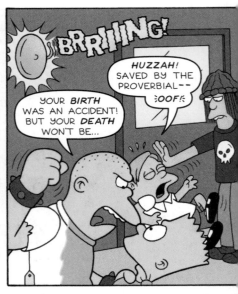

BRRIIING!

HUZZAH! SAVED BY THE PROVERBIAL-- {OOF{

YOUR *BIRTH* WAS AN ACCIDENT! BUT YOUR *DEATH* WON'T BE...

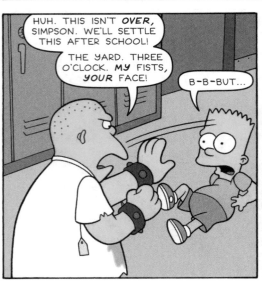

HUH. THIS ISN'T *OVER,* SIMPSON. WE'LL SETTLE THIS AFTER SCHOOL!

THE YARD. THREE O'CLOCK. *MY* FISTS, *YOUR* FACE!

B-B-BUT...

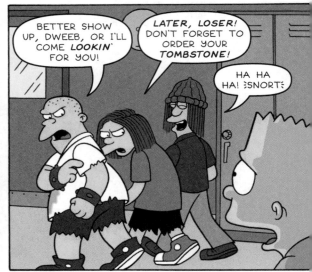

BETTER SHOW UP, DWEEB, OR I'LL COME *LOOKIN'* FOR YOU!

LATER, LOSER! DON'T FORGET TO ORDER YOUR *TOMBSTONE!*

HA HA HA! {SNORT{

OH, *MAN!* WHAT AM I GONNA DO?

MY GUESS IS YOU'RE GOING TO BE *HORRIFICALLY MANGLED* BY A SCHOOLYARD *PSYCHOPATH,* SPORTING *FISTS* THE SIZE OF *HAMS.*

THANKS FOR THE PEP TALK, MARTIN.

DON'T WORRY, BART. I'M SURE YOU'LL THINK UP AN AWESOME PLAN TO GET OUT OF IT.

HEY, THAT'S *RIGHT!* I'M BART SIMPSON! I CAN WEASEL OUT OF ANYTHING! I JUST GOTTA STAY COOL, STAY *POSITIVE!* WHICH MEANS I GOTTA TRY NOT TO THINK ABOUT WHAT MIGHT HAPPEN IF KEARNEY GETS HIS MITTS ON ME!

...BUT AS I'M *SURE* YOU ALL SAW IN THE MOVIE *300,* ULTIMATELY THE *SMALL* GROUP OF PLUCKY SPARTAN DEFENDERS WERE *ALL KILLED* FIGHTING THE FAR *LARGER* AND MORE *POWERFUL* PERSIAN ARMY AT THERMOPYLAE...

WORLD HISTORY

NOW WITH EVEN 20% U.S. CULPABILITY!

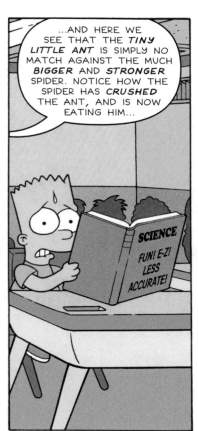

...AND HERE WE SEE THAT THE *TINY LITTLE ANT* IS SIMPLY NO MATCH AGAINST THE MUCH *BIGGER* AND *STRONGER* SPIDER. NOTICE HOW THE SPIDER HAS *CRUSHED* THE ANT, AND IS NOW EATING HIM...

SCIENCE

FUN! E-Z! LESS ACCURATE!

...HOWEVER, UNLIKE IN DAVID AND GOLIATH, THE DIMINUTIVE HERO OF OUR STORY IS *DEFEATED* BY HIS *OVERSIZED OPPONENT,* WHO BEATS HIM UP *SO* BADLY THAT EVEN THE *CORONER TOSSES HIS COOKIES...*

DANGLING PARTICIPLES
CONJUNCTIONS
PRONOUNS
POSSESSIVE

ENGLISH AS A FIRST LANGUAGE: REALLY SHORT STORIES WITH SIMPLE WORDS

The Springfield Shopper

BELOVED BOY TRICKSTER SILENCED, SPRINGFIELD WEEPS

"I LOVED HIM LIKE A SON".

R.I.P.
BART SIMPSON

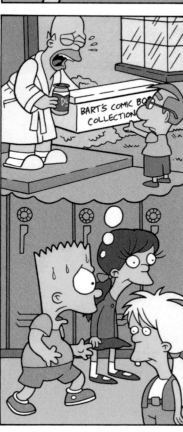

BART'S COMIC BOOK COLLECTION

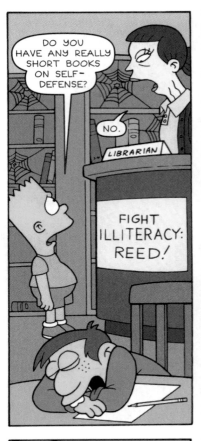
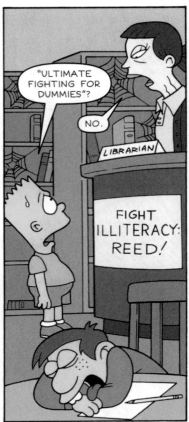
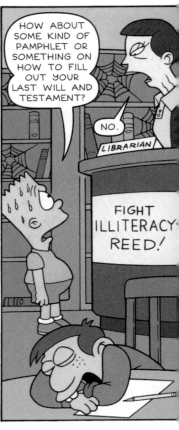
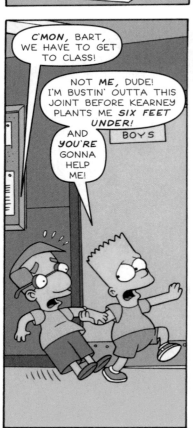
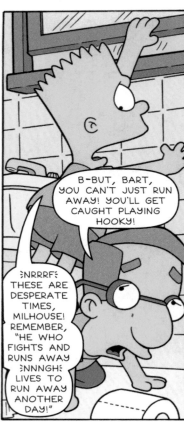
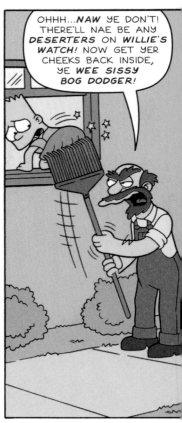

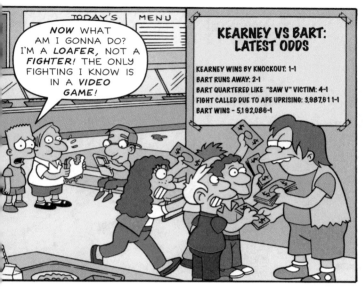

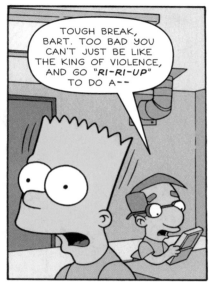

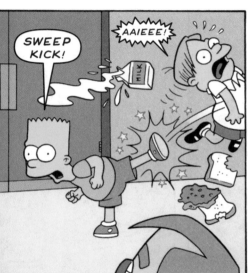

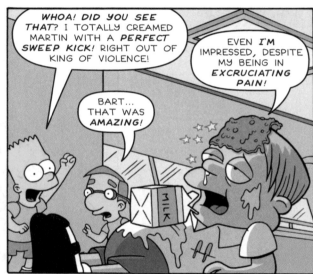

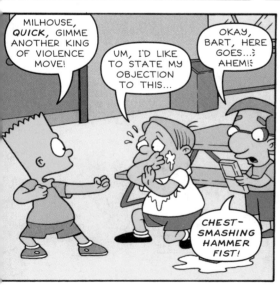

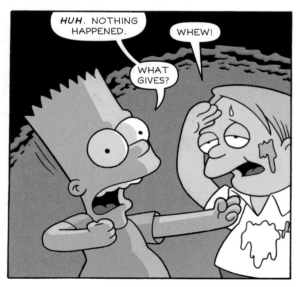

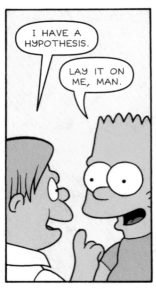

I HAVE A HYPOTHESIS.

LAY IT ON ME, MAN.

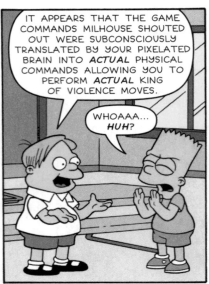

IT APPEARS THAT THE GAME COMMANDS MILHOUSE SHOUTED OUT WERE SUBCONSCIOUSLY TRANSLATED BY YOUR PIXELATED BRAIN INTO *ACTUAL* PHYSICAL COMMANDS ALLOWING YOU TO PERFORM *ACTUAL* KING OF VIOLENCE MOVES.

WHOAAA... *HUH?*

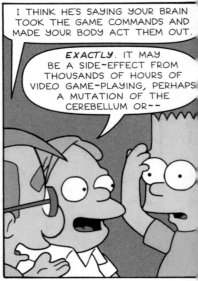

I THINK HE'S SAYING YOUR BRAIN TOOK THE GAME COMMANDS AND MADE YOUR BODY ACT THEM OUT.

EXACTLY. IT MAY BE A SIDE-EFFECT FROM THOUSANDS OF HOURS OF VIDEO GAME-PLAYING, PERHAPS A MUTATION OF THE CEREBELLUM OR--

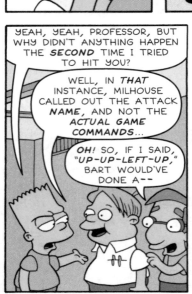

YEAH, YEAH, PROFESSOR, BUT WHY DIDN'T ANYTHING HAPPEN THE *SECOND* TIME I TRIED TO HIT YOU?

WELL, IN *THAT* INSTANCE, MILHOUSE CALLED OUT THE ATTACK *NAME*, AND NOT THE *ACTUAL GAME COMMANDS...*

OH! SO, IF I SAID, "*UP-UP-LEFT-UP*," BART WOULD'VE DONE A--

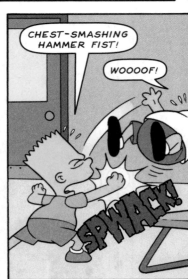

CHEST-SMASHING HAMMER FIST!

WOOOOF!

SPWACK!

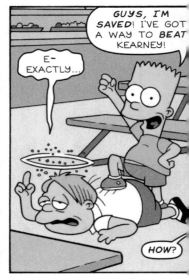

GUYS, I'M SAVED! I'VE GOT A WAY TO *BEAT* KEARNEY!

E-EXACTLY...

HOW?

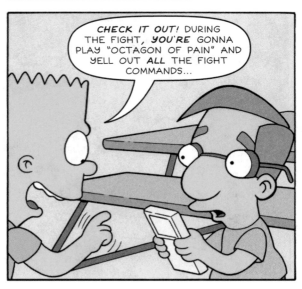

CHECK IT OUT! DURING THE FIGHT, *YOU'RE* GONNA PLAY "OCTAGON OF PAIN" AND YELL OUT *ALL* THE FIGHT COMMANDS...

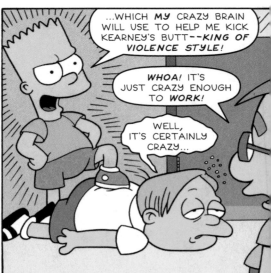

...WHICH *MY* CRAZY BRAIN WILL USE TO HELP ME KICK KEARNEY'S BUTT--*KING OF VIOLENCE STYLE!*

WHOA! IT'S JUST CRAZY ENOUGH TO *WORK!*

WELL, IT'S CERTAINLY CRAZY...

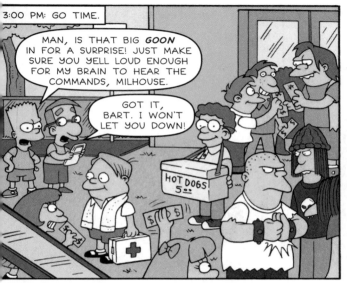

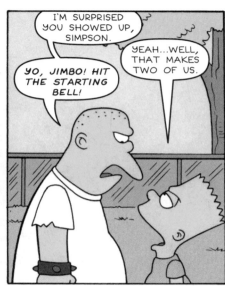

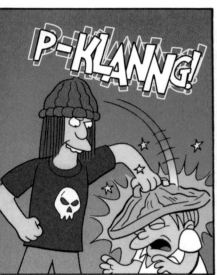

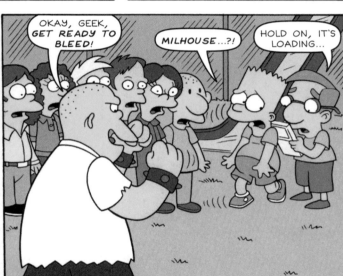

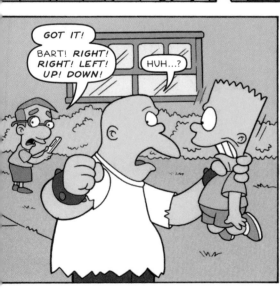

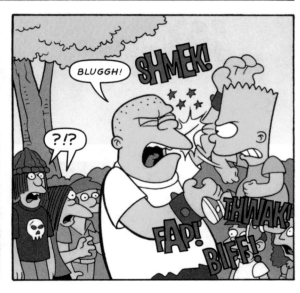

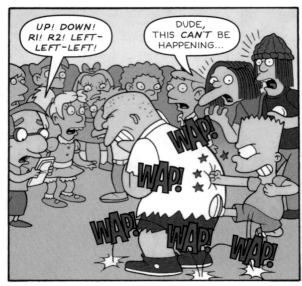

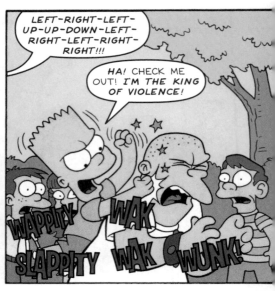

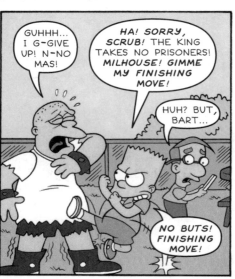

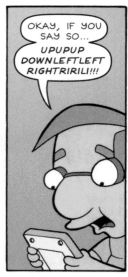

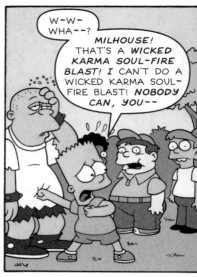

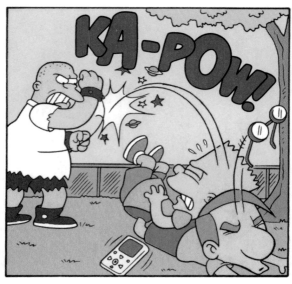

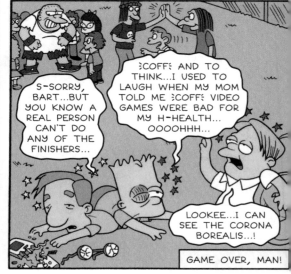

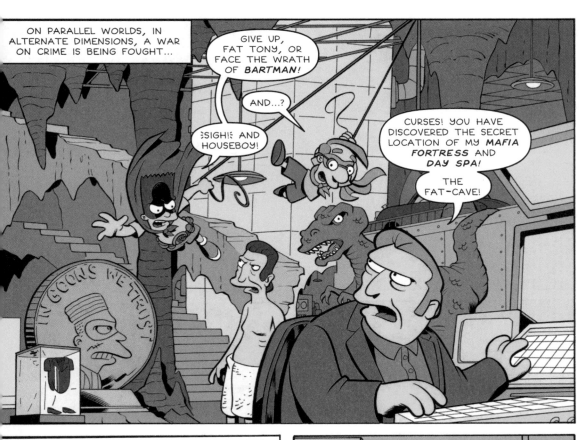

ON PARALLEL WORLDS, IN ALTERNATE DIMENSIONS, A WAR ON CRIME IS BEING FOUGHT...

GIVE UP, FAT TONY, OR FACE THE WRATH OF *BARTMAN!*

AND...?

:SIGH!: AND HOUSEBOY!

CURSES! YOU HAVE DISCOVERED THE SECRET LOCATION OF MY *MAFIA FORTRESS* AND *DAY SPA!*

THE FAT-CAVE!

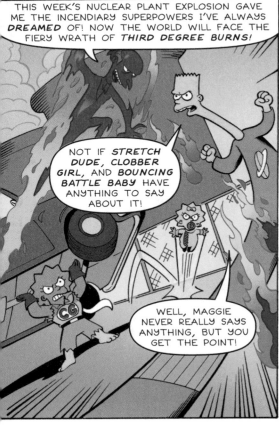

THIS WEEK'S NUCLEAR PLANT EXPLOSION GAVE ME THE INCENDIARY SUPERPOWERS I'VE ALWAYS *DREAMED* OF! NOW THE WORLD WILL FACE THE FIERY WRATH OF *THIRD DEGREE BURNS!*

NOT IF *STRETCH DUDE, CLOBBER GIRL,* AND *BOUNCING BATTLE BABY* HAVE ANYTHING TO SAY ABOUT IT!

WELL, MAGGIE NEVER REALLY SAYS ANYTHING, BUT YOU GET THE POINT!

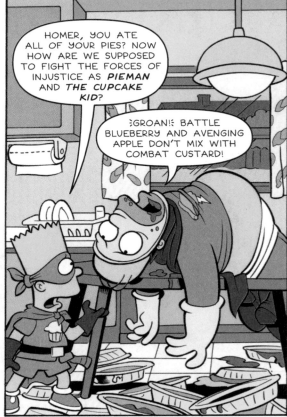

HOMER, YOU ATE ALL OF YOUR PIES? NOW HOW ARE WE SUPPOSED TO FIGHT THE FORCES OF INJUSTICE AS *PIEMAN* AND *THE CUPCAKE KID?*

:GROAN!: BATTLE BLUEBERRY AND AVENGING APPLE DON'T MIX WITH COMBAT CUSTARD!

THEN SUDDENLY, AS IF IN ORDER TO MOVE THE PLOT ALONG...

WHAT...

HEY, WHERE ARE YOU *GOING*? CAN I COME?

ZAP!

THE...

ZAP!

HECK?!!

ZAP!

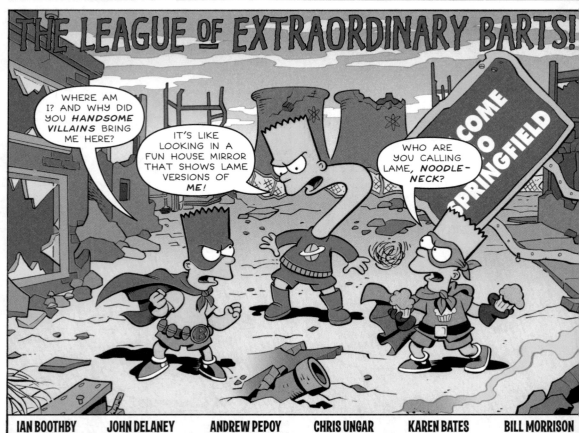

THE LEAGUE OF EXTRAORDINARY BARTS!

WHERE AM I? AND WHY DID YOU *HANDSOME VILLAINS* BRING ME HERE?

IT'S LIKE LOOKING IN A FUN HOUSE MIRROR THAT SHOWS LAME VERSIONS OF *ME!*

WHO ARE YOU CALLING LAME, *NOODLE-NECK?*

WELCOME TO SPRINGFIELD

IAN BOOTHBY
SCRIPT

JOHN DELANEY
PENCILS

ANDREW PEPOY
INKS

CHRIS UNGAR
COLORS

KAREN BATES
LETTERS

BILL MORRISON
EDITOR

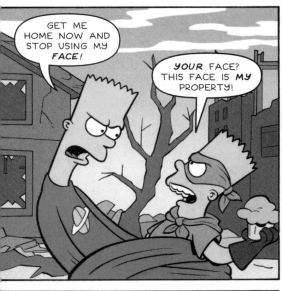

GET ME HOME NOW AND STOP USING MY *FACE!*

YOUR FACE? THIS FACE IS *MY* PROPERTY!

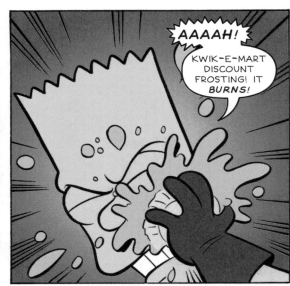

AAAAH!

KWIK-E-MART DISCOUNT FROSTING! IT *BURNS!*

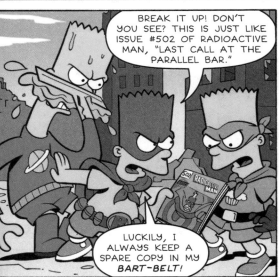

BREAK IT UP! DON'T YOU SEE? THIS IS JUST LIKE ISSUE #502 OF RADIOACTIVE MAN, "LAST CALL AT THE PARALLEL BAR."

LUCKILY, I ALWAYS KEEP A SPARE COPY IN MY *BART-BELT!*

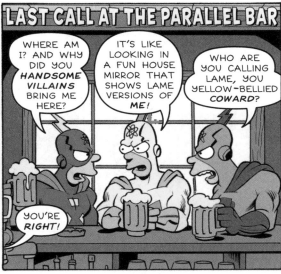

LAST CALL AT THE PARALLEL BAR

WHERE AM I? AND WHY DID YOU *HANDSOME VILLAINS* BRING ME HERE?

IT'S LIKE LOOKING IN A FUN HOUSE MIRROR THAT SHOWS LAME VERSIONS OF *ME!*

WHO ARE YOU CALLING LAME, YOU YELLOW-BELLIED *COWARD?*

YOU'RE *RIGHT!*

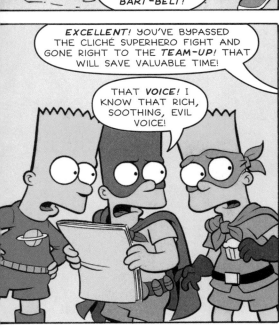

EXCELLENT! YOU'VE BYPASSED THE CLICHÉ SUPERHERO FIGHT AND GONE RIGHT TO THE *TEAM-UP!* THAT WILL SAVE VALUABLE TIME!

THAT *VOICE!* I KNOW THAT RICH, SOOTHING, EVIL VOICE!

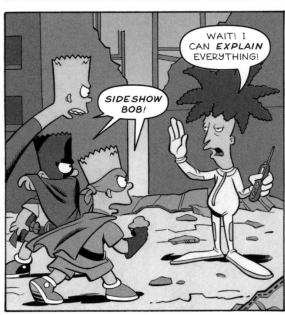

WAIT! I CAN *EXPLAIN* EVERYTHING!

SIDESHOW BOB!

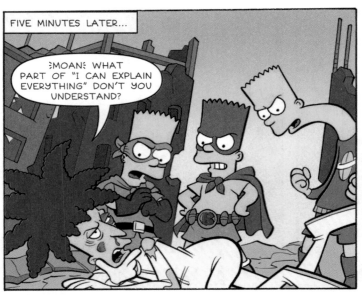

FIVE MINUTES LATER...

MOAN WHAT PART OF "I CAN EXPLAIN EVERYTHING" DON'T YOU UNDERSTAND?

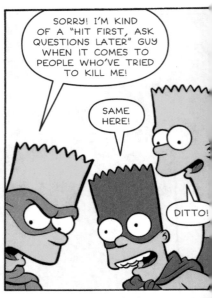

SORRY! I'M KIND OF A "HIT FIRST, ASK QUESTIONS LATER" GUY WHEN IT COMES TO PEOPLE WHO'VE TRIED TO KILL ME!

SAME HERE!

DITTO!

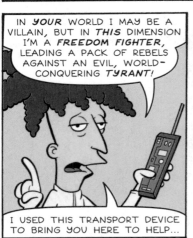

IN *YOUR* WORLD I MAY BE A VILLAIN, BUT IN *THIS* DIMENSION I'M A *FREEDOM FIGHTER*, LEADING A PACK OF REBELS AGAINST AN EVIL, WORLD-CONQUERING *TYRANT*!

I USED THIS TRANSPORT DEVICE TO BRING YOU HERE TO HELP...

WHAM!

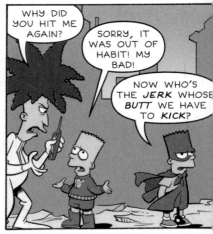

WHY DID YOU HIT ME AGAIN?

SORRY, IT WAS OUT OF HABIT! MY BAD!

NOW WHO'S THE *JERK* WHOSE *BUTT* WE HAVE TO *KICK*?

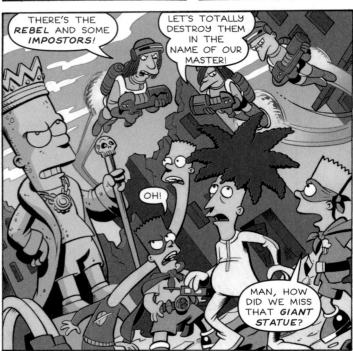

THERE'S THE *REBEL* AND SOME *IMPOSTORS*!

LET'S TOTALLY DESTROY THEM IN THE NAME OF OUR MASTER!

OH!

MAN, HOW DID WE MISS THAT *GIANT STATUE*?

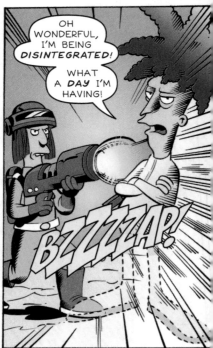

OH WONDERFUL, I'M BEING *DISINTEGRATED*!

WHAT A *DAY* I'M HAVING!

BZZZZAP!

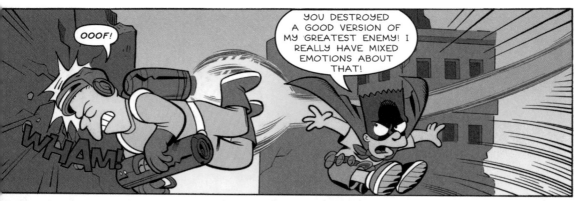

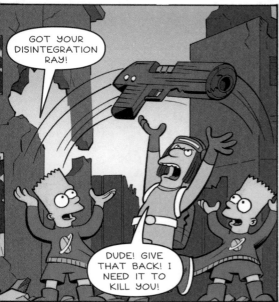

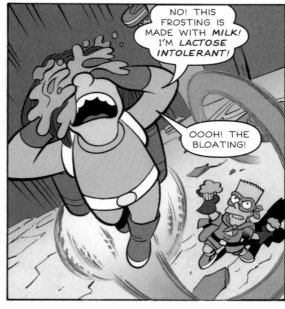

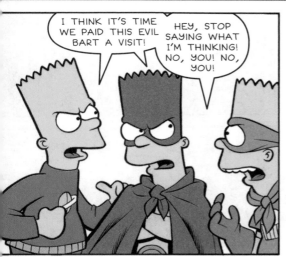

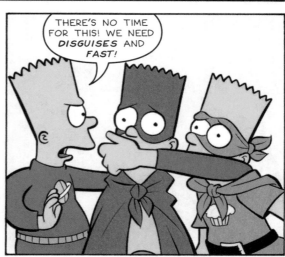

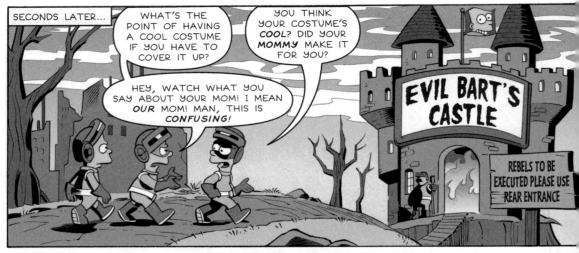

SECONDS LATER...

WHAT'S THE POINT OF HAVING A COOL COSTUME IF YOU HAVE TO COVER IT UP?

YOU THINK YOUR COSTUME'S *COOL*? DID YOUR *MOMMY* MAKE IT FOR YOU?

HEY, WATCH WHAT YOU SAY ABOUT YOUR MOM! I MEAN *OUR* MOM! MAN, THIS IS *CONFUSING*!

EVIL BART'S CASTLE

REBELS TO BE EXECUTED PLEASE USE REAR ENTRANCE

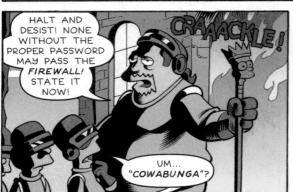

HALT AND DESIST! NONE WITHOUT THE PROPER PASSWORD MAY PASS THE *FIREWALL*! STATE IT NOW!

CRAAACKLE!

UM... *"COWABUNGA"*?

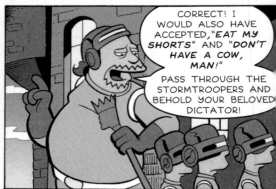

CORRECT! I WOULD ALSO HAVE ACCEPTED, *"EAT MY SHORTS"* AND *"DON'T HAVE A COW, MAN!"*

PASS THROUGH THE STORMTROOPERS AND BEHOLD YOUR BELOVED DICTATOR!

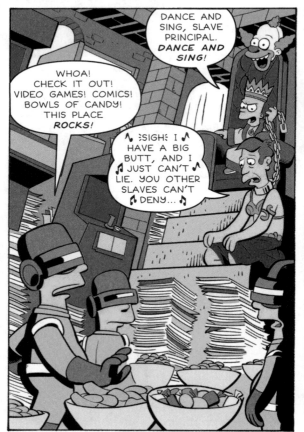

DANCE AND SING, SLAVE PRINCIPAL. *DANCE AND SING!*

WHOA! CHECK IT OUT! VIDEO GAMES! COMICS! BOWLS OF CANDY! THIS PLACE *ROCKS!*

♪ ≍SIGH≍ I ♪ HAVE A BIG BUTT, AND I JUST CAN'T ♪ LIE. YOU OTHER SLAVES CAN'T ♪ DENY... ♪

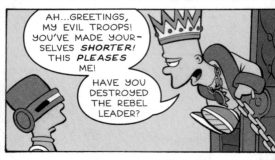

AH...GREETINGS, MY EVIL TROOPS! YOU'VE MADE YOUR- SELVES *SHORTER*! THIS *PLEASES* ME!

HAVE YOU DESTROYED THE REBEL LEADER?

YEAH, WE JUST HAVE ONE MORE PERSON TO STOP, AND THEN WE'RE DONE FOR THE DAY!

WHO?

YOU! *GET HIM!*

WHAT THE--?!

HMMMMMM!

HA HA! I KNEW WHO YOU WERE THE SECOND I SAW YOU AND HEARD YOUR VOICES. YOU CAN'T FOOL *YOURSELF!*

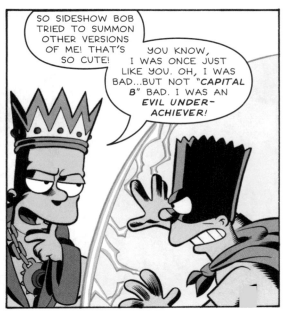

SO SIDESHOW BOB TRIED TO SUMMON OTHER VERSIONS OF ME! THAT'S SO CUTE!

YOU KNOW, I WAS ONCE JUST LIKE YOU. OH, I WAS BAD...BUT NOT "*CAPITAL B*" BAD. I WAS AN *EVIL UNDER-ACHIEVER!*

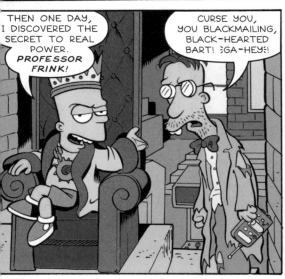

THEN ONE DAY, I DISCOVERED THE SECRET TO REAL POWER. *PROFESSOR FRINK!*

CURSE YOU, YOU BLACKMAILING, BLACK-HEARTED BART! ⋛GA-HEY⋛!

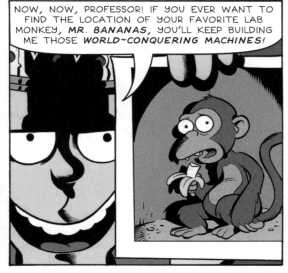

NOW, NOW, PROFESSOR! IF YOU EVER WANT TO FIND THE LOCATION OF YOUR FAVORITE LAB MONKEY, *MR. BANANAS,* YOU'LL KEEP BUILDING ME THOSE *WORLD-CONQUERING MACHINES!*

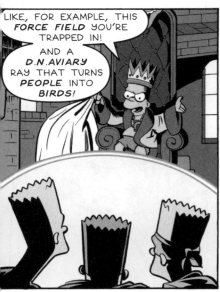

LIKE, FOR EXAMPLE, THIS *FORCE FIELD* YOU'RE TRAPPED IN!

AND A *D.N.AVIARY* RAY THAT TURNS *PEOPLE* INTO *BIRDS!*

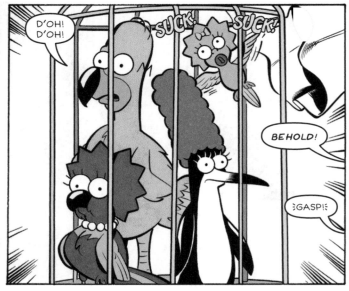

D'OH! D'OH!

SUCK!

SUCK!

BEHOLD!

⋛GASP⋛!

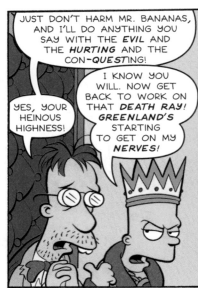

JUST DON'T HARM MR. BANANAS, AND I'LL DO ANYTHING YOU SAY WITH THE *EVIL* AND THE *HURTING* AND THE CON-*QUESTING*!

YES, YOUR HEINOUS HIGHNESS!

I KNOW YOU WILL. NOW GET BACK TO WORK ON THAT *DEATH RAY*! *GREENLAND'S* STARTING TO GET ON MY *NERVES*!

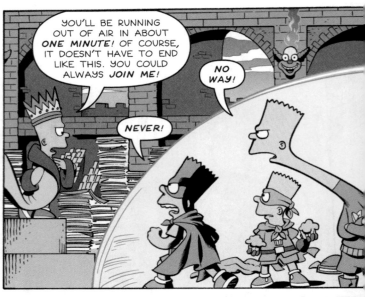

YOU'LL BE RUNNING OUT OF AIR IN ABOUT *ONE MINUTE*! OF COURSE, IT DOESN'T HAVE TO END LIKE THIS. YOU COULD ALWAYS *JOIN ME*!

NO WAY!

NEVER!

YEAH, OKAY I'M *IN*!

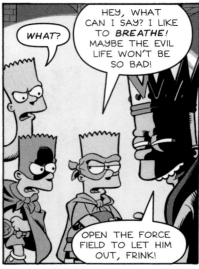

WHAT?

HEY, WHAT CAN I SAY? I LIKE TO *BREATHE*! MAYBE THE EVIL LIFE WON'T BE SO BAD!

OPEN THE FORCE FIELD TO LET HIM OUT, FRINK!

CAN I GET A TOUR OF YOUR FORTRESS?

SURE, WANNA SEE THE *DUNGEON*?

DO *I*?!

I CAN'T BELIEVE IT. MAN, I'M REALLY DISAPPOINTED IN MYSELF! WELL, MY OTHER SELF! AAAH! THIS REALLY *IS* CONFUSING!

HE DROPPED A *CUPCAKE*. MAYBE IT'S GOT SOME EXTRA AIR IN IT!

IT'S A DIVERSION DUMMIES!

OOOOH!

AND THESE ARE MY *SLAVES!* IF THEY DON'T WORK HARD ENOUGH, THE COLLARS *EXPLODE,* AND IT KEEPS THEM FROM FORMING A *UNION!* WHO NEEDS THAT PAPERWORK? AM I *RIGHT?!*

MOAN FOR MY NEW FRIEND, WILL YOU, SLAVES?

MOOOOOAN! GROOOOOAN!

HEY, FRINK! C'MON! LET US OUT!

I CAN'T UNTIL I FIND MY MONKEY!

YOU MEAN, *THIS* MONKEY?

MR. BANANAS! WHAT HAVE THEY DONE TO YOU WITH ALL THE *TECHNI-COLOR!* SWEET ⸢GLAVIN!⸣

CLICK!

THANKS, *FRINKY!*

⸢GA-HOYVEN!⸣

WE *OWE* YOU ONE!

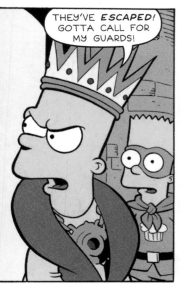

THEY'VE *ESCAPED!* GOTTA CALL FOR MY GUARDS!

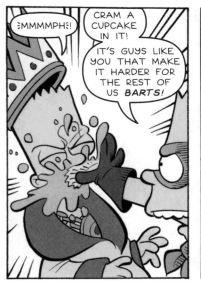

⸢MMMMPH!⸣

CRAM A CUPCAKE IN IT!

IT'S GUYS LIKE YOU THAT MAKE IT HARDER FOR THE REST OF US *BARTS!*

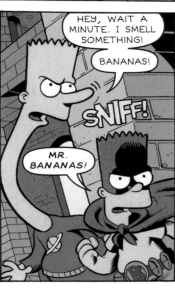

HEY, WAIT A MINUTE. I SMELL SOMETHING!

BANANAS!

SNIFF!

MR. BANANAS!

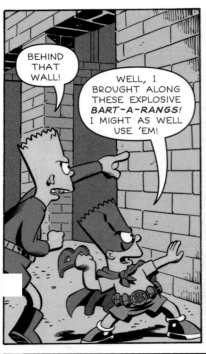

BEHIND THAT WALL!

WELL, I BROUGHT ALONG THESE EXPLOSIVE *BART-A-RANGS!* I MIGHT AS WELL USE 'EM!

BLAM-O!

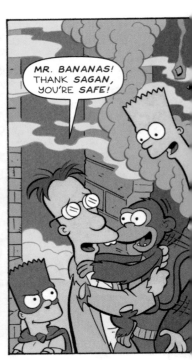

MR. BANANAS! THANK *SAGAN,* YOU'RE *SAFE!*

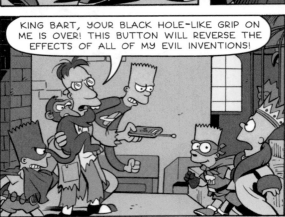

KING BART, YOUR BLACK HOLE-LIKE GRIP ON ME IS OVER! THIS BUTTON WILL REVERSE THE EFFECTS OF ALL OF MY EVIL INVENTIONS!

CLICK! CLICK!

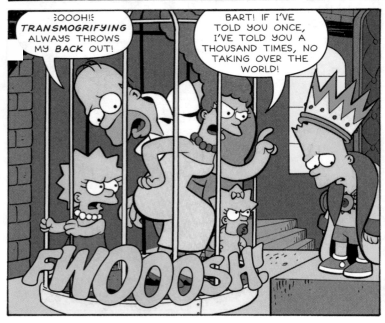

¡OOOH!¡ *TRANSMOGRIFYING* ALWAYS THROWS MY *BACK* OUT!

BART! IF I'VE TOLD YOU ONCE, I'VE TOLD YOU A THOUSAND TIMES, NO TAKING OVER THE WORLD!

FWOOOSH

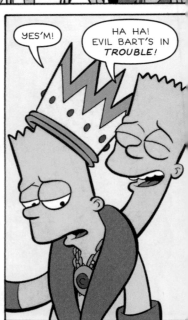

YES'M!

HA HA! EVIL BART'S IN *TROUBLE!*

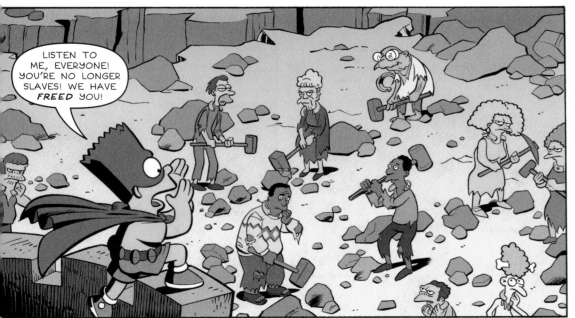

LISTEN TO ME, EVERYONE! YOU'RE NO LONGER SLAVES! WE HAVE *FREED* YOU!

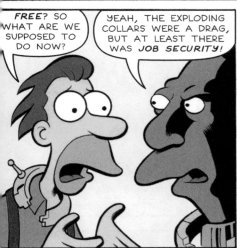

FREE? SO WHAT ARE WE SUPPOSED TO DO NOW?

YEAH, THE EXPLODING COLLARS WERE A DRAG, BUT AT LEAST THERE WAS *JOB SECURITY!*

WHO'S UP FOR STORMING THE FORTRESS, TRASHING THE JOINT, AND STEALING STUFF?

YEAH!

GU-OOOH!

ACCORDING TO MY CALCULATIONS, THE EFFECTS OF THE INTERDIMENSIONAL TRANSPORT DEVICE SHOULD WEAR OFF IN THIRTY SECONDS, RETURNING THE THREE OF YOU TO YOUR OWN DIMENSIONS!

THIS WAS *FUN!* LISTEN, MAYBE WE CAN *TEAM-UP* AGAIN SOME TIME!

SURE, YOU COULD BOTH USE SOME *POINTERS* FROM THE *REAL DEAL!*

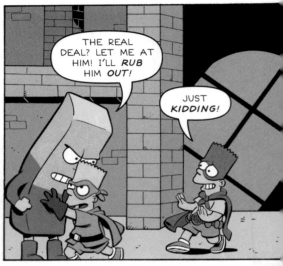

THE *REAL DEAL?* LET ME AT HIM! I'LL *RUB* HIM *OUT!*

JUST *KIDDING!*

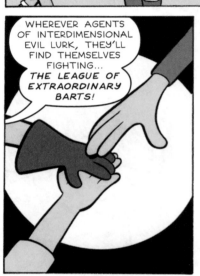

WHEREVER AGENTS OF INTERDIMENSIONAL EVIL LURK, THEY'LL FIND THEMSELVES FIGHTING... *THE LEAGUE OF EXTRAORDINARY BARTS!*

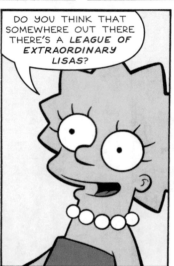

DO YOU THINK THAT SOMEWHERE OUT THERE THERE'S A *LEAGUE OF EXTRAORDINARY LISAS?*

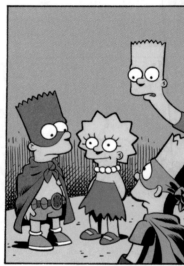

HA! HA! HA! HA! HA!

ZAP!

IF ANYONE WANTS ME I'LL BE IN MY *BIRD CAGE!*

THERE THEY ARE! GET 'EM!

HA! HA! HA!

THE END

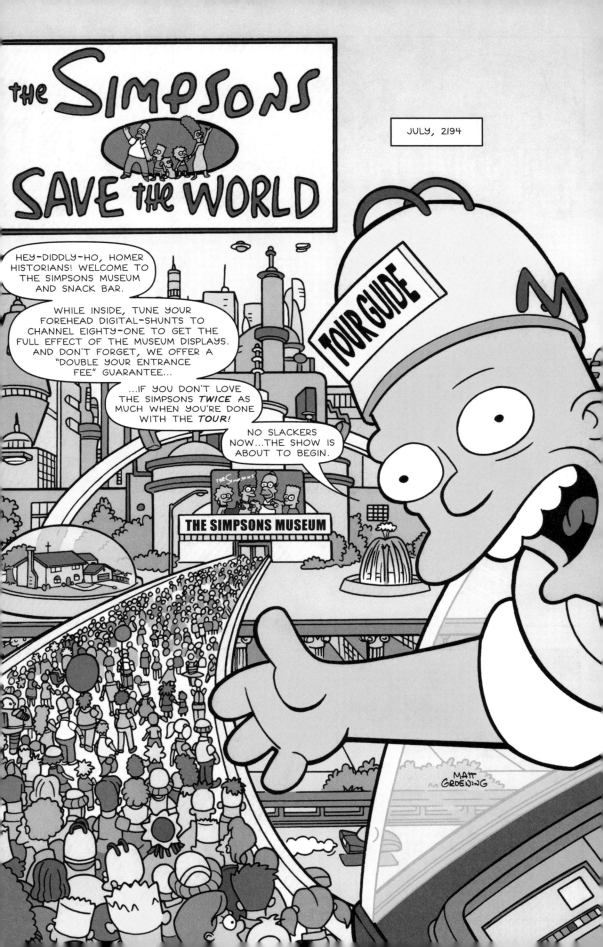

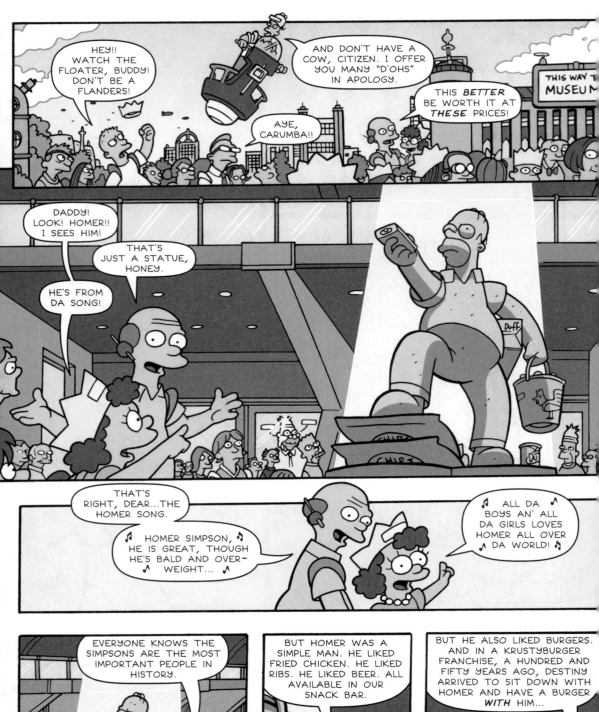

HEY!! WATCH THE FLOATER, BUDDY! DON'T BE A FLANDERS!

AND DON'T HAVE A COW, CITIZEN. I OFFER YOU MANY "D'OHS" IN APOLOGY.

THIS *BETTER* BE WORTH IT AT *THESE* PRICES!

AYE, CARUMBA!!

THIS WAY T[O] MUSEU[M]

DADDY! LOOK! HOMER!! I SEES HIM!

THAT'S JUST A STATUE, HONEY.

HE'S FROM DA SONG!

THAT'S RIGHT, DEAR...THE HOMER SONG.

♪ HOMER SIMPSON, ♪ HE IS GREAT, THOUGH HE'S BALD AND OVER-WEIGHT... ♪

♪ ALL DA ♪ BOYS AN' ALL DA GIRLS LOVES HOMER ALL OVER ♪ DA WORLD! ♪

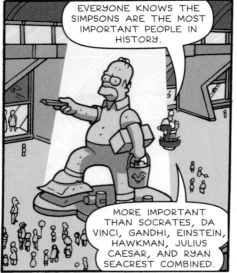

EVERYONE KNOWS THE SIMPSONS ARE THE MOST IMPORTANT PEOPLE IN HISTORY.

MORE IMPORTANT THAN SOCRATES, DA VINCI, GANDHI, EINSTEIN, HAWKMAN, JULIUS CAESAR, AND RYAN SEACREST COMBINED.

BUT HOMER WAS A SIMPLE MAN. HE LIKED FRIED CHICKEN. HE LIKED RIBS. HE LIKED BEER. ALL AVAILABLE IN OUR SNACK BAR.

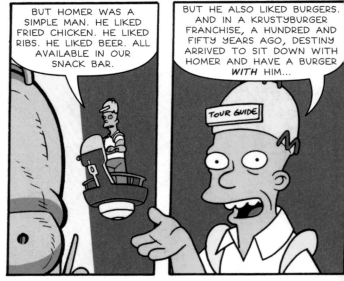

BUT HE ALSO LIKED BURGERS. AND IN A KRUSTYBURGER FRANCHISE, A HUNDRED AND FIFTY YEARS AGO, DESTINY ARRIVED TO SIT DOWN WITH HOMER AND HAVE A BURGER *WITH* HIM...

TOUR GUIDE

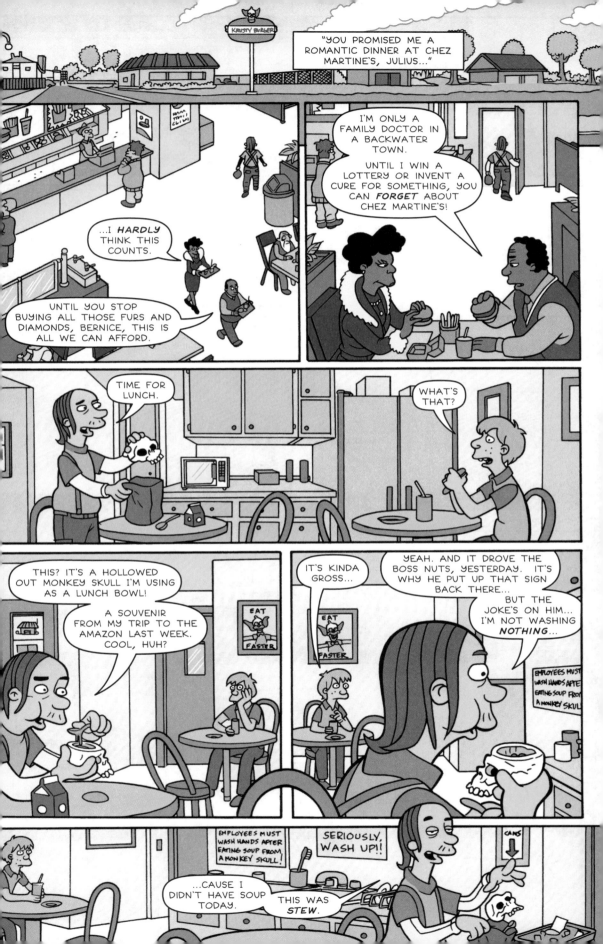

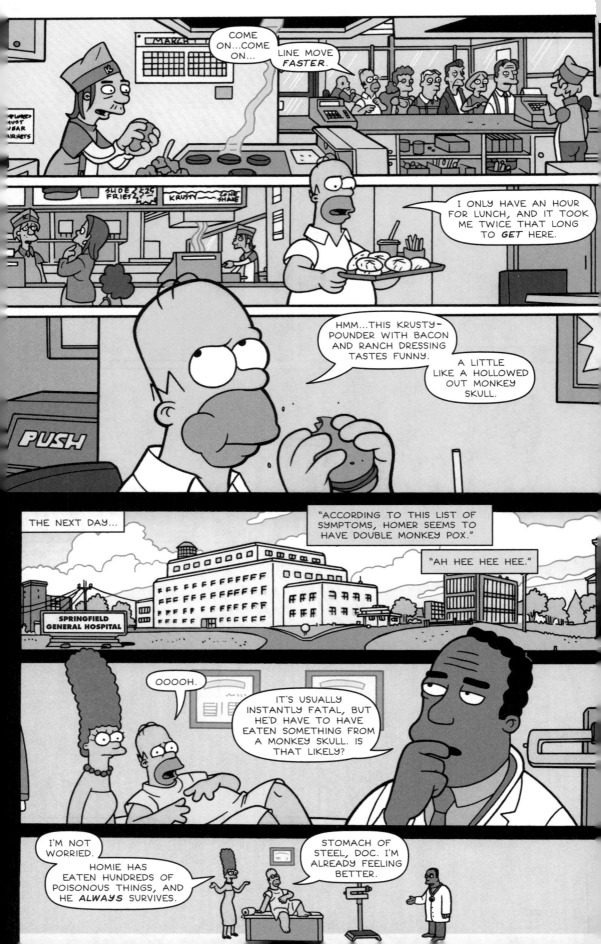

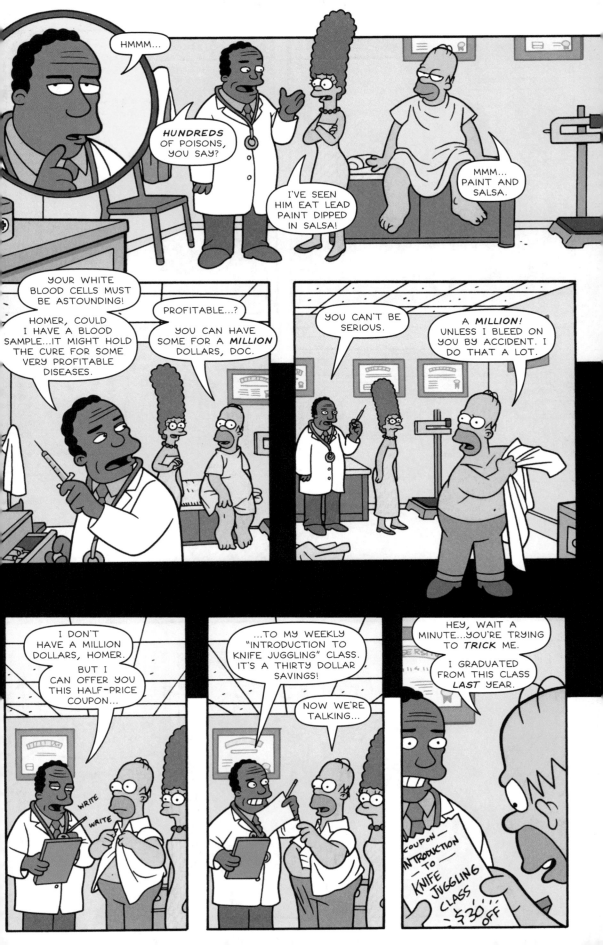

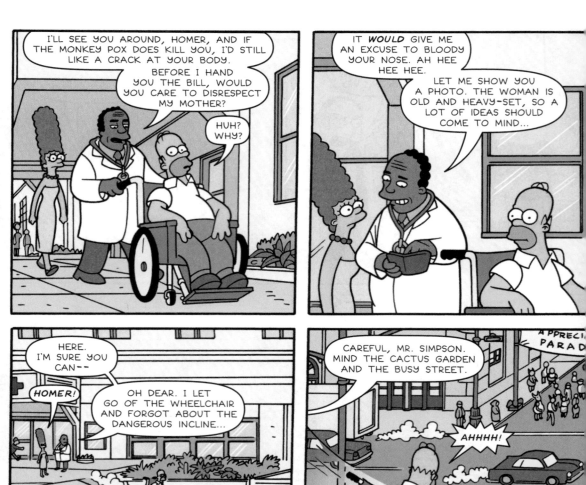

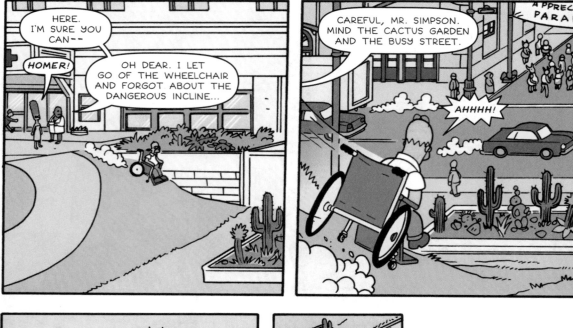

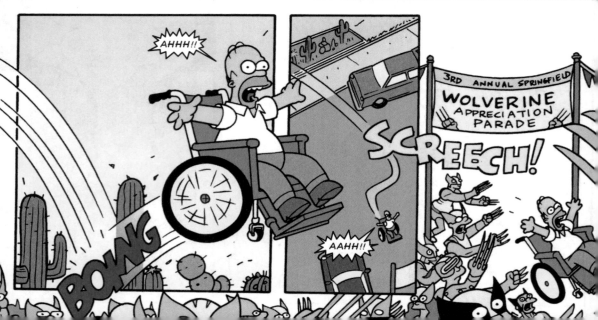

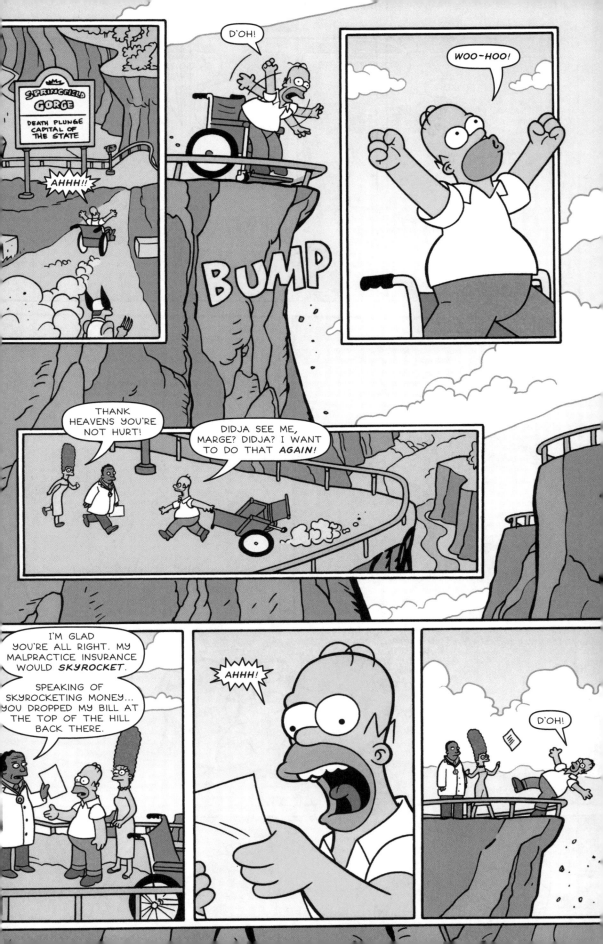

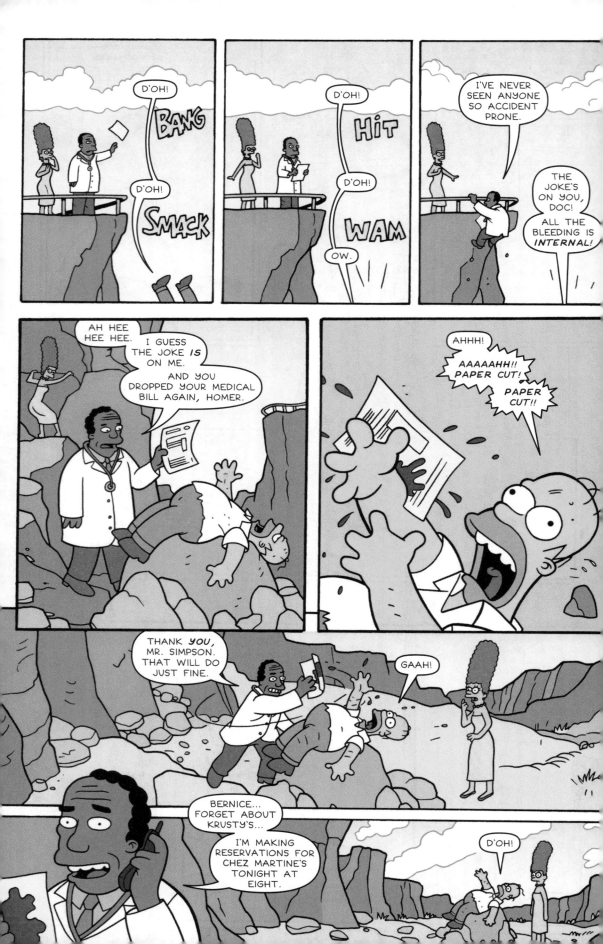

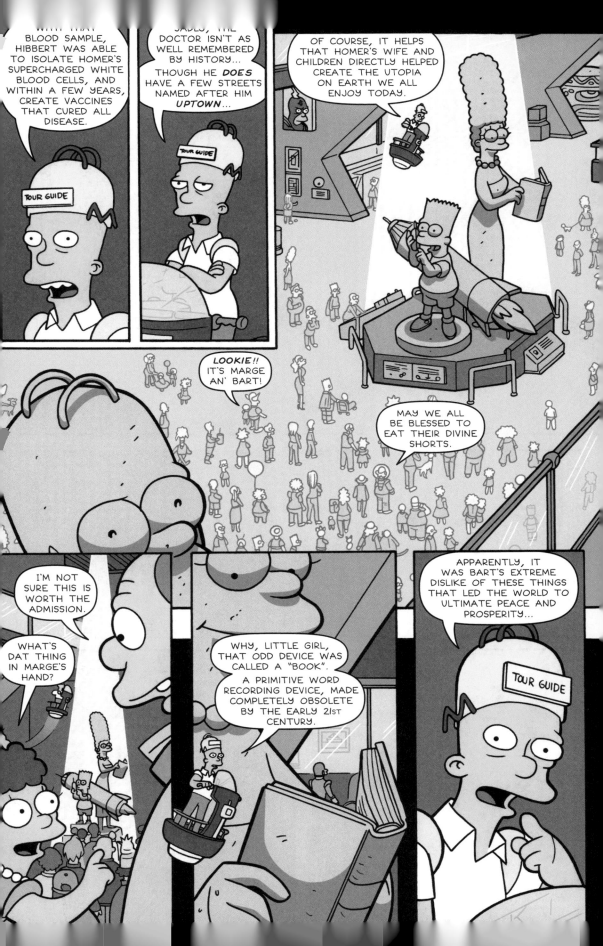

WITH THAT BLOOD SAMPLE, HIBBERT WAS ABLE TO ISOLATE HOMER'S SUPERCHARGED WHITE BLOOD CELLS, AND WITHIN A FEW YEARS, CREATE VACCINES THAT CURED ALL DISEASE.

SADLY, THE DOCTOR ISN'T AS WELL REMEMBERED BY HISTORY... THOUGH HE **DOES** HAVE A FEW STREETS NAMED AFTER HIM *UPTOWN*...

OF COURSE, IT HELPS THAT HOMER'S WIFE AND CHILDREN DIRECTLY HELPED CREATE THE UTOPIA ON EARTH WE ALL ENJOY TODAY.

LOOKIE!! IT'S MARGE AN' BART!

MAY WE ALL BE BLESSED TO EAT THEIR DIVINE SHORTS.

I'M NOT SURE THIS IS WORTH THE ADMISSION.

WHAT'S DAT THING IN MARGE'S HAND?

WHY, LITTLE GIRL, THAT ODD DEVICE WAS CALLED A "BOOK". A PRIMITIVE WORD RECORDING DEVICE, MADE COMPLETELY OBSOLETE BY THE EARLY 21st CENTURY.

APPARENTLY, IT WAS BART'S EXTREME DISLIKE OF THESE THINGS THAT LED THE WORLD TO ULTIMATE PEACE AND PROSPERITY...

THIS IS A LOUSY THING FOR MY MOM TO DO TO ME ON A SATURDAY.

GIVING ME TEN DOLLARS AND MAKING ME COME *HERE*. THERE'S NOTHING *FUN* HERE.

WHAT AM I SUPPOSED TO DO AT A *BOOK FAIR*?!?

WHO WANTS TO *READ* ABOUT SPORTS STARS AND PRESIDENTS? THAT STUFF'S ONLY INTERESTING WHEN IT'S ON TV! THIS PLACE IS *BOREDOM* CENTRAL!

YOU'RE TELLING ME.

I EVEN SWIPED THIS WHATSAMAJIGGY, BUT IT'S NO GOOD.

WHAT IS IT?

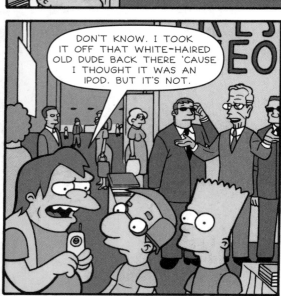

DON'T KNOW. I TOOK IT OFF THAT WHITE-HAIRED OLD DUDE BACK THERE 'CAUSE I THOUGHT IT WAS AN IPOD. BUT IT'S NOT.

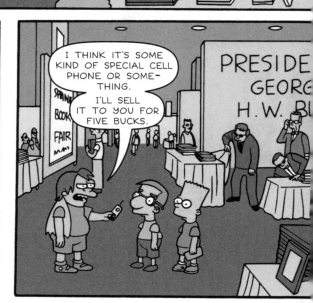

I THINK IT'S SOME KIND OF SPECIAL CELL PHONE OR SOME-THING.

I'LL SELL IT TO YOU FOR FIVE BUCKS.

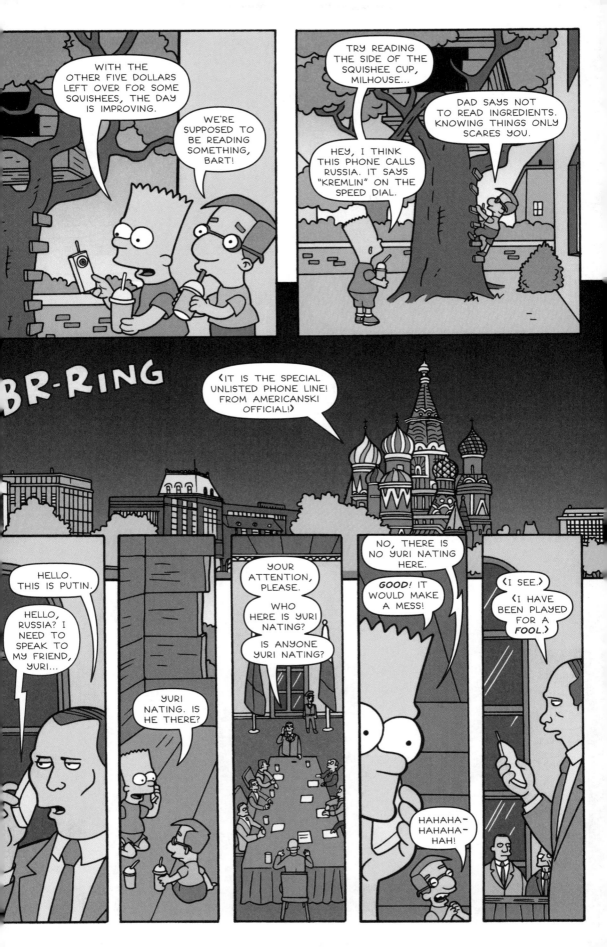

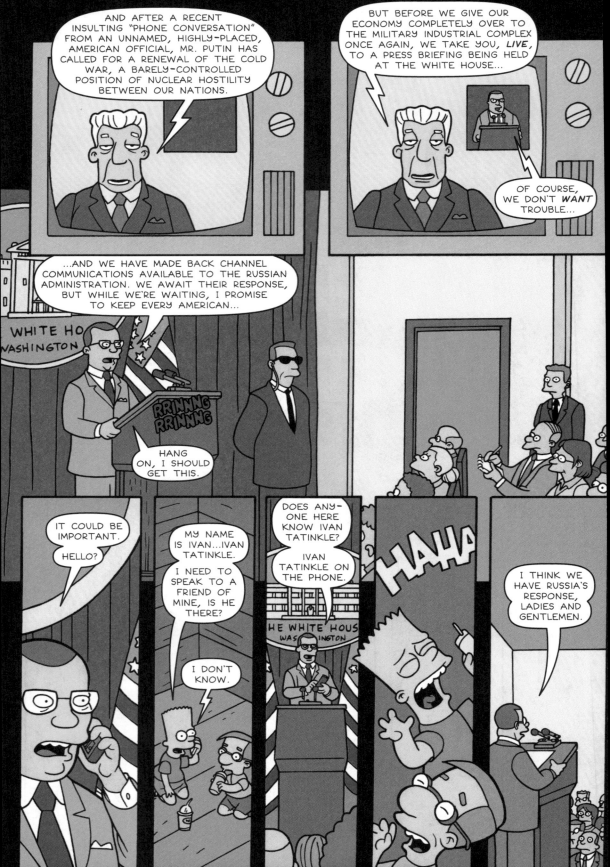

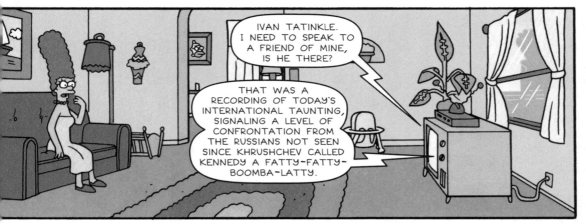

IVAN TATINKLE. I NEED TO SPEAK TO A FRIEND OF MINE, IS HE THERE?

THAT WAS A RECORDING OF TODAY'S INTERNATIONAL TAUNTING, SIGNALING A LEVEL OF CONFRONTATION FROM THE RUSSIANS NOT SEEN SINCE KHRUSHCHEV CALLED KENNEDY A FATTY-FATTY-BOOMBA-LATTY.

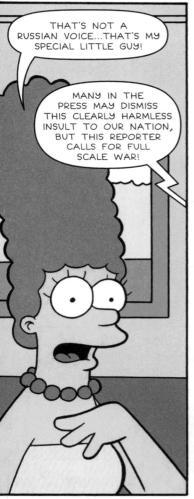

THAT'S NOT A RUSSIAN VOICE...THAT'S MY SPECIAL LITTLE GUY!

MANY IN THE PRESS MAY DISMISS THIS CLEARLY HARMLESS INSULT TO OUR NATION, BUT THIS REPORTER CALLS FOR FULL SCALE WAR!

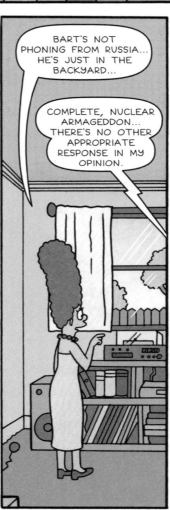

BART'S NOT PHONING FROM RUSSIA... HE'S JUST IN THE BACKYARD...

COMPLETE, NUCLEAR ARMAGEDDON... THERE'S NO OTHER APPROPRIATE RESPONSE IN MY OPINION.

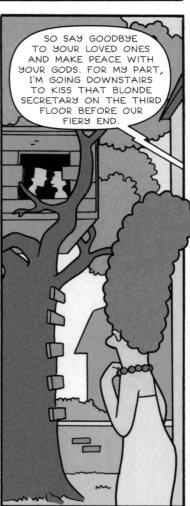

SO SAY GOODBYE TO YOUR LOVED ONES AND MAKE PEACE WITH YOUR GODS. FOR MY PART, I'M GOING DOWNSTAIRS TO KISS THAT BLONDE SECRETARY ON THE THIRD FLOOR BEFORE OUR FIERY END.

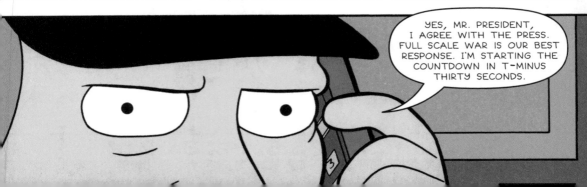

YES, MR. PRESIDENT, I AGREE WITH THE PRESS. FULL SCALE WAR IS OUR BEST RESPONSE. I'M STARTING THE COUNTDOWN IN T-MINUS THIRTY SECONDS.

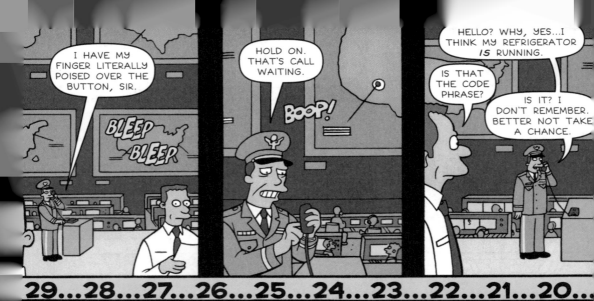

29...28...27...26...25...24...23...22...21...20...

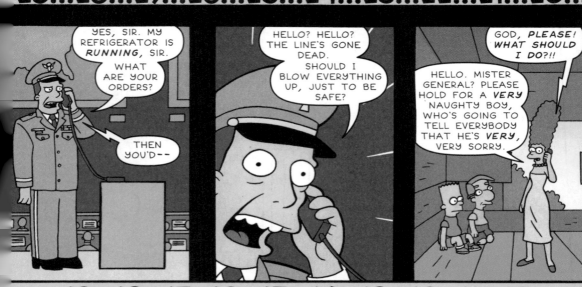

...19...18...17...16...15...14...13...12...11...10...

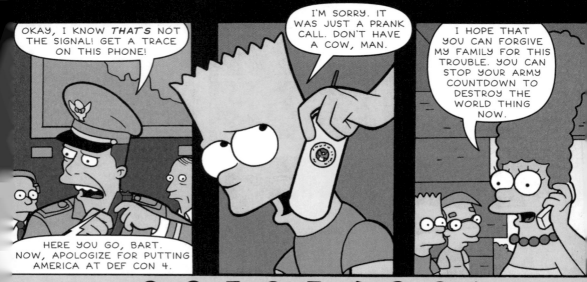

...9...8...7...6...5...4...3...2...1

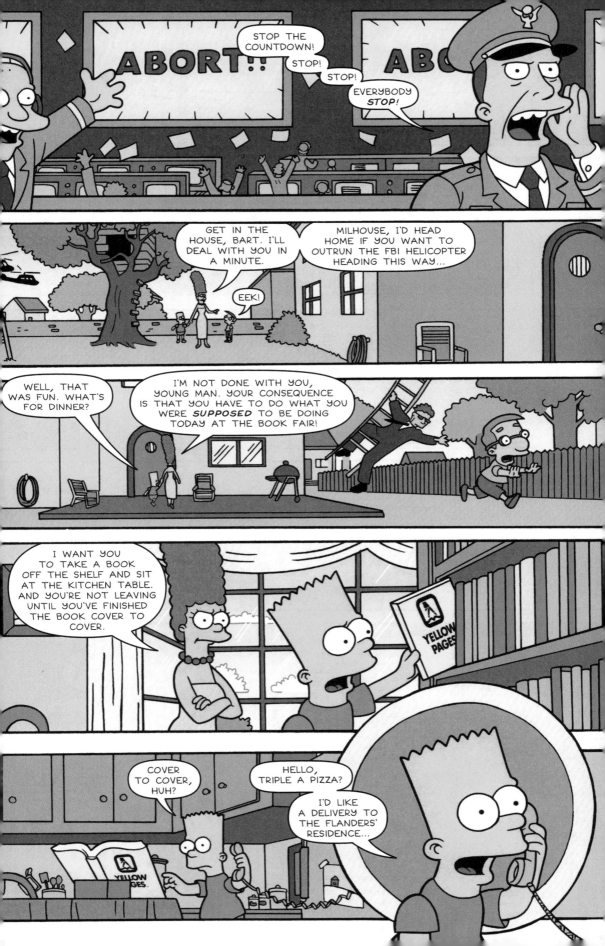

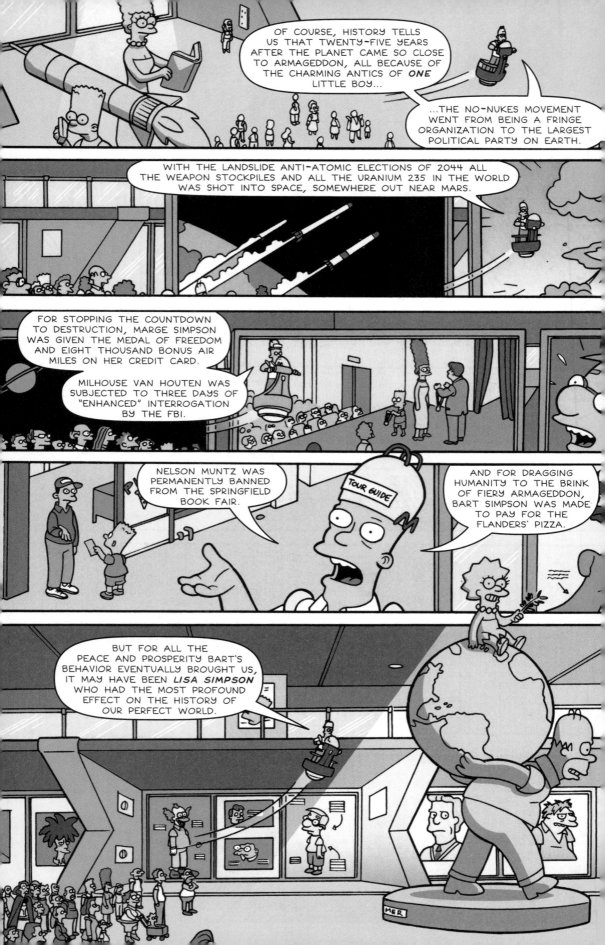

Dear Diary,
Today I'm doing MY part to save the world,
even if it's just a little. I'm writing a
school report about GLOBAL WARMING and
alternative energy sources. I get to visit
dad at work to ask him important questions,
and EVERYONE will read my report and...
maybe even pay attention THIS time.

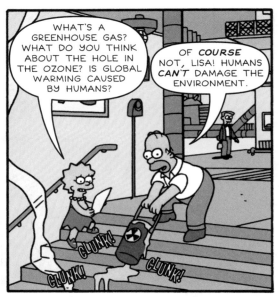

WHAT'S A GREENHOUSE GAS? WHAT DO YOU THINK ABOUT THE HOLE IN THE OZONE? IS GLOBAL WARMING CAUSED BY HUMANS?

OF *COURSE* NOT, LISA! HUMANS *CAN'T* DAMAGE THE ENVIRONMENT.

GLUNK!
GLUNK!
CLUNK!

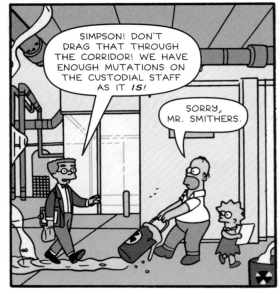

SIMPSON! DON'T DRAG THAT THROUGH THE CORRIDOR! WE HAVE ENOUGH MUTATIONS ON THE CUSTODIAL STAFF AS IT *IS!*

SORRY, MR. SMITHERS.

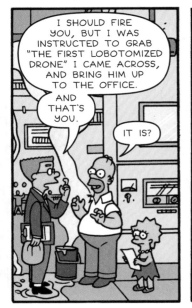

I SHOULD FIRE YOU, BUT I WAS INSTRUCTED TO GRAB "THE FIRST LOBOTOMIZED DRONE" I CAME ACROSS, AND BRING HIM UP TO THE OFFICE.

AND THAT'S YOU.

IT IS?

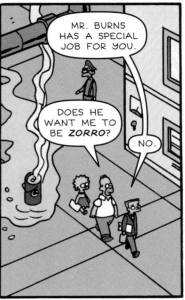

MR. BURNS HAS A SPECIAL JOB FOR YOU.

DOES HE WANT ME TO BE *ZORRO?*

NO.

BECAUSE I'VE BEEN *PRACTICING* TO BE ZORRO...

JUST FOLLOW ME.

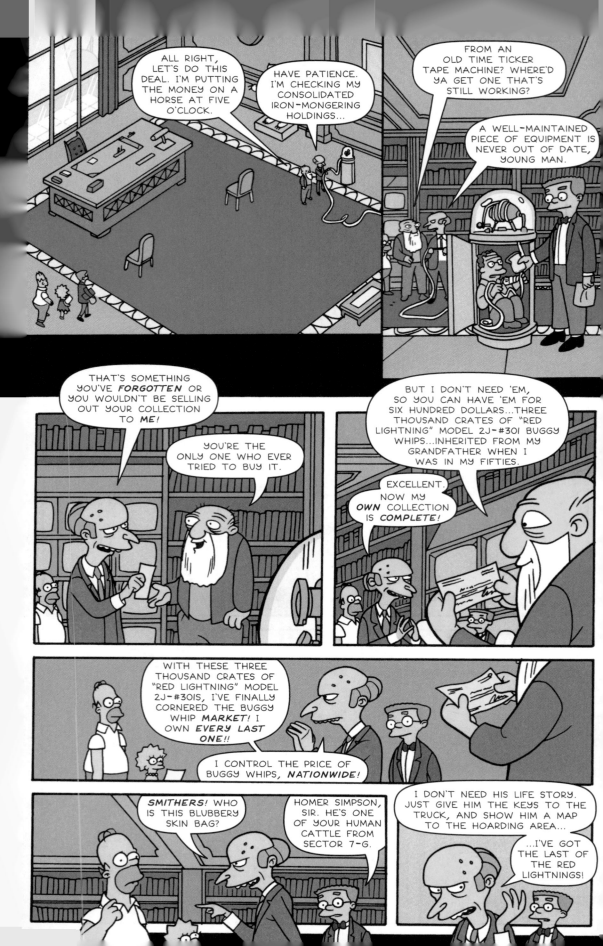

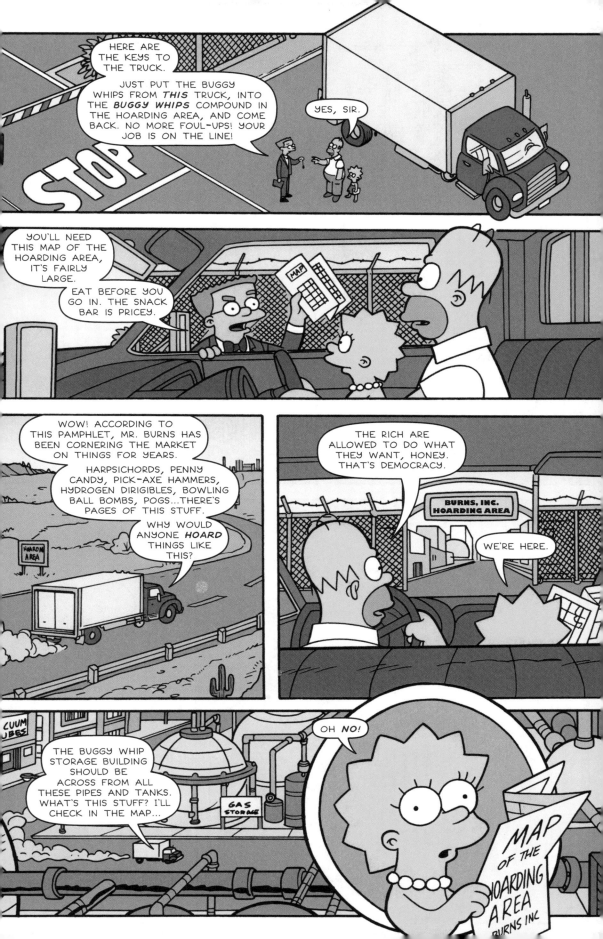

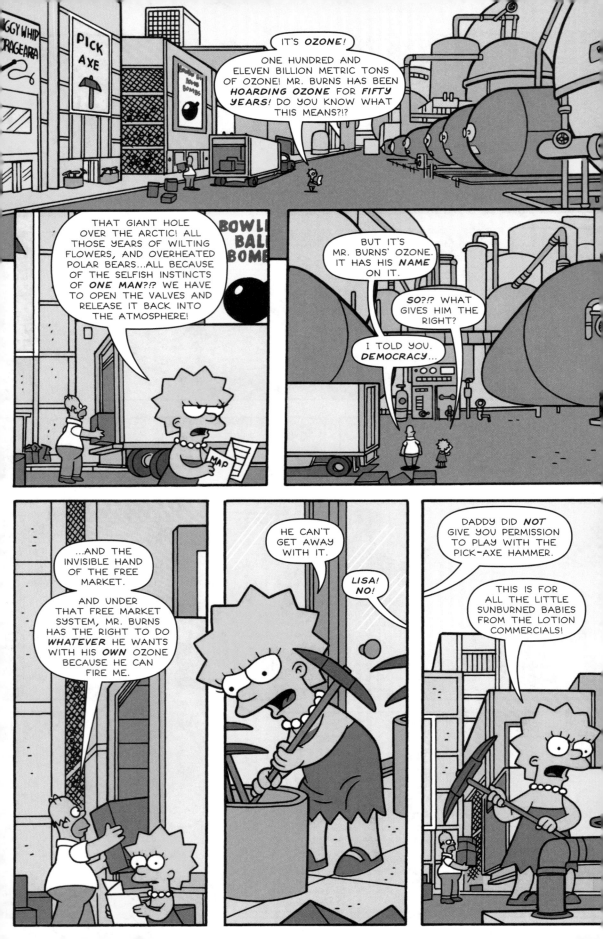

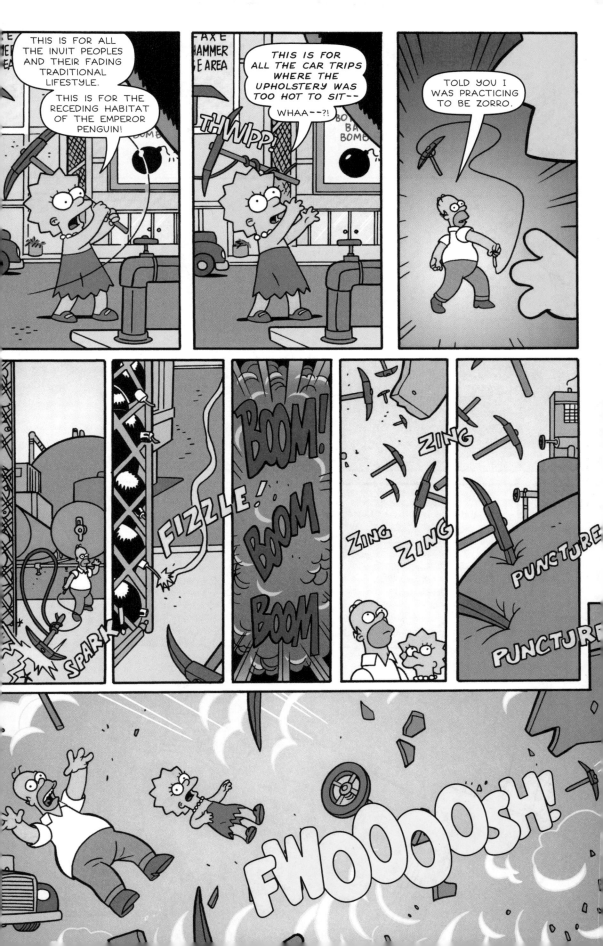

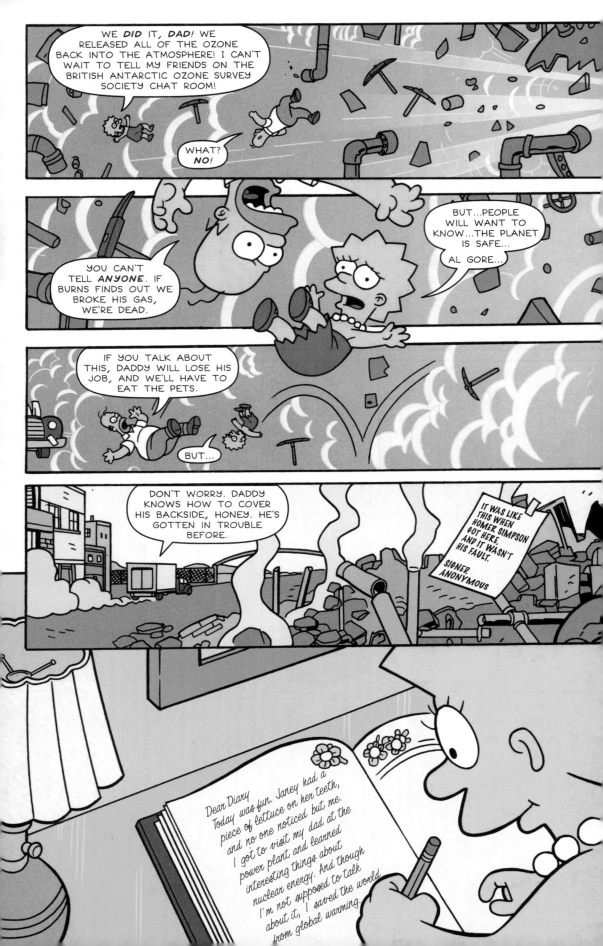

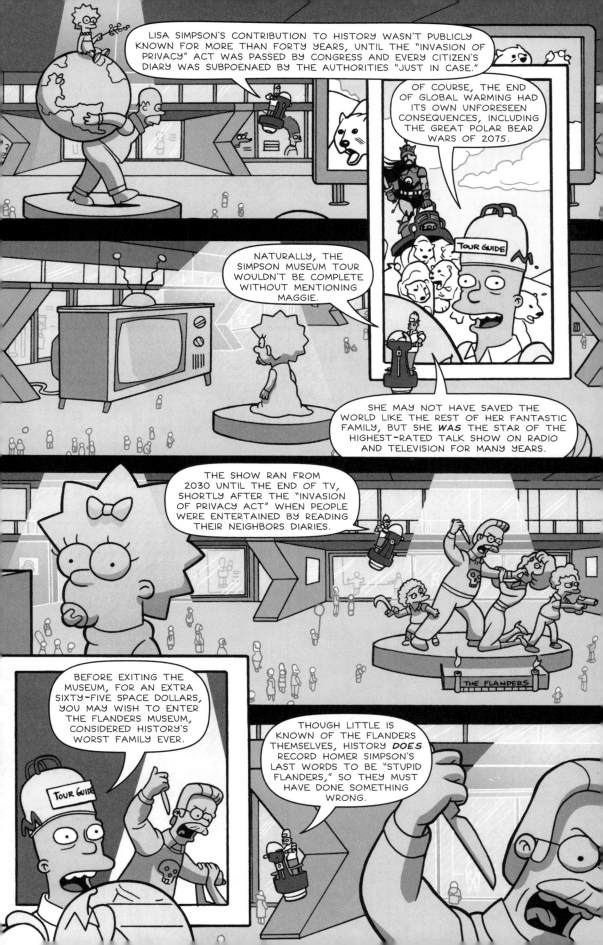

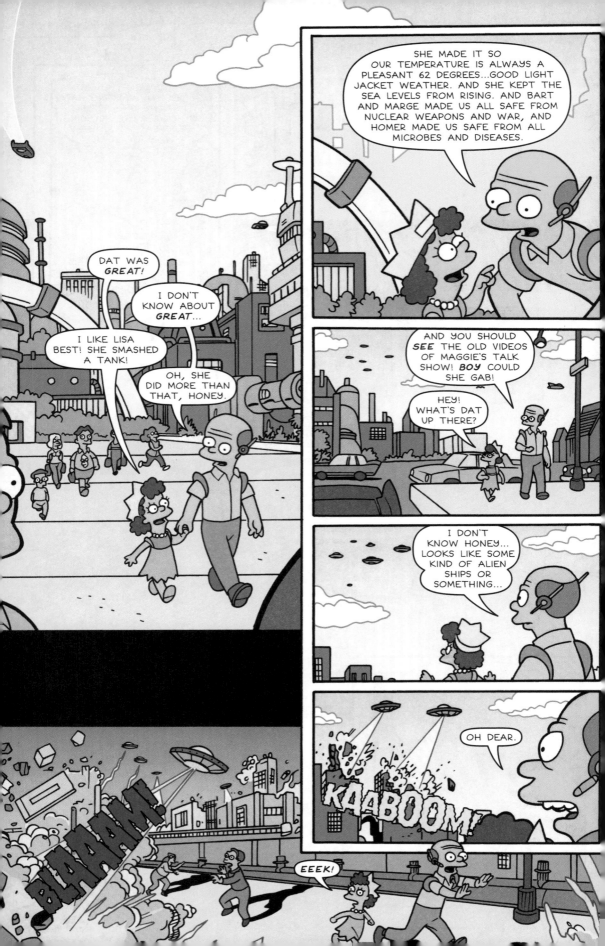

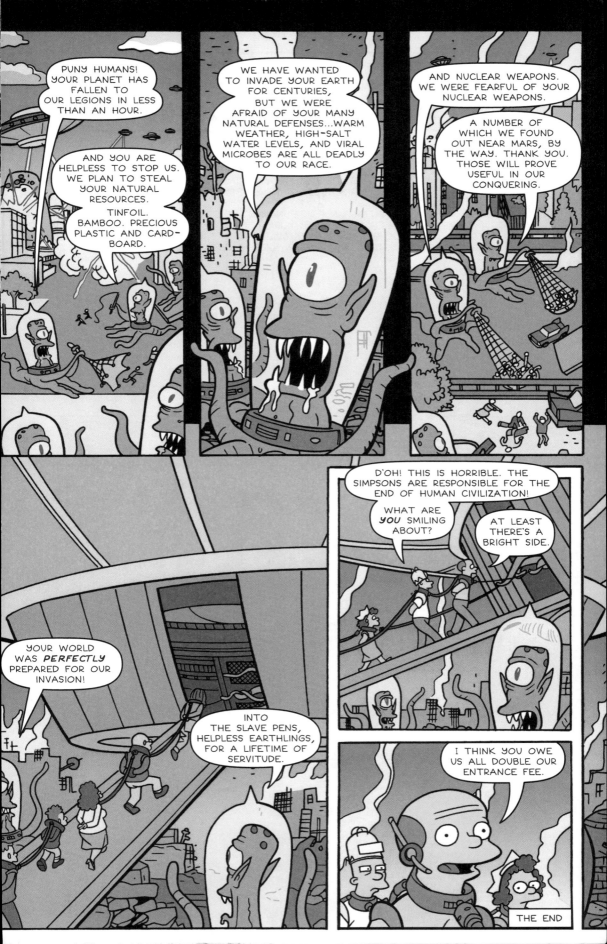

WHAT HO, FAITHFUL COMIC READER! IT IS MY DUBIOUS HONOR TO INTRODUCE BONGO'S VERY FIRST INSTALLMENT OF

THE BUSY HANDS PAPERCRAFT PROJECT!

EACH VOLUME OF THE COLOSSAL COMPENDIUM SERIES WILL INCLUDE A BUILDABLE REPLICA OF ONE OF SPRINGFIELD'S FINEST LANDMARKS. WITH A LITTLE PLUCK (AND COPIOUS AMOUNTS OF TAPE) YOU WILL BE ABLE TO BUILD YOUR VERY OWN SPRINGFIELD IN NO TIME AT ALL. (ACTUALLY IT WILL TAKE SEVERAL YEARS; BUT WE COLLECTORS ARE A STUBBORN AND DETERMINED LOT, WHO WOULD RATHER DIE THAN SEE OUR COMPLETIST THIRST BE LEFT UN-SLAKED.)

I, THUSLY, PRESENT TO YOU THE ANDROID DUNGEON AND COMIC BOOK STORE IN MINUSCULE. COMICS AND POP CULTURE EPHEMERA NOT INCLUDED, OF COURSE. FOR THOSE, YOU WILL HAVE TO VISIT MY LAVISH 600-SQUARE FOOT RETAIL SPACE IN THE HEART OF SPRINGFIELD'S MERCHANT DISTRICT, WHERE OUR MOTTO IS, "NO PERSONAL CHECKS!"

WHAT YOU WILL NEED:
- Scissors, adhesive tape, and a straight edge (such as a ruler).
- An ability to fold along straight lines.
- An additional "mint condition" copy of this book secured elsewhere!
 (Be forewarned... cutting up this collection will reduce the grade from "mint" to "poor plus" at best!)

1. Before cutting out the building and awning shapes, use a ruler and a slightly rounded metal tool (like the edge of a key) to first score, and then fold lightly along all the interior lines (this will make final folds much easier).
2. Cut along the exterior shape. Make sure to cut all the way to where the walls, the roof, and the flaps lines meet (Fig 1).

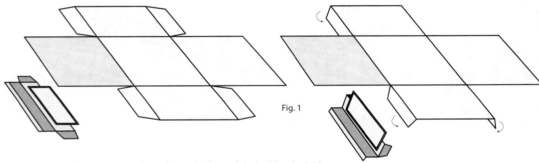

Fig. 1

3. Fold awning as shown (Fig. 2) and attach it to the front of the building by folding the flaps around the front wall and securing them with tape (Fig. 3).

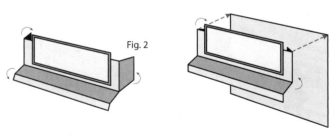

Fig. 2

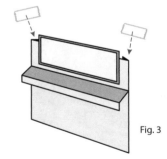

Fig. 3

4. Form building by folding walls into place (Fig. 4) and secure all tabs to the interior of the building with tape (Fig. 5).

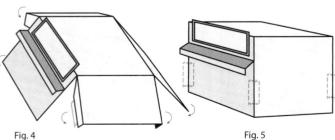

Fig. 4

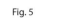

Fig. 5

5. Cut out figures and bases.
6. Cut along the dotted line at the base of each figure and also the center of each curved base. (Be careful not to cut too far!)
7. Connect base to figure as shown.

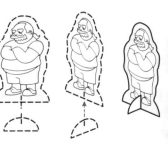

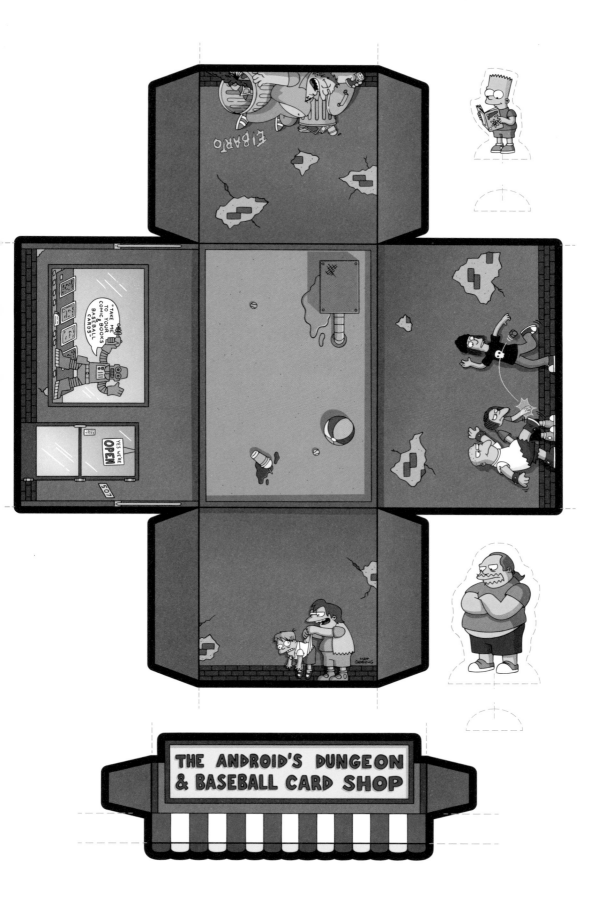

THE ANDROID'S DUNGEON & BASEBALL CARD SHOP